IN THE STREAM OF STARS

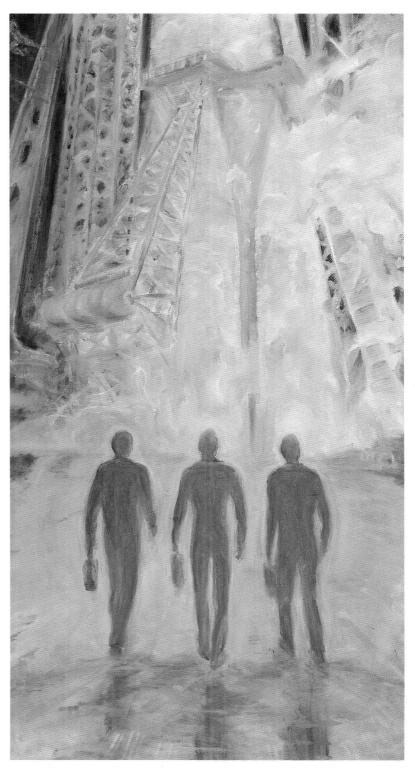

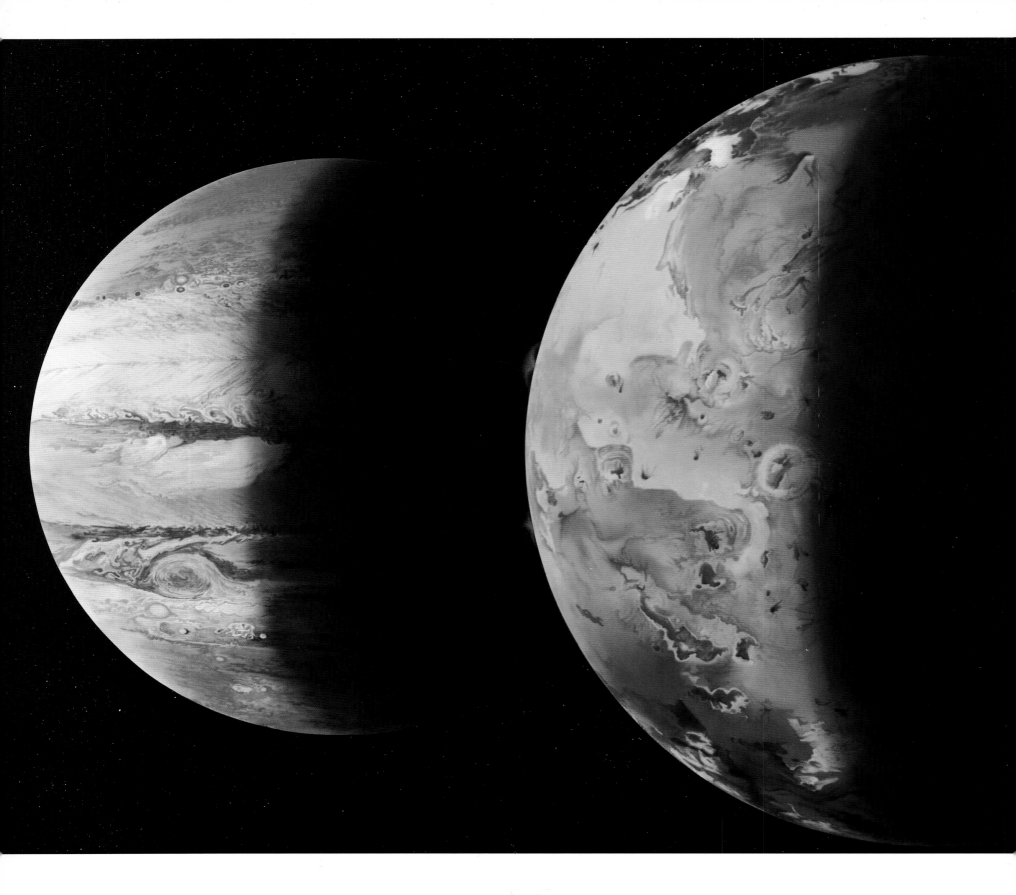

IN THE STREAM OF STARS
THE SOVIET/AMERICAN SPACE ART BOOK

Edited by

WILLIAM K. HARTMANN • ANDREI SOKOLOV
RON MILLER • VITALY MYAGKOV

With a Historical Perspective by

RAY BRADBURY

———————

With the cooperation of
The International Association for the Astronomical Arts
The Planetary Society
The U.S.S.R. Union of Artists

———————

WORKMAN PUBLISHING • NEW YORK

By the same authors:

Ron Miller and William K. Hartmann
Grand Tour
Out of the Cradle (with Pamela Lee)
Cycles of Fire (with Pamela Lee and Tom Miller)

William K. Hartmann
Desert Heart:
Chronicles of the Sonoran Desert

Ron Miller
Space Art
Worlds Beyond: The Art of Chesley Bonestell (with Fred Durant)

Library of Congress Cataloging-in-Publication Data

In the stream of stars : the Soviet/American space art book / edited by William K. Hartmann . . . [et al.] ; with a historical perspective by Ray Bradbury.
p. cm.
"With the cooperation of the International Association for the Astronomical Arts, the Planetary Society, the U.S.S.R. Union of Artists."
ISBN 0-89480-705-6 (paper) ISBN 0-89480-875-3 (cloth)
1. Outer space in art. 2. Art, Soviet. 3. Art, American.
I. Hartmann, William K. II. International Association for the Astronomical Arts. III. Planetary Society. IV. Soiuz khudozhnikov SSSR.
N8234.08I5 1990
758′.96294—dc20 90-46211
 CIP

Cover, "Flags on Mars," by Paul Hudson

Jacket design by Charles Kreloff
Book design by Charles Kreloff and Tom Starace

Workman Publishing
708 Broadway
New York, New York 10003

Printed in Hong Kong

First printing November 1990

10 9 8 7 6 5 4 3 2 1

Vladimir Dzhanibekov
Crew

(Half-title page) "The start of the cosmic ship," explains Dzhanibekov, "is one of the most intense moments. They are the last minutes on the Earth before a long flight." His shadowy figures, silhouetted against the glowing complexity of the spacecraft, express some of that loneliness and introspection.

Robert Kline
In the Shadow of Giants

(Frontispiece)

Portions of a collaborative work by various artists
First Steps

(Facing page) Each panel on the right is by a different artist from the international workshop in Moscow in 1989. They commemorate important moments of space exploration, such as the landing of Yuri Gagarin's spherical capsule in 1961 (top center).

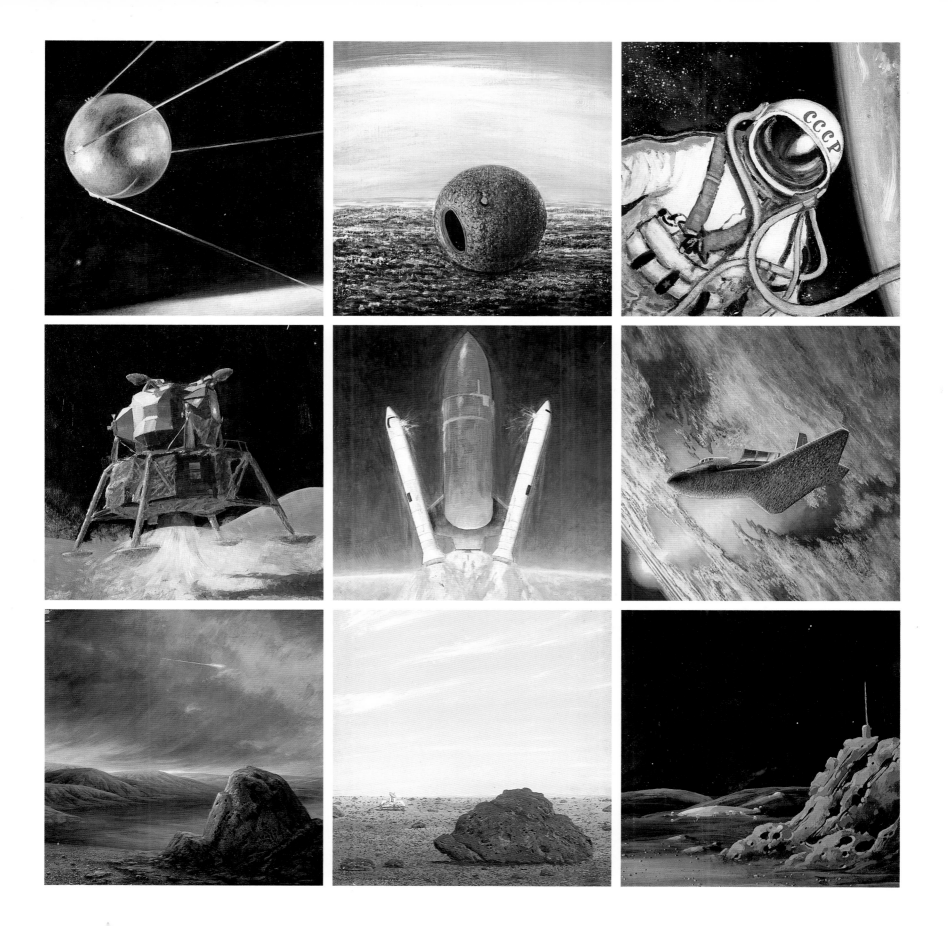

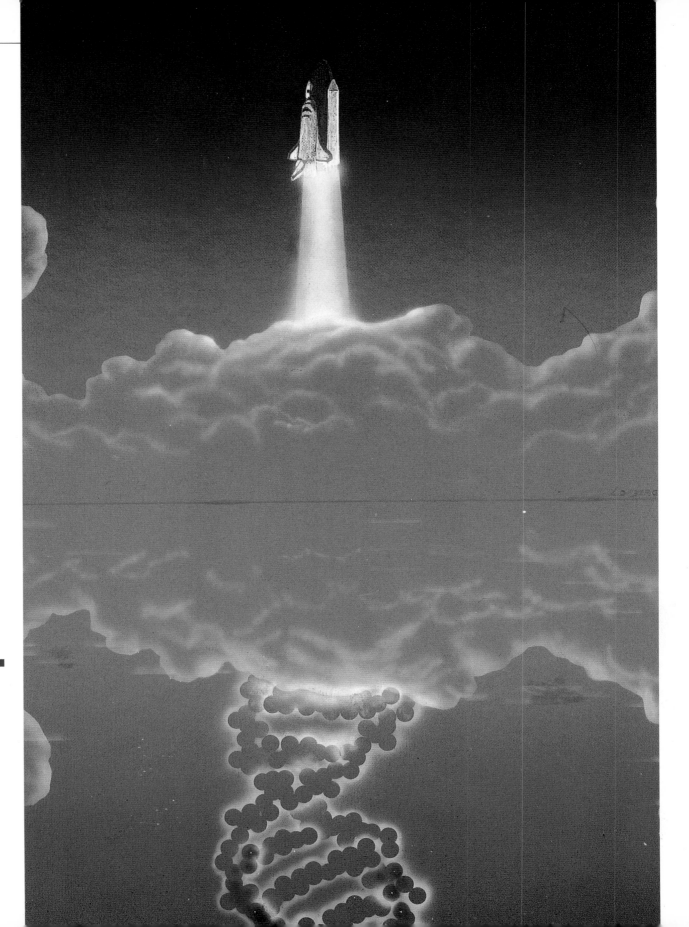

Jon Lomberg
DNA Leaves the Planet

The artist often weaves DNA strands into his representations of space exploration to symbolize the role of life and expanding consciousness in the universe. This picture was painted for NASA's Life Sciences Report for 1987 to head a chapter about biosciences experiments on the space shuttle, and it symbolizes how the machines that take us into space are serving to lift our genetic pool of life off-planet.

We Are the Carpenters of an Invisible Cathedral

A Historical Perspective by Ray Bradbury

Think: if God had not invented the eye, there would never have been space travel. You do not reach for stars you cannot see. And yet the eye was invented in the genetic soup of one billion years past, as sea-plants and animalcules swarmed up after the light. They followed the sun from horizon to horizon through 365 million dawns, high noons, and twilights until the eye, ascendant, focussed itself in a caveman's head. That caveman hid fireless, staring skyward at a single great and a million small fires that one day would beckon him out and up. Did some peculiar itch for far-traveling circumnavigate his soul in those primitive times? Perhaps in intuitive dreams he flew toward light and warmth to wake shivering with cold. We cannot know.

We only know that the itch for stupendous journeys circumnavigates us. We search the skies and let that fire sneak down our nerves into our fingers to issue forth in the oils and watercolors which panoply this book.

We came out of the sun. The volcanic eruptions of four billion years past are the air we breath today. And so we are fire-apes; we long to re-join that sun. But not ours; someone else's furnace, someone else's star.

In some far attic where genetic factories turn out wonders of un-imaginable flesh, a sun beckons. To that celestial lighthouse we wish to ship out with our own miraculous cargos of sight, sound, and souls just as indescribable.

We will never stop. Operation Outreach will unwind our tape-measure souls across as much of the universe as will stand still, agreeable to measurement.

In doing so, we will be the Carpenters of An Invisible Cathedral.

Is that too romantic, too grandiose? Do I ask you to wear a suit ten sizes too large? I do. For the universe is grandiose, romantic, endless. It asks us to expand to fit eternity. We anthill humans hasten to oblige.

We will indeed build the greatest cathedral ever blueprinted, and digital-compute it on star charts to be connected-by-numbers. Like those old child's puzzles, drawing lines, this time by radio and laser beam, between Earth, Mars, Saturn and on out to the incalculable algebras of a rimless universe. Our shouts of life will ricochet off tombstone planets and the stuff of the void.

But, doing so, we often feel we believe in space travel more than does our government and even, oh, no, *NASA!*

In the years since the Apollo missions ceased, we have felt our spirits gutter low and, for a time after Challenger, be snuffed out.

And now we shuttle mail instead of high frontiers. We position telstars and loft telescopes, well and good, but still we circle our cradle

and fail to progress our spirit much beyond ground and gravity.

The works within this book revive in part the old holy mission. They remind us of where we have been and might go again. To go for what? In search of ourselves. In search of our children's future generations.

Consider the *avant-garde*, the vanguard: how rarely in history has it truly *been* the avant-garde? This book is completely that. How so?

Well, examine the so-called "avant-garde" paintings, essays, short stories, sculptures, or novels of the last forty years. Choking on them, we have doubted the sanity of the people who owned the galleries and the critics who ran the asylums. We have feared to protest, thus opening ourselves to jeers and taunts: Philistine! Reactionary! Numskull! Neo-Luddite!

But then in a grand upheaval of fire, Sputnik blazed across our night skies. We all ran out to worship it as the center of a newfound religion in the autumn sky of 1957.

And doing so we redefined our artistic concepts toward a truly future-oriented avant-garde. This book, on tomorrow morning's sill, proves that the *garde* of just yesterday afternoon was always *derrière*. For tomorrow's promise is not formless, empty metaphor done by the mindless to please the morons. It is a real, touchable, enactment of the architecture already mentioned: the great cathedral walls that we will inhabit in space and time to prove ourselves worthy and deliver immortality.

Is *that* what this is all about? Could it be that space travel is not only good for the Soviets and us, but good for Jehovah, Allah, or why not say it, the Lord God Almighty? If I toned it down to the "Life Force" would you stop blushing and tune your ears?

Attention, then. Space travel is the religious endeavor of humankind to comprehend the mystery, box the miracle, understand the immense Why of life here and somewhere so far off we will never meet its Mother Ship.

The word religion is based on *religio*, to "relate," to bind facts together to make some sort of scientific, philosophic, or worshipful whole that we can turn in our hands even as we package it with our minds.

We have important riddles to solve. Ourselves. And one of the ways we solve us is with our rockets.

This book winds up being the jungle gym, the ladder, the glass stair up which we bright chimps with our fiery outreach will climb, and fall, and climb again. We move from nursery Earth to uncompromising heavens, which will yield if we use our foresight and will.

We insist upon Becoming. To do anything else is to sink into the tarpits in which ten million years of dinosaurs, unremembering of themselves, are buried.

We refuse such burials. We will not accept a sun that might explode and burn Shakespeare, Alexander Pope, Edgar Allen Poe, or John Smith on his porch in Greenwater, Mass. We refuse to pay a penalty of two billion people to an Ice Age or a celestial holocaust. If the heat is turned up in the oven, we will flee. If the glaciers creep down our metropolitan yards, mowing our lawns with borrowed stones, we will deny the iceman and send ourselves special delivery to Mars and beyond. Do I predict, borrowing from Robert Frost, fire and ice, one or t'other? No, but I imagine them. And that dire image lubricates my motors and instills the dream of possible survival beyond the death of frost or flame.

Can we act this melodrama, fill the parts: live forever? The blueprints are here. All we must do is determine our passion, and fill in the forms.

There is a remarkable and touching story by Pirandello titled "The Medal," which in some ways reminds me of our present failure to recognize space travel for what it obviously is.

In Pirandello's tale, an elderly woman on a train tells and re-tells the valor of her dead son and displays his posthumous medal and recounts his deeds and shows his medal again and goes on and on, until at last—

An old man across from her asks: "And then, is he *really* dead?"

The old woman is destroyed. Until now, she has not let herself believe in her son's death. She has fixed on the medal and not on his mortality.

So, in relation to space and the destiny of Humankind, I ask, gently:

"And then, are we *really* alive?"

Alive for what reason?

We are so busy rushing about building small and then larger and then super-large Canaveral toys, that we forget to pose that simplest of questions.

Sir Edmund Hillary, asked why he climbed Everest, replied, "Because it was there."

Which is no answer at all. I refuse his meaningless response.

We climb not because Space is *there*, but because the gift of life, of seeing, of hearing, smelling, tasting, touching is worth survival. The poet Phoebe Hesketh summed it thus:

> Life is grass,
> And man a moment of hope
> From centuries' dust
> . . . all things that live are preparing to leave.

We are preparing to leave. Not into the grave and some unprovable heaven, but into the sky where we will deliver ourselves back to the Garden.

So it has always been, though we did not guess or know it one hundred centuries ago.

Many labels fit our century.

It is the Age of The Greatest Journey.

It is the Space Age.

It is the Time of Going Away.

Birds, at the proper time, thrust from their nest, fly or fall. We, both parent and fledgling, thrust ourselves from the technological nest and, against the will of gravity, fall upward.

The future Apollos will be technological marvels, military miracles, communications giants, astronomical wizards; all that most certainly, yes.

But above all they will be the attempt of humankind to outlive the lifetime of our sun.

Can we do that and, immortal, live forever?

My answer? A resounding Yes.

We cannot stay home now, even as we did not sit on the front porches of 1492 Spain or refused to follow Giovanni Caboti's 1550 jaunts or Verrazano's Francis the First expedition which wound up landfalling where? At Kitty Hawk!

The eye that was invented a billion years ago provides evidence for just such a future, here in this book.

Here in this book is also a promise and a reward as yet unfulfilled. It would seem to me that without the fusing of energies between the Soviets and America we might never leave Anthill-formerly-Spaceship Earth.

Why a partnership with the Soviet New-Soft-Liners and our somewhat fallen-away Apollo aspirations?

Because, despite the damaged dreams of Challenger, Phobos 1 and 2, or blinded eye of Hubble, ours are still the only major spacefaring societies. Simultaneously, we are still half-in and half-out of our political pasts; cold warrior mythic enemies. Enemies, that is, whose hostilities have taken on knee-jerk, mythic, status. That status changes now, in these times when we might, if we wished, beat our swords into star-shares, to harvest if not the Milky Way, at least the golden apples circling our sun.

Could not the Soviets and Americans organize a consortium that would include all who wish to contribute to the humanizing, the restructuring of goals across our world?

I have shouted and whispered, alternately, for countless years on the obvious idea that space can be the substitute for war. That space and time are a proper foe to oppose, to fight the good fight against what is out there waiting to kill us if we do not behave. Let us then change the weather with our rocket engines, insuring a long summer after a cold war.

And to start with, we must study the preliminary excursions, the work of these artists who have here sketched and painted the immediate past and the promise of a future. Then, let us raise our voices.

The universe listens for our cry.

The universe waits the arrival of our eye to see, our blood to stir, our soul to worship.

For if the void were not terrifying and empty and beautiful we'd need not go there to fill it. We could stay home and mend our socks.

I would not do that. I cannot sleep without dreams, I cannot dream without doing.

The carpenter in me spits rocket nails, the hammer in me would run up that cathedral arch and bind it in place.

If we must die, let it be from a high place where we will be seen and the structure stays long after our death.

For who will little note nor long remember if we fall out of bed, dead long years before we hit the floor?

Choose. Where would you wish to die?

Why not up there on the beams and catwalks which these artists have sketched and caught in line and color?

Shall we go?

Ray Bradbury
June 21, 1990

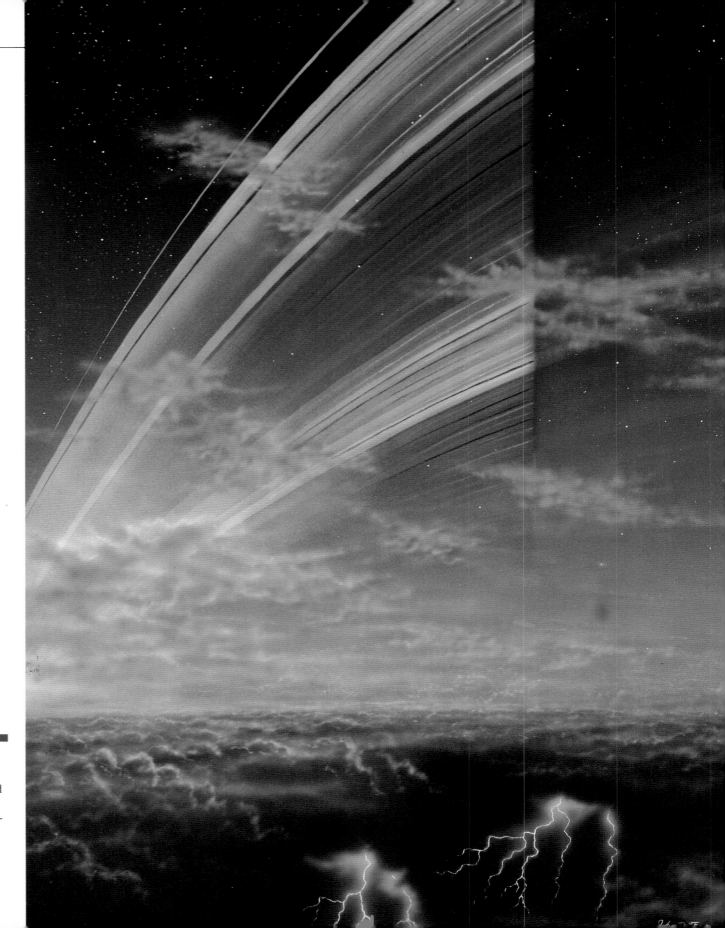

John Foster

Saturn's Rings in Storm

The ring system of Saturn is here viewed from the upper reaches of Saturn's cloud deck. The nighttime cloudscape is illuminated by the rings, but the planet's shadow cuts across the system, plunging the rings into darkness.

CONTENTS

BEGINNINGS

By William K. Hartmann

Long before the first Sputnik circled the Earth in 1957, a certain breed of artists, inspired by astronomical discoveries, adopted the whole cosmos as their muse. Like artists re-creating the world of the dinosaurs, these painters revelled in the challenge of combining the latest scientific findings with their own creativity.

For want of a better term, current artists of this school have evolved the term "space art" for their work. Space art is art inspired by a human adventure that transcends national differences: space exploration. The artists paint vistas of other planets, moons, asteroids, comets, and star systems; events of the past, present and future of the cosmos; and their own abstract responses to our cosmic environment.

The story behind this book goes back to the 1981 Voyager 2 encounter with Saturn. The Planetary Society, a space advocacy group founded by Carl Sagan and others, organized Planetfest, a celebration of this milestone in human exploration. Among the festivities was an exhibition of space art, where many of the North American participants in this book first met.

As we got to know one another, I realized that many of these painters, especially those from the East Coast, had never had a chance to see active volcanoes, craters, lava flows, deserts, and other such planetary features. Thus, I organized the first Space Art Workshop in Hawaii Volcanoes National Park in 1982. This event was sponsored by the Volcano Art Center, a unique gallery within the park, which emphasizes the link between art, nature, and science. Here, for two weeks, a group of nine participants hiked, sketched, photographed, studied the geology of an otherworldly environment, and mounted an exhibition.

So successful was the first workshop that San Diego–based artist Michael Carroll organized a second workshop that drew nineteen artists to Death Valley National Monument in 1983. It was here that the International Association of Astronomical Artists (IAAA) was founded for the purpose of organizing shows and promoting interest in space art and space exploration. The Death Valley venture was followed by other working visits to sites such as Arizona's Meteor Crater, Houston's Johnson Space Flight Center, and a second meeting in Hawaii.

Fate intervened to broaden our horizons in 1987. The Soviet Union invited scientists, journalists, and luminaries from around the world to Moscow for a celebration of the thirtieth anniversary of the launch of Sputnik 1. They decided to include artists in the program, and the ensuing events emphasized fascinating differences in the evolution of the art worlds of these two disparate societies. While Western tradition dictates that painters must struggle on their own for "individual expression," artists in the Soviet Union are organized in a Union of Artists, which coordinates art activities (see the chapter by Vitaly Myagkov,

**A. Petrov, E. Korennova, and
W. K. Hartmann**
One World

This picture was painted collaboratively by a Soviet husband and wife and an American artist in a Soviet studio near Moscow for the 1989 international show Dialogs (also titled Starway of Humanity in Russian), which opened in Moscow.

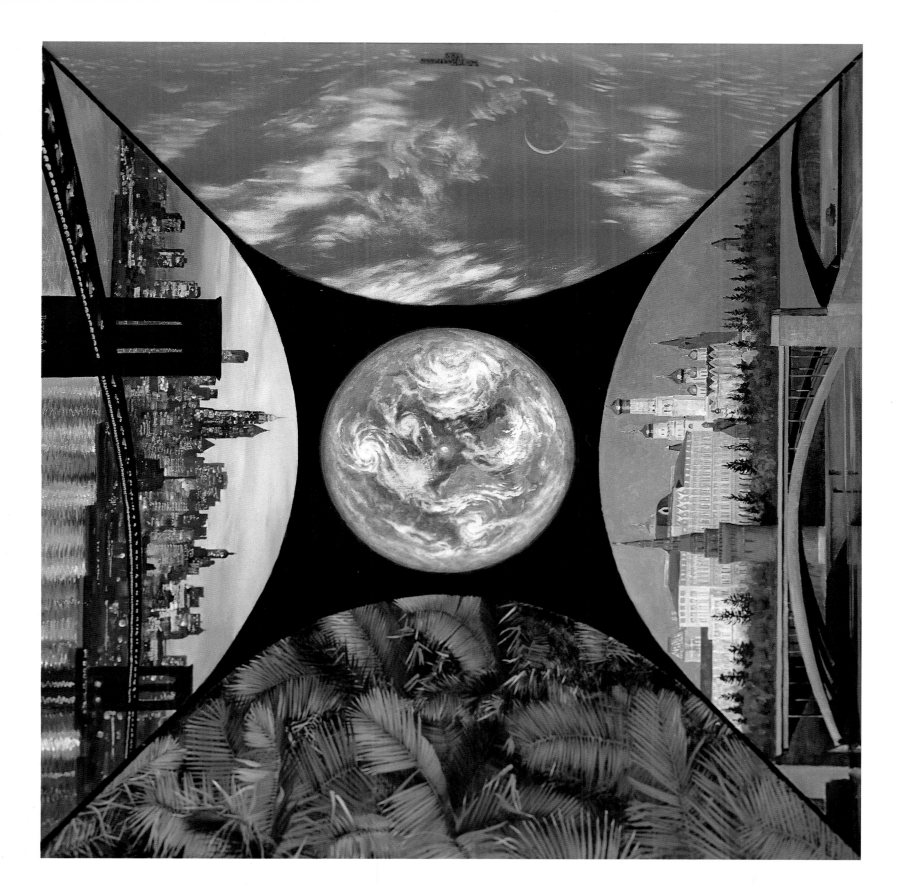

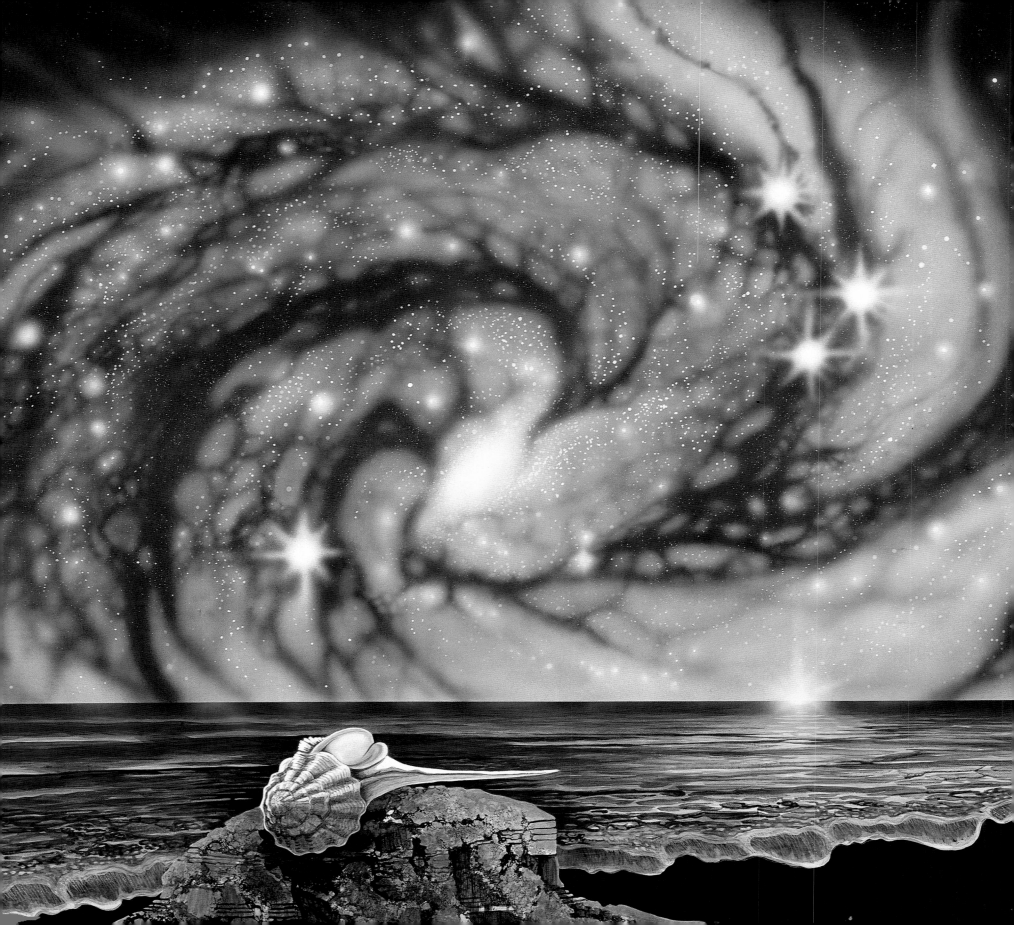

painter and Union of Artists secretary). Because they are accustomed to working with organizations instead of individuals, the Soviets were happy to find that the IAAA already existed. Working with the Planetary Society in this country, the Russians invited several IAAA members on an expenses-paid visit to Moscow.

So it came about that only five years after forming their own organization, a group of little-known artists, unconnected to the big-name gallery scene, found themselves winging their way on Aeroflot to Moscow. Here they were whisked through customs and taken by limousine to gala events with cosmonauts, government officials, and leading Soviet painters.

This first meeting came at a momentous time. Just as *glasnost* began to emerge as a real international force, we were able to form close bonds between Soviet and Western painters. As it turned out, two streams of space art had evolved independently in these two alien worlds. Now "first contact" had been made between these two worlds. We were all deeply affected by the experience and were eager to learn more about life and art on the other side. An agreement was made to meet during the next few years to pursue artistic exploration of space.

In 1988 the two groups met in Iceland and toured lava plains, otherworldly glaciers, hot springs, and geysers under the joint sponsorship of the Planetary Society

Beth Avary
Galactiscope

A spiral galaxy and a spiral shell remind us of the intimate connections between the cosmos and our planet. The very atoms of our bodies were fused in earlier generations of stars.

and the IAAA. We were a band of about two dozen: twelve from the West and twelve from the East, including Alexei Leonov, the first man to walk in space and also a fine painter.

In April 1989 we met again in Moscow and mounted the first international space art exhibition there, planned to coincide with the arrival of the Soviet Phobos 2 spacecraft in orbit around Mars. The exhibition, titled "Dialogs: Starway of Humanity," was set up in downtown Moscow. While scientists analyzed the damaged spacecraft's new data about Mars's moon Phobos, we worked on collaborative paintings at a rustic artists' retreat, operated by the Union of Artists at Lake Cenezh on the northern outskirts of Moscow.

Finally, in August 1989, the Soviet group came to Pasadena, California, home of the Jet Propulsion Lab, where we mounted the same exhibition again, this time in conjunction with the spectacular flight of Voyager 2 past Neptune and its moons. During the following week we worked together again at a guest ranch in Moab, Utah, where we painted in Arches and Canyonlands National Parks.

It was fascinating to see the diverse styles that had evolved in our isolated artistic "environmental niches." The Soviet artists tended to find the Americans more "materialistic" because many of us tried to show the actual appearance of other worlds, based on scientific data. The Soviets, for their part, said that they were trying to show the more "spiritual" side of space exploration, the response of the "soul." (Interestingly, the religious terminology came mainly from their side.)

The discussion was fascinating. Some of the Western artists (and at least one Soviet)

good-humoredly countered that the Soviet space painters had not yet absorbed enough scientific and technological information from the newly-opening Soviet space program to render planets and spacecraft with high realism. Was a soulful painting with a cosmic title really astronomically inspired, or just an abstract painting with an astronomical name? How could anyone know? The debates made us all think more deeply about our art and the sources of our creative impulses.

During these times together, we celebrated our opportunity to be a small but significant role model for international collaboration. We planned this book as a record of our adventures together to demonstrate that exploration of our universe is not just a nationalistic venture or a techno-boondoggle, but something that strikes a deep chord in all of humanity, including creative artists as well as creative scientists. This book draws substantially from our international exhibition, including some new collaborative paintings. It also includes additional work done by artists participating in the exhibition and work by other artists. Equally important, we have included some historic pieces by founders of the genre, as it was these artists who in many ways inspired today's engineers, scientists, and astronauts to explore our universe. "What one person can imagine, another person can do," said Jules Verne; it was the imaginations of these founding artists that got many of our modern explorers interested in space.

We hope that you'll find reflected in this volume our deep belief that the exploration of space is an adventure that should be shared by all humanity. We are, after all, citizens not only of our countries, but of the cosmos. ☐

"How little appreciation of the beauty (of Nature) there is among us! We have to be told that the Greeks called the world Κοσμοσ (Cosmos), Beauty or Order, but we do not see clearly why they did so, and we esteem it at best only a curious philological fact."

—Henry David Thoreau

Bob Eggleton
Sands of Mars

Fog sometimes collects in the canyons of Mars, and this view contrasts the whitish mist with a dust storm raging near the rim of the canyon.

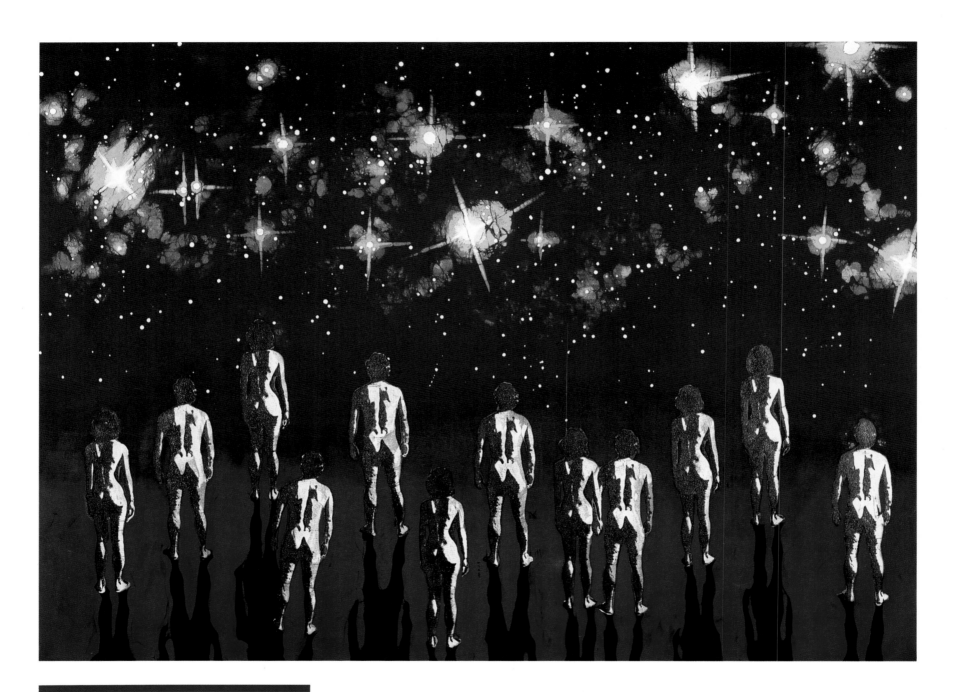

Angela Manno
Man Is a Star's Way

This batik and color Xerox image was inspired by a
statement of Nobel laureate George Wald: "Matter
has reached a point of beginning to know itself.
Man is a star's way of knowing about stars."

Alexei Stepanov
Morning in Space

Artist Stepanov has drawn upon his Kazakhstanian heritage to produce this powerful image. A crowd of cosmonauts flocks around the sun like dozens of white doves — or perhaps moths around a flame. Two of them have been engulfed by the crab-like giant, one raising his arms in either homage or supplication . . . as an Aztec or ancient Egyptian might have done.

The simple, graphic imagery, the bold shapes and colors, the repetitive patterns, all bring to mind the traditional carpets and tapestries of this far eastern province of the Soviet Union.

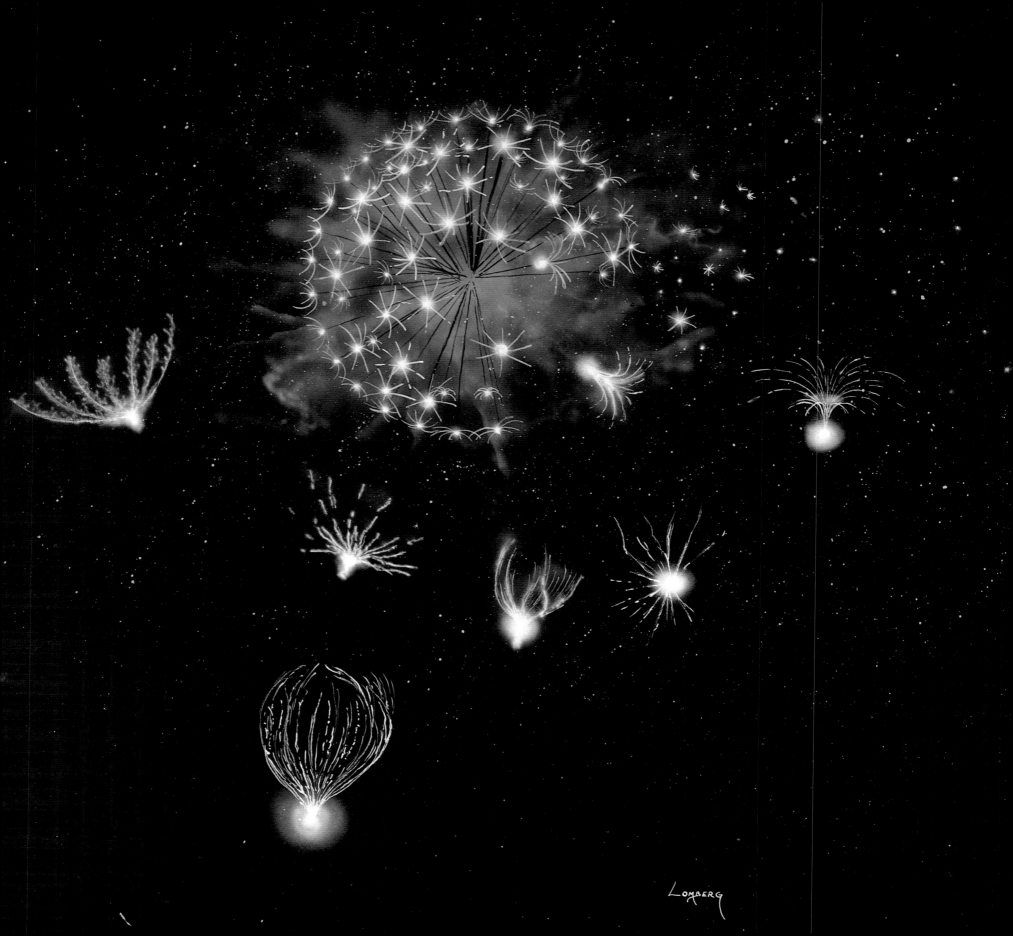

Ron Miller
Landing on Mars

In planning for manned Mars landings, humankind has not given much thought to the fact that Mars is still a pristine, un-spoiled world. We have an opportunity to either care for a new planet better than we have cared for our own, or to bring another world to the brink of disaster. Mars is as fragile as our own world.

Jon Lomberg
Seeds

This painting was originally conceived and executed for the television series *Cosmos*, and provided the dandelion metaphor that ran through the series. A nebula produces new stars, which then scatter throughout the galaxy.

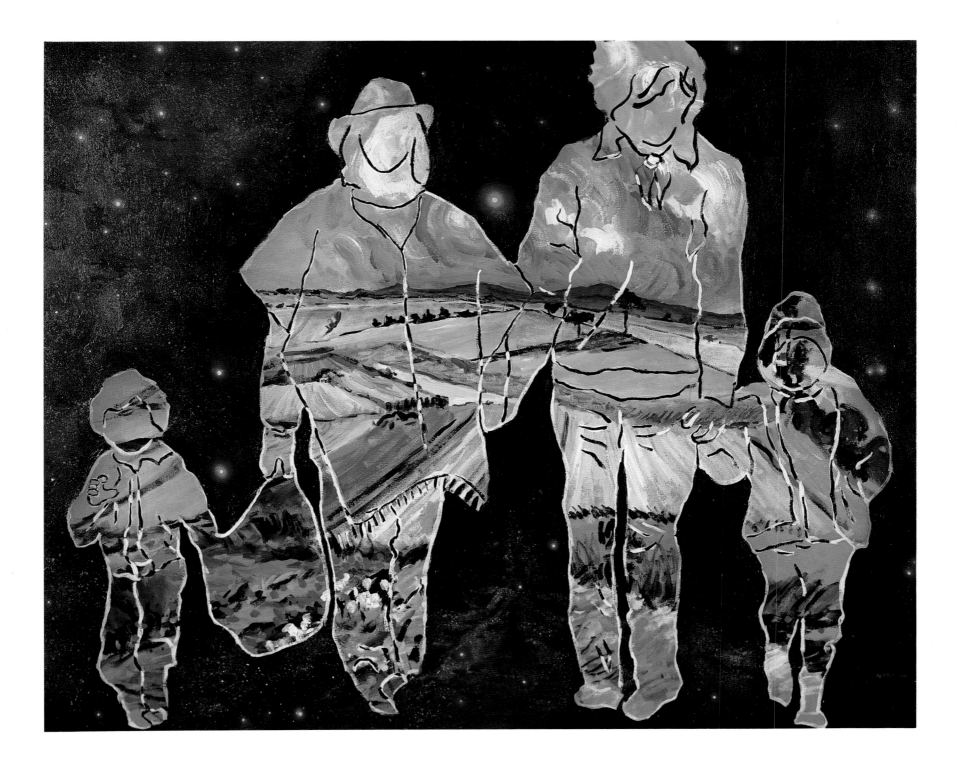

William K. Hartmann
Anticipation

This color sketch was painted mostly from life during participation in the NASA Art Program coverage of the space shuttle STS-34 launch of the Galileo probe to Jupiter. The painting is a view from an observation post near the launch pad a few days before the launch.

Kara Szathmáry
In Pursuit of Paradise

A self-portrait of the Canadian artist and his family, this painting symbolizes humanity moving outward into the cosmos, in terms of both our intellectual studies of space, and our physical flights from the Earth.

THE HISTORY OF SPACE ART

By Ron Miller

Space art—the depiction of the universe around us—has an ancient and complex history. Its disparate roots—literature, art, and science—evolved independently before finally coming together only a century ago to produce a full-fledged art form inspired by astronomy and space travel.

Clear landmarks are the classic space travel novels of Jules Verne, *From the Earth to the Moon* (1865) and *Round the Moon* (1870). Before them, literary flights to the moon were almost exclusively allegory, satire, or fantasy: the journey was made with the aid of geese, demons, or magic. The environment of the moon was wholly the product of the author's or artist's imagination, such as the cities of pumpkin-houses in Filippo Morghen's eighteenth-century picture book, or the mountains of ruby described in Richard Locke's 1835 *Moon Hoax*.

Before Verne there was little attempt to use even the limited astronomical knowledge then available. Instead, artists and authors used the moon simply as an outlet for their particular religious or occult beliefs.

Two things were needed to change this situation: scientific knowledge about actual physical conditions in space and on the other planets, and a realistic means of leaving the Earth. The accumulation of knowledge to meet the first requirement began in 1610, when Galileo Galilei turned a telescope toward the heavens, and mankind realized for the first time that there were worlds other than this one. And when the Montgolfier brothers demonstrated their miraculous invention, the balloon, in 1783, the second requirement was satisfied. Before then no human being in history had ever gotten further from the surface of the Earth than he could jump. The first event moved the heavens from the realm of the mystical into that of the physical. The second event showed that science could make the heavens accessible.

There *were* imaginary flights into space —of a kind—long before Galileo's momentous discoveries.

In approximately 165 B.C., Lucian of Samosata, a Syrian-born Greek philosopher, satirist, and speaker, wrote his *Dialogues*. One of these, *Icaromenippus*, concerns itself with a visit to the moon. The hero, Menippus, flies there by grasping in one hand the wing of a vulture and in the other the wing of an eagle. His goal is scientific: he wants to prove that the Earth is round.

Lucian's more ambitious and better-known work is *The True History*. In it a ship carrying fifty Greek athletes is carried off "by a whirlwind, which turned our vessel several times around in a circle with tremendous speed and lifted it down again in the sea, but kept it suspended above the water at that height, and carried us on, with swelled sails, above the clouds." After sailing through the clouds for seven days, an island is sighted, "luminous, spherical, and shining with a strong light." This mysterious island is, of course, the Earth's moon, in perhaps the first attempt at an astronomical description. At night, the stars are visible (by their greater proximity) in their true nature as smaller, fiery islands. Below, another land "with cities, rivers, seas, woods, and mountains on it. This," they concluded, "was our own world . . ."

Not for another thirteen centuries would an author look toward the heavens for the setting of a story or attempt to describe the appearance of another world.

In 1532 the Italian poet Ludovico Ariosto published his epic poem *Orlando Furioso*. After the hero, Orlando, goes completely *furioso*, his friend, the knight Astolpho, goes in search of Orlando's reason. Traveling to the moon in the same chariot that carried off the prophet Elijah, he passes first through the Region of Fire that surrounds the Earth. Beyond he sees the "circle of the Moon . . . whose spheric face in many a part outshin'd/The polish'd steel from spots and rust refin'd." As he nears the moon he

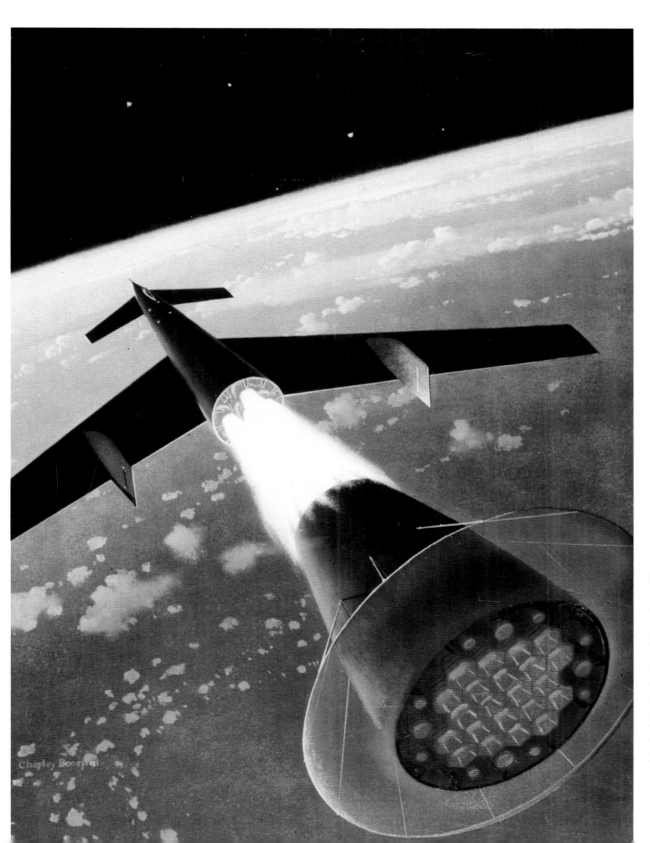

Chesley Bonestell

Separation of Stages

A painting done for the March 22, 1952, cover of *Collier's* magazine, illustrating the classic manned orbital rocket of Wernher von Braun. Here the winged third stage is being inserted into orbit, 40 miles above the Pacific Ocean. Like the space shuttle, the ferry rocket will eventually glide back to the Earth for a conventional aircraftlike landing. Bonestell's paintings were instrumental in the development of our space program.

"Magic has paved the way for science."

— Sir James Frazer

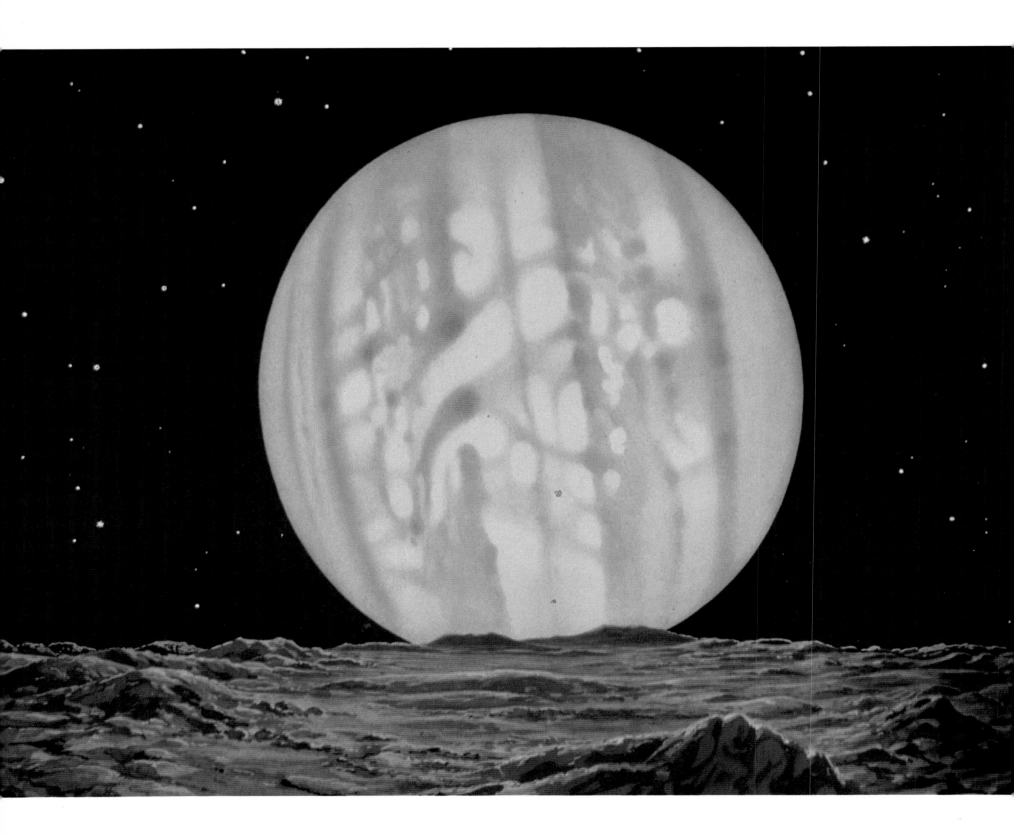

sees its "orb increasing" as it "Swell'd like the Earth, and seem'd an Earth in size." Astolpho discovers the world there to be a "rich champagne" of cities and towns, and the repository for everything lost on Earth.

In 1615, as Galileo's discoveries became known, German astronomer Johannes Kepler wrote his strange moon-voyage tale, *Somnium*. It was the first science-fiction novel written by a scientist, or by anyone at all knowledgeable in science for that matter. And, importantly for us, it is perhaps the first example of an astronomical discovery influencing an art form.

The novel is a bizarre mixture of fantasy and science in which Kepler's hero, Duracotus, imagines that he is transported to the moon by the magic of the witch Filoxhilda. They cross to the moon on the bridge of shadow that connects the two worlds during a lunar eclipse. At this point Kepler's scientific training insinuates itself. Unlike any other author before him, Kepler is aware that the Earth's atmosphere does not extend indefinitely upward; that on a journey as far as the moon, it must be necessary to pass through a region of vacuum. Lacking a spacesuit, Kepler does the best he can to protect his hero. Duracotus is given a "sleeping draught" that acts like an anesthetic to ease the discomfort, and moist sponges are held to his nostrils.

Kepler's moon is a harsh and nightmarish

Lucian Rudaux
Jupiter Seen From a Moon

Rudaux was the great pioneer of space art. This painting was reproduced in his classic *Sur les autres mondes* (1937), and shows Jupiter as it might appear from one of its inner large moons (probably Io).

world: "Night is fifteen or sixteen days long, and dreadful with uninterrupted shadow." The finned, serpent-like inhabitants that Kepler called "Selenites" spend their nomadic lives fleeing from extremes of heat and cold. Their world is one of soaring, craggy mountains, and precipitous fissures and valleys. The lunar craters are constructed by the Selenites to provide protection against the sun (the first attempt by anyone to explain, however fancifully, the origin of these features). Kepler wrote elsewhere that "I take the dark areas (of the moon) to be seas, I take the light to be land," so the moon of *Somnium* is covered with vast shallow marshes, which afford some respite to its miserable inhabitants.

Kepler's *Somnium* marked a watershed not only in fiction, but in the way people were thinking about the universe.

It is unfortunate that *Somnium* was unillustrated, for, if it had been, it might have provided the first true astronomical art.

B efore Galileo, little was known of the moon as a world in its own right. That the planets themselves might be worlds like the Earth was inconceivable: they were nothing more than special sorts of stars that wandered through the skies. The word "planet" comes from the Greek word meaning "wanderer," and before Galileo's time it did not have the same significance that it has today. While we use the word to mean any solid, spherical body circling a star, before 1610 it meant any one of five bright stars that were not "fixed" in the heavens. The term "planet Earth," so familiar to us

today, would have been nonsensical before Galileo.

Before Galileo there had been speculation about the nature of the moon and the Earth. Some of these ideas came remarkably close to the truth, but they had little impact because they were, after all, only imaginative theorizing.

For example, in approximately 600 B.C., the Greek scientist Anaximander speculated that the moon might be a kind of fiery chariot wheel; Anaxagoras suggested that it was an incandescent solid, albeit with "plains, mountains and ravines"; Pythagoras and, later, Plutarch both thought that the moon might be Earthlike, the latter with great prescience speculating that the moon might have "many great Sinuosities and Vallies . . . and (be) cleft with many deep Caves and Ruptures, in which there is Water, or very obscure Air, to the bottom of which the Sun cannot reach or penetrate."

But by the time Plutarch was writing, the burgeoning faith of Christianity was laying the foundation of the religious fundamentalism that eventually produced the Dark Ages. So between the time of Lucian and the writing of Kepler's *Somnium*, lay a barren thirteen centuries.

Literally overnight, Galileo changed humankind's view of the universe forever. The moon, he reported, "does not possess a smooth and polished surface, but one rough and uneven, and just like the face of the earth itself, is everywhere full of vast protuberances, deep chasms, and sinuosities." While many of the ancient Greek philosophers had speculated that the moon may be like this, Galileo was the first to *know*: he had seen it with his own eyes. He next turned his instrument on the planets. Jupiter, he discovered, was not a point of

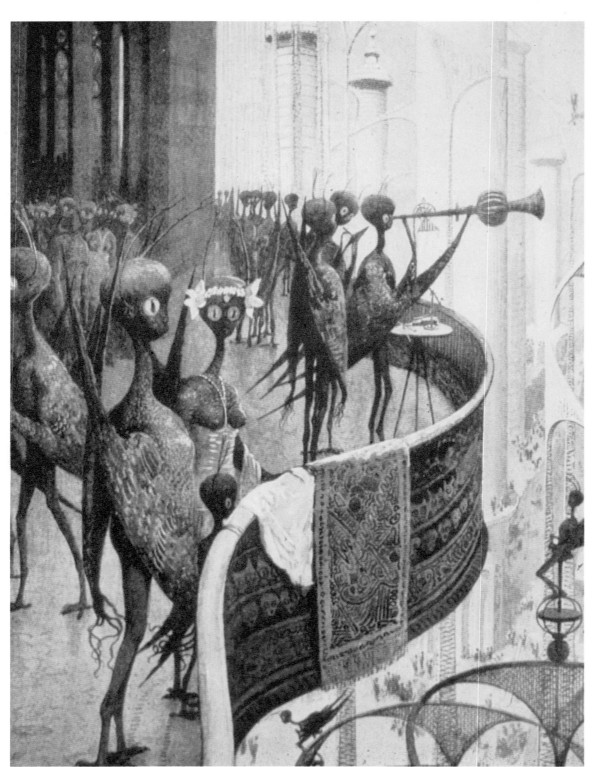

light like the other stars, but was instead a pale, golden globe with—miracle of miracles!—four tiny worldlets circling it.

Galileo was forced by the Church to recant his discoveries and his interpretations of them. But the damage was done. When men looked skyward, they no longer saw abstract points of light, but instead saw the possibility of other worlds than their own.

At the same time Galileo and others were discovering new worlds in the sky, so were explorers finding new worlds on the other side of the Atlantic Ocean. Between 1519 and 1522 Cortez found the fabulous "alien" Aztec civilization, and Magellan and Del Cano made their epic voyage around the now undoubtedly spherical earth. By the time of Galileo, hundreds of ships and thousands of explorers, colonists, soldiers, and adventurers had made the journey to these amazingly fertile, rich, and strange new lands. Now the world had found that not only were there unknown lands on Earth, but that the sky was full of them. It is little wonder that Galileo's discoveries

William R. Leigh
Inhabitants of Mars

This charming illustration of sweet-faced Martians was done to accompany an article on the possibilities of life on Mars written by H. G. Wells and published in *Cosmopolitan* magazine in 1908. Leigh was primarily known as an illustrator of Western scenes, and this represents one of his rare forays into fantasy. The painting accurately reflects the conditions on the red planet as they were thought to be at the turn of the century.

could not be suppressed and were quickly followed by a yearning expressed in a spate of space travel stories: *Somnium*, *The Man in the Moone*, *Voyage to the Moon*, *A Voyage to the World of Cartesius*, *Iter Lunaire*, *John Daniel*, *Micromegas*, *A Voyage to the Moon*, and countless others. If it was not possible to reach these new worlds in the sky in reality, it would be done by proxy. Few of these books were illustrated and when they were the artists demonstrated as much disregard for astronomy as did the authors. Nevertheless, they were representative of the rapidly increasing interest in outer space voyaging and the possibilities of other worlds.

The moon was a real place, with its own landscapes, scenery, perhaps even flora and fauna. But in the long run, the whole thing was fantastic because it seemed to be only common sense that humans were permanently earthbound. In all the history of humankind, no one had ever left the Earth any farther than his own muscles could push him. That is, until 1783 and another revolution.

Emile Bayard
Nothing Could Equal the Splendor

This is a woodcut illustration from *Around the Moon*, Jules Verne's 1870 sequel to his classic *From the Earth to the Moon* (1865). Here, in one of the first depictions of a spacecraft in space, Verne's projectile, with its three astronauts, is approaching the moon during a lunar eclipse. Without the glare of the sun, the stars are visible with a magnificence impossible on the Earth. Verne was meticulous in supplying his illustrators with accurate reference material so that aside from the general correctness of the concept, even the features dimly visible on the lunar surface are accurate.

The Abbé Theophile Moreux
The Straight Wall

The Straight Wall is one of the moon's most striking features. Here it is shown as it might look to an astronaut in an illustration done for *Splendour of the Heavens* (1925). Moreux was a prolific illustrator of astronomical subjects, and his style and technique were representative of the state of astronomical art. There was little pretense of realism, and the stigma of "artist's impression" came between the viewer and his acceptance of these scenes as representing real places. Compare this relatively naive rendering with the Chesley Bonestell painting on the facing page.

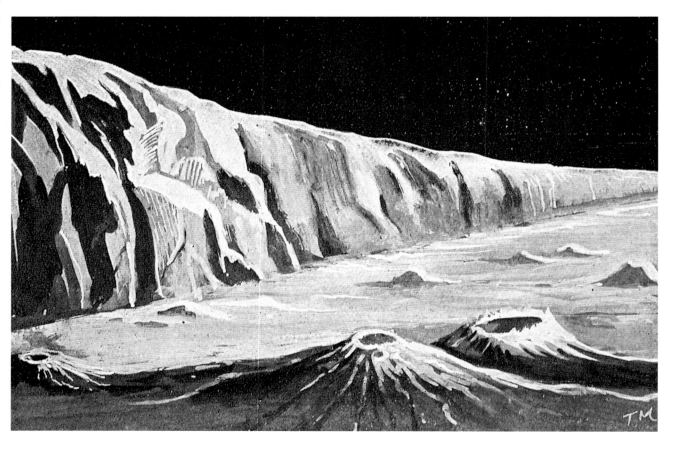

In that year the Montgolfier brothers, in France, invented the balloon. By then the Industrial Revolution had been under way for some thirty years. Science, whether blessing or curse, was now an integral and ever-growing part of daily life. The steam engine had already been invented, as had the spinning jenny, the circular saw, and the steel pen. Two years earlier, Uranus, the first new planet in recorded history, had been discovered. In the same year the Montgolfiers flew, the steamboat was invented. And in the half century following came the iron plow, the power loom, the first crossing of the Atlantic by steamboat, the first railways, the cotton gin, the electric storage battery, motor, generator, electromagnet, telegraph, bicycle, camera, cement, and the revolver.

Science could do anything. There was not only an industrial revolution taking place, but a revolution in the way people were looking at the universe around them. There seemed to be nothing they were incapable of conquering or understanding.

If humankind was going to leave the Earth, and travel to other worlds in space, then it was going to be science that provided the means, not witchcraft nor wishful thinking. Already, the human imagination had begun to be able to predict how the trip would *look*.

It was the nineteenth century that finally conceived of the machine that we know as the *spaceship*. By the time Robert Goddard in the United States, Konstantin Tsiolkovsky in Russia, and the members of the *Verein für Raketenshiffart* (VfR), the "German Rocket Society," had designed or built their first large liquid-fueled rockets, the *shape* of the spaceship had already been determined. It had evolved from ungainly cubes and rubber bags (such as those in the stories of George Tucker and Edgar Allan Poe) to Verne's streamlined projectile to, by the end of the century, the finned spindle shape

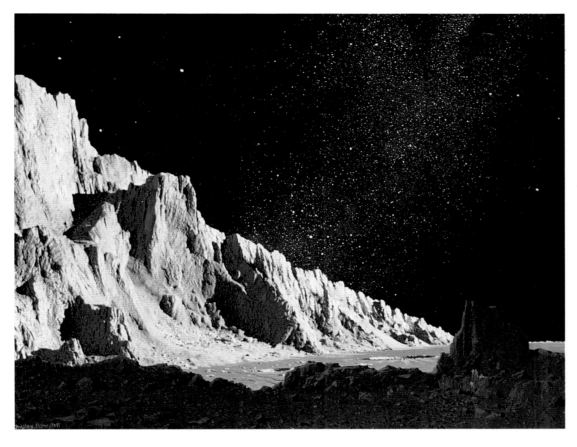

Chesley Bonestell
The Straight Wall

First published in *The Conquest of Space* (1949), Bonestell's work represented a quantum leap in the quality of space art. By combining his experience as an architectural renderer (for the knowledge of perspective and light and shadow) with his experience as a Hollywood special effects matte painter (for realistic painting techniques), Bonestell was able to bring a sense of reality to space art that set a standard that is still admired today.

with which we are familiar today.

The illustrations that accompanied Jules Verne's *From the Earth to the Moon* (1865) were the first attempts to realistically depict a spaceflight and the conditions beyond the earth's atmosphere. This realism is as much due to the excellent illustrators Verne's books invariably received as to Verne himself. Verne's prime interest always was to present a series of scientific or geographical facts made palatable by the sugar-coating of a rousing story. He realized that the illustrations that accompanied his books had to conform to fact as strictly as did the texts. Therefore, he was in the habit of providing his illustrators with reference materials and

checking the final results for authenticity. (He even went to the effort of having a map of the moon specially drawn for *From the Earth to the Moon* by Beer and Madler, the two leading selenographers of his day.) In this particular case the illustrators, Emile Bayard and A. de Neuville, provided some of the most memorable images created during the last century. The launch of the Projectile, the three astronauts enjoying freefall, the spashdown in the Pacific, are still being reprinted in books on space travel today. In 1877, Verne's novel *Hector Servadac* (perhaps better known as *Off on a Comet*) contained illustrations by P. Phillipoteaux showing Jupiter and its satellites

as seen from a passing asteroid, and a view of Saturn's rings as seen from the surface of that planet (probably the first such illustration attempted and arguably the first true astronomical illustration).

One passage from this novel—perfectly indicative of the nineteenth century's charming if occasionally uneasy blend of science and romance—is precursive of the spirit of the astronomical art to appear a century later:

To any observer stationed on the planet, between the extremes of lat. 45 degrees on either side of the equator, these wonderful rings would present various strange phenomena. Sometimes they would ap-

pear as an illuminated arch, with the shadow of Saturn passing over it like the hour-hand over a dial; at other times they would be like a semi-aureole of light. Very often . . . daily eclipses of the sun must occur through the interposition of this triple ring.

Truly, with the constant rising and setting of satellites, some with bright discs at their full, others like silver crescents, in quadrature, as well as by the encircling rings, the aspect of the heavens from the surface of Saturn must be as impressive as it is gorgeous.

How evocative and exciting this must have been to the Victorian reader, who hitherto had recourse only to the dry descriptions of astronomers. From the latter they could learn *about* Saturn, but from Verne and his illustrators they learned what Saturn was *like*. Verne and the art he inspired had made the planet real.

The year 1874 saw publication of Nasmyth and Carpenter's *The Moon*, uniquely illustrated by photographs of meticulous plaster models of the lunar surface. These were immensely influential, possessing both the inherent realism of the photograph and the cachet of two eminent astronomers. Images pirated from this book appeared

E. Seppings Wright
The Earth as Seen From the Moon

This may have been the only astronomical painting ever done by Wright (from *Splendour of the Heavens*, 1925), but it is a typical representative of the space art of the period: romanticized, Doré-like, and little changed from the visualizations of half a century earlier, such as the illustration on the facing page.

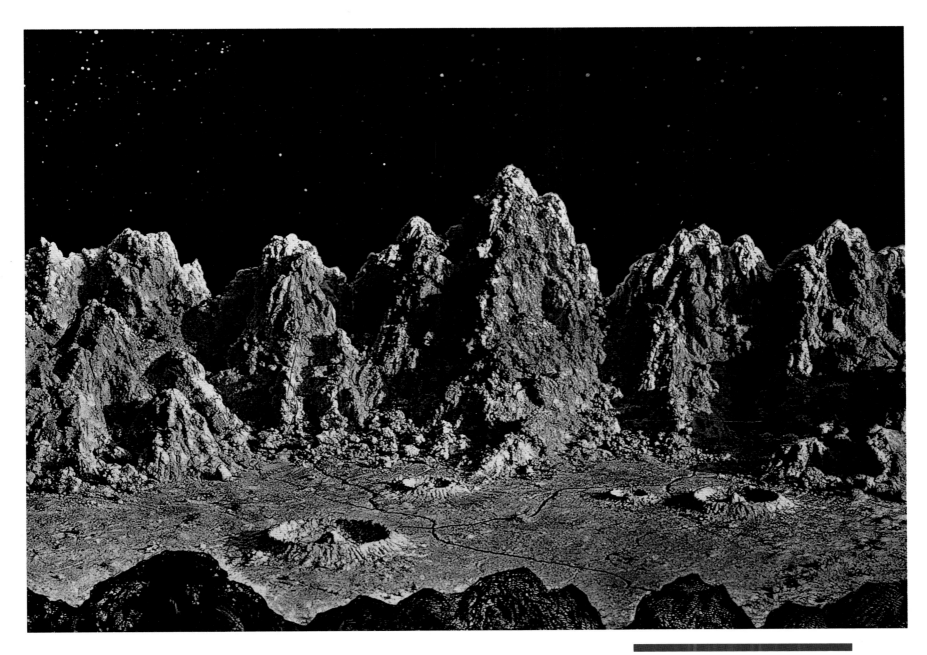

well into the twentieth century. In 1887
"Letters from the Planets," a series of
stories by W. S. Lach-Szyrma, began in
Cassel's Family Magazine. The series took
its readers to the sun, Mercury, Mars, and
Jupiter. The accompanying illustrations by
Paul Hardy (apparently no relation to the
present-day space artist, David Hardy) in-
cluded some evocative images, such as a
closeup view of millions of meteorites fall-
ing into the sun (which, according to con-
temporary theory, accounted for the sun's
heat), a view of craggy lunar mountains,
and a nighttime scene on Mars, illuminated
by its twin moons.

Other interplanetary novels were well-
served by their illustrators. The 1889 novel
The Conquest of the Moon, by André Laurie
(pseudonym of Pascal Grousset) contained
numerous views by Verne illustrator Georges

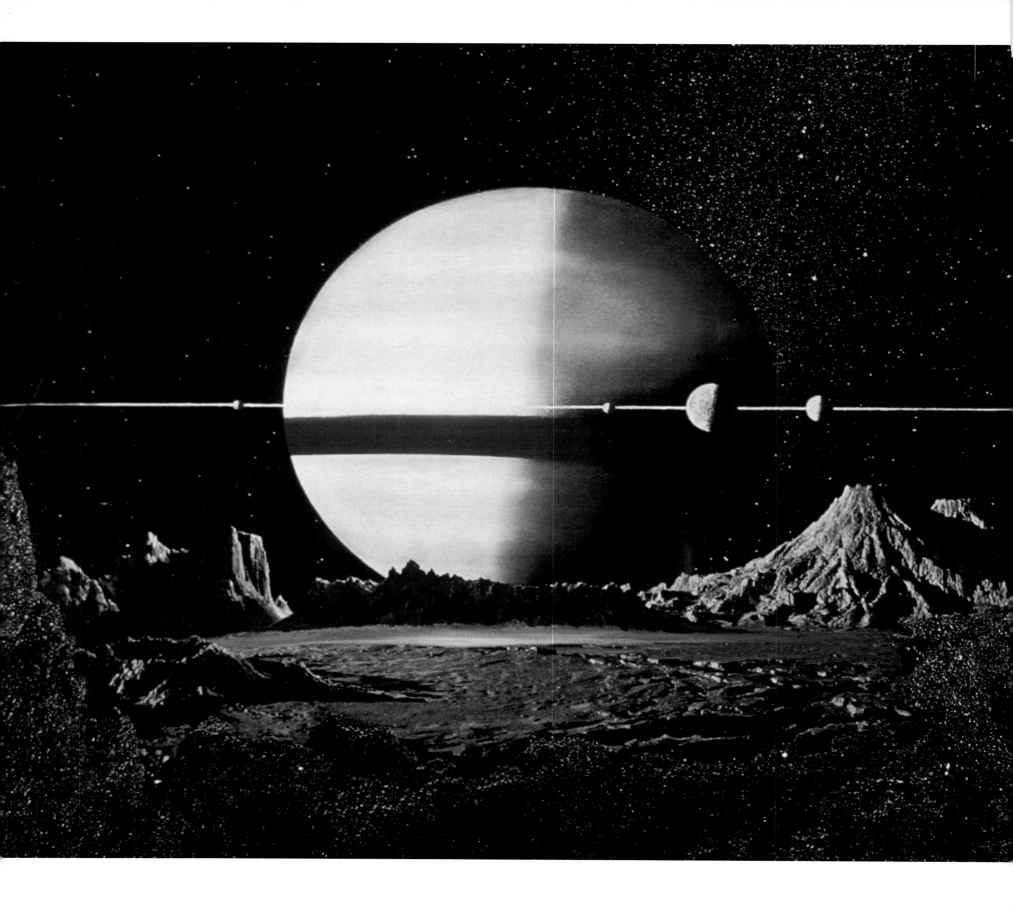

Roux, of respirator-equipped explorers on a craggy lunar surface, as well as a striking view of an eclipse of the sun by the Earth, seen from the moon.

A Honeymoon in Space was a novel by George Griffith, serialized as "Stories of Other Worlds" beginning in 1900. It was illustrated by Stanley L. Wood, and his painting of the honeymooning couple on the moon, holding spacesuited hands, is one of the most charming products of Victorian science fiction. The surfaces of the planets are shown in the light of contemporary science: a balmy Mars, volcanic Jupiter, a prehistoric, marine Saturn, and so forth.

A Journey in Other Worlds (1894) by John Jacob Astor was illustrated by Dan Beard (who later founded the Boy Scouts of America). The book begins with a tour of America in A.D. 2000 (demonstrating that financier Astor was also a knowledgeable and prescient engineer) and continues with a flight to Jupiter and Saturn, whose terrains are described with great accuracy, according to the science of the time. Included is a description of "Cassandra," a transneptunian planet that is not only poetically evocative, but highly prophetic:

Chesley Bonestell
Saturn as Seen From Rhea

First published in *Life* magazine in 1944, this was among the first of Bonestell's space paintings to see print—one of a series showing Saturn as it would appear from several of its moons. As in the painting *The Straight Wall* on page 31, Bonestell employed an unusual technique: portions of the painting are a tinted print of a pinhole camera photograph of a plaster and clay model constructed by the artist.

The temperature of Cassandra's surface is but little above the cold of space, and no water exists in the liquid state, it being as much a solid as aluminum or glass. There are rivers and lakes, but these consist of liquified hydrogen and other gasses, the heavier liquid collected in deep places, and the lighter . . . floating upon it without mixing, as oil on water . . . [W]ere there mortal inhabitants on Cassandra, they might build their houses from blocks of oxygen or chlorine . . . and use ice that never melts, in place of glass. . . .

Rivalling Griffith's honeymooners' portrait for charm are the illustrations William R. Leigh provided for H. G. Wells's article "Is There Life on Mars?" in *Cosmopolitan* for March 1908 (when that magazine was very different from its present-day namesake). Leigh's atmospheric and detailed paintings show a traditional Victorian Mars in full flower. Solar-powered waterwheels the size of the Woolworth Building keep the great Martian canals flowing, spindly-legged birds and beasts congregate in Martian marshes, and cities bustle with gyroscope-equipped unicycles racing along precarious aerial tracks while sweet-faced winged Martians watch from their soaring towers.

For a period of years artist Fred T. Jane produced a series of illustrations under the title "Guesses at Futurity." Some of these, such as "Gold Mining in the Mountains of the Moon," are the first depictions of colonies and industrial activity on the moon. Interestingly, Jane went on to found the series of military equipment catalogs that bear his name.

Between the time of Jules Verne's novel and the launch of the first liquid-fueled rocket in 1926, spaceships of every possible configuration had been imagined. For instance: Edward Everett Hale described the

first artificial manned satellite in his novelette *The Brick Moon* (1869), in which he listed nearly every function assigned to modern satellites. In 1881 Hermann Ganswindt created artificial gravity in his spacecraft by suggesting that two spacecraft could be joined by a cable and spun around their common center. Frenchman Robert Esnault-Pelterie, considered one of the founders of theoretical astronautics, suggested the use of "intra-atomic energy" for spaceflight in 1912; Franz Ulinski designed the first of his electric "cathode rockets" in 1913, and in the same year B. Krasnogorskii elaborately described a solar sail.

Hermann Oberth's seminal *The Rocket in Planetary Space* was first published in 1923, one of the theoretical cornerstones of modern spaceflight. His "Model E" was the first modern spaceship and its design set the standard for many years. By this time Konstantin Tsiolkovsky had published extensively and his plans included not only large manned rockets but lunar rovers and self-contained space colonies.

By the time Goddard flew his rocket, these dreamers and theorists—and scores of others—had not only established that space travel would ultimately take place, but had anticipated virtually every step on the road to achieving it.

While the authors of scientific romances were creating more and more imaginative—and increasingly plausible—schemes for leaving Earth, artists, as we have seen, were illustrating the lure of distant space. And, although writers and art-

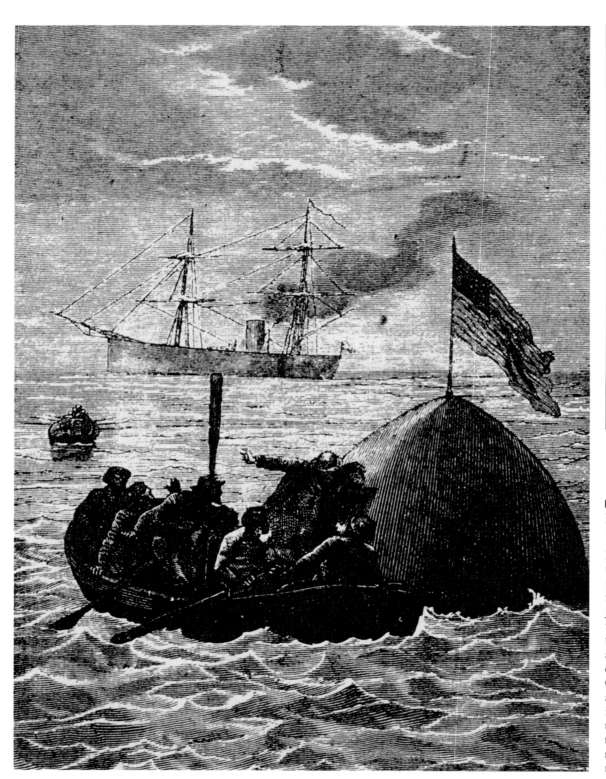

ists, as we have seen, were illustrating the lure of distant space. And, although writers and artists ultimately worked toward the same end—inspiring humankind to leave the Earth and explore space—their roots could not have been more different.

Space art could not have existed before the Romantic nineteenth century, and its revolutionary discovery of the visionary landscape. Perhaps inspired most by the writing of Jean-Jacques Rousseau, the Romantic artists did not merely observe nature, they rediscovered it in moments of intensely heightened vision. Landscape painting evolved from the merely decorative and pastoral to the highly charged emotional.

Almost diametrically opposed to the Romantic landscapes were those of the Pre-Raphaelites, yet these, too, were ancestors of space art. The Pre-Raphaelites insisted upon a strictly accurate re-creation of nature in the most infinitely observed detail, with no interpretation from the artist.

Emile Bayard
White All!

Here is another example of the almost uncanny prescience of Verne and his illustrators. In this woodcut illustration from *Around the Moon*, the projectile has just returned from space. It made a tail-first reentry into the atmosphere, as did the Mercury and Apollo spacecraft, after altering its course with retro-rockets, eventually splashing down into the Pacific Ocean. Here the three astronauts are about to be rescued by a U.S. Navy ship in a scene that was duplicated dozens of times during the U.S. space program (see the painting on the facing page). The title refers to the game of dominoes the spacemen were calmly playing when rescued.

The American version of the Romantic landscape came from the Hudson River School, whose practitioners were enamoured with the American wilderness. Like the European Romantics, they looked for the grandiose and awe-inspiring, but like the Pre-Raphaelites they were also fascinated by detail. Probably because they were Americans and inheritors of a tradition of Yankee practicality, they were akin to the geologists, botanists, and other scientists who were then exploring the unknown west of the Mississippi. Artists accompanied these scientific expeditions as a matter of course. Thomas Moran, for example, was the official artist with the first official survey of the Yellowstone region (other examples are discussed in the accompanying articles by Hartmann and Schulman). It is difficult to overestimate the effect of their paintings on the American people. Vast canvases, some measuring more than a dozen feet wide, were circulated throughout the East, drawing crowds like popular motion pictures do today. They revealed to an astonished public awesome wonders no one had thought could exist outside the mind of the most imaginative poet or novelist. Space art as it existed by the 1920s was heir to this realistic Romantic-naturalist tradition.

By the first years of the new century certain artists were beginning to specialize in astronomical renderings. One of the first was British illustrator Scriven Bolten. His work, appearing often in *The Illustrated London News*, was consistently dramatic, if not overly accurate. He originated a technique where he constructed model landscapes of plaster that he later photographed and retouched, adding starfields and planets, for example. His work in *The Illustrated London News* inspired a young American artist

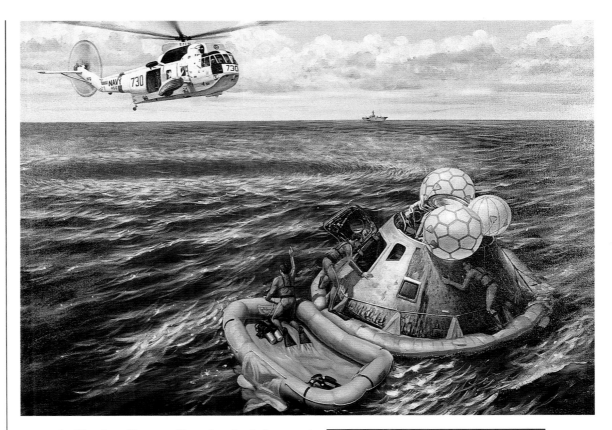

named Chesley Bonestell, who had been providing architectural renderings for that magazine, to "indulge in space painting." But there will be more about Bonestell later. Bolton's contemporary, G. F. Morrell, not only created some splendidly expressionistic extraterrestrial landscapes, but made something of a specialty of showing what other worlds might look like were they to replace the Earth's moon. For example, one painting shows what Saturn would look like seen from 238,000 miles away—the moon's mean distance from the Earth. Morrell's masterpiece might be his strikingly surrealistic illustration of Saturn's rings as they would appear from London, if that city were to be transported to Saturn. The Abbé Theophile Moreau (1867–1954), whose work first appeared in the late nineteenth

Roger Arno
Apollo Capsule Recovery in Pacific Ocean

Arno's painting of the recovery of an Apollo capsule eerily mimics the scene on the facing page, created 110 years earlier. Arno sketched this scene while aboard a naval recovery ship, as part of the NASA Art Program.

century, had his astronomical renderings published widely. One nice image he created was a scene of Saturn as seen from Titan, the planet reflected in a pool of liquid on the moon's surface. The Abbé was the first of the astronomer-artists; he was the director of the Observatory of Bourges (Department of Cher, France). In the 1920s Howard Russell Butler, N.A. (1836–1934)

contributed paintings to the American Museum of Natural History, one of which, a dramatic scene set near the central peak of a lunar crater, was later copied by artists working for a dozen different publications.

However, the first real specialist in astronomical art, and the one who first brought both scrupulous scientific accuracy and fine art together, was the French illustrator-astronomer Lucian Rudaux (1874–1947). He can rightly be regarded as the grandfather of astronomical art. Originally a commercial artist, he eventually became a highly regarded astronomer (the crater on Mars that is named for him was in honor of his work as an astronomer, rather than for his art). He created hundreds of illustrations to accompany his own articles and books, as well as those written by others. His masterpiece is probably the 1928 deluxe volume, *Sur les Autres Mondes (On Other Worlds)*. It contains more than 400 illustrations, including twenty full-page color paintings that gave readers an unprecedented look at the solar system. These paintings achieved a level of accuracy that was not to be challenged for nearly twenty years. As a careful astronomer and a superlative observer, Rudaux knew what the surfaces of the planets ought

Lucien Rudaux
Saturn Seen From a Moon

In another of the paintings created for his masterwork, *Sur les autres mondes* (1937), Rudaux has produced an image that could be published today with little or no change. This view of Saturn as seen from one of its moons (Rudaux did not say which one, but it appears to be Rhea) is as accurate today as it was when painted fifty years ago. This is a tribute to Rudaux's skills as astronomer and artist.

to look like. Many of his images look as though they could have been based on NASA photos. His portrayals of the lunar surface are especially remarkable. At a time when every other artist was still producing the stereotyped craggy, sawtoothed mountain ranges that dated back to Nasmyth and Carpenter's work, Rudaux was showing us the rounded mountains and rolling landscapes found by the Apollo astronauts. He pictured Venus as an eroded, rocky dustbowl, and Mars as flat and boulder-strewn, its sky sometimes reddened with pink dust clouds.

Science fiction magazines, interestingly enough, were far ahead of "respectable" journals in the accurate description of astronomical subjects. One of the first and probably the finest was Charles Schneeman's cover for *Astounding*, a view of Saturn as seen from Iapetus that remains one of the most outstanding astronomical paintings published in the first half of this century. Other *Astounding* covers during this period were contributed by Gilmore, Hubert Rogers ("An Einstein Eclipse") and "A. von Munchausen." By comparison, the paintings provided by Charles Bittinger for the July 1939 issue of *National Geographic*, though described as "combining a fine sense of color values and artistic composition with a painstaking effort to achieve scientific accuracy," are generally rather crude both artistically and scientifically.

Only two other pre-spaceflight artists had a major influence on the shaping of astronomical art as a genre in its own right—yet their contribution outweighs that of all of their predecessors combined. The first was Chesley Bonestell (1888–1987), who can rightly be called the father of astronomical art (if Rudaux can be regarded as the grandfather). It is hard to overstate his influence

Scriven Bolton
The Sun Seen From Mercury

Bolton worked at about the same time as Rudaux, that is, during the 1920s and 1930s. The bulk of his work appeared in such British publications as the *Illustrated London News*, and he was the first artist to employ the technique of painting on top of specially made photographs, a technique later refined by Bonestell who also worked for the *Illustrated London News* for a short time during the 1920s.

and inspiration: his was the right kind of art at the right time. The best of his work appeared between the end of World War II and 1960, when the American public was on a postwar technology high. Spaceflight symbolized everything that the postwar period promised, and it seemed as though it was just around the corner. Magazines, books, and motion pictures that featured anything about space travel became bestsellers, and it seemed that Bonestell was contributing something to them all. His space art first appeared publicly in *Life* in 1944: a series of paintings showing Saturn as it might appear from its various moons. Nothing like them had ever been seen before. He had combined a highly polished technical skill as a painter with his experience as a Hollywood special-effects matte artist to create images that looked more like picture postcards than "artist's impressions." His paintings possessed an almost intense believability that was far more important than any mere scientific accuracy they contained. That was the sole problem with Rudaux's artwork: accurate as his paintings were—

Paul Hardy
A Mercurian Spaceship Approaching the Sun

This woodcut originally illustrated the series of stories, "Letters From the Planets," by William Lach-Szyrma, published in *Cassell's Family Magazine* in 1887–93. It is especially interesting for the design of its spaceship, clearly influenced by nineteenth-century submarines. Here our heroes are observing the thousands of Mercurian spacecraft that are hovering above their cratered planet.

and ironically, they were far more accurate than Bonestell's—they nevertheless looked like *paintings*. There was always that nagging little doubt in his viewers' minds that perhaps he just might have made it all up. Bonestell managed to remove himself from the scene he was depicting. Never before had the planets taken on such a reality.

These paintings and many others were gathered into a best-selling book, *The Conquest of Space* (1949), with a text by Willy Ley. This was followed by countless magazine articles, books and special effects art (*Destination Moon*, *When Worlds Collide*, *War of the Worlds*, and *The Conquest of Space*).

Though Bonestell's art was known for years to space enthusiasts, wider tributes began to come only in his last years. A number of Bonestell originals are in the collection of the Smithsonian National Air and Space Museum and are occasionally seen on display in its gallery of aviation and space art, and the Adler Planetarium has its own "Bonestell Room." The Space and Rocket Center in Huntsville, Alabama, has dozens of his pieces on display. A biography and retrospective collection of his work appeared in the book, *Worlds Beyond: The Art of Chesley Bonestell*, published in 1983 by Ron Miller and space authority and art dealer, Frederick Durant III. A few months before Bonestell died in 1986, an asteroid was named "Bonestell," much to his satisfaction. (It is number 3129 among cataloged asteroids—those with well-observed orbits.)

The second artist who shaped modern astronomical art was the British painter Ralph A. Smith (1905–1959), whose work was almost exclusively connected with the British Interplanetary Society, and until recently collected only in one book, *The Exploration of the Moon* (1954, with text by Arthur C.

Clarke). From the founding of the BIS in the late 1930s until his death in 1959, Smith used his engineering background to meticulously recreate the detailed space program developed by the society. Unlike Bonestell, who simply rendered the designs created by Werner von Braun, Smith was an active contributor to the design of the spacecraft he illustrated. In particular, he was the co-designer of the "Smith-Ross" space station, an immediate predecessor of von Braun's giant wheel. Also unlike Bonestell, Smith was relatively uninterested in astronomy and his lunar and Martian landscapes exist only as backgrounds for his spacecraft.

With any luck, space artists have served the same function as the painters of the Hudson River School, inspiring a sense of wonder about the universe. There is an educational side to this art form but, in this writer's opinion, bald scientific facts are not the main point—any more than Moran or Bierstadt were trying to teach their audience geology. What space art ought to teach is not so much what the other planets are like, but that they are there at all, that they are *real*. Believability is at least as important as accuracy, for if no one believes that the scene represents some place in reality, all the scientific accuracy in the world is for naught. Bonestell is a perfect example. Much of his work was astronomically unsound at the time he created it—he was indicating canals on Mars as late as the 1950s—to say nothing of natural bridges on Phobos and volcanoes on Jupiter. Nevertheless, so persuasive is his art

that when the Apollo astronauts returned photos from the moon's surface showing that lunar mountains were not the craggy alpine peaks Bonestell had painted, it truly seemed as though it were the moon's fault, not Bonestell's. Although Rudaux a generation earlier had been correct in his less dramatic renderings of the lunar surface, and for all the right reasons, would we have been so anxious to visit the moon if we had known—or admitted—that he was right and Bonestell wrong?

During the twenty or twenty-five years separating Bonestell's first published work and the 1970s, space art was reserved, in general, for a few specialists. While numerous artists occasionally dabbled in astronomical illustration, or were forced to accept a space art assignment, fewer than half a dozen made any attempt to take the art form seriously.

Mel Hunter provided a large number of meticulously rendered astronomical and astronautical covers for science fiction magazines (notably *Astounding/Analog*) that were consciously Bonestellian in effect. He painted a series of astronomical murals for the 1965 World's Fair. Jack Coggins created scores of vigorous paintings for the same magazines, all of which shared a nuts-and-bolts engineer's approach to spaceflight. Coggins illustrated several books on spaceflight, two of which, *By Spaceship to the Moon* and *Rockets, Jets, Guided Missiles and Spaceships*, are fondly remembered by many space enthusiasts who treasured them as children.

The most outstanding name to appear in the sixties and seventies was that of the Czechoslovakian/Swiss painter, Ludek Pesek. He had already published two "coffee table" collections of his space art in

Europe: *Planet Earth* and *The Moon and the Planets*. Each contained more than forty double-page paintings. These books, however, were little known in the United States and it was not until 1970 when his work was published as part of a major article in *National Geographic* magazine that he made a real impact in this country. Pesek's work was a breath of fresh air; it combined realism with a painterly style that never attempted to be photographic. Yet, ironically, it was just this relatively loose, matter-of-fact technique that enhanced his art's believability: they looked like paintings that had been created on location.

1970 saw the end of the isolated specialist in space art. The ever-increasing awareness and interest in space travel that was created by the Apollo program, Skylab, the Space Shuttle, the planetary flybys of Pioneer, Mariner, Viking, and Voyager in turn created a demand for space art that was met by equally increasing numbers of illustrators and painters. They were inspired not only by the commercial demand, but more importantly (for their artistic success) by the adventure of space exploration. Many of them are represented in this book. □

David A. Hardy
The Way It Should Have Been

British painter Hardy (no relation to Paul Hardy) here combines the best of two worlds—the past and the present. A contemporary astronaut has just emerged from the squat and insectlike lunar module, similar to the one flown by the Apollo 11 astronauts, and is stepping into a landscape from the romantic past: the craggy, alpine peaks that everyone had expected—and hoped—the moon would have.

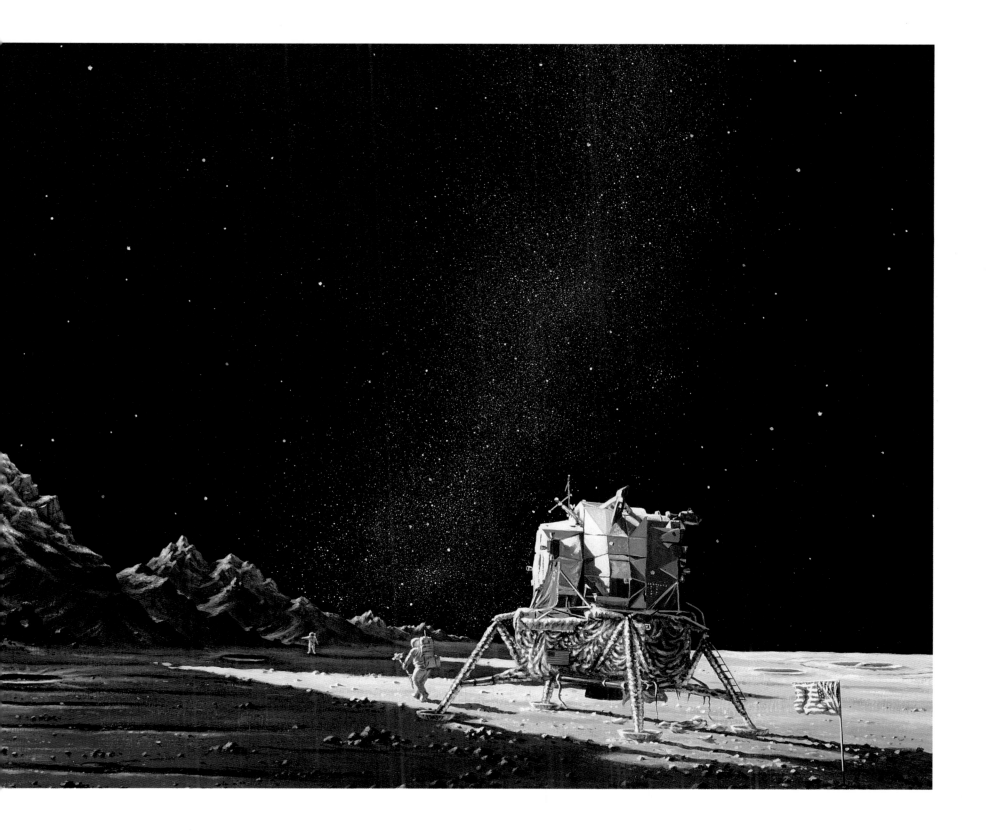

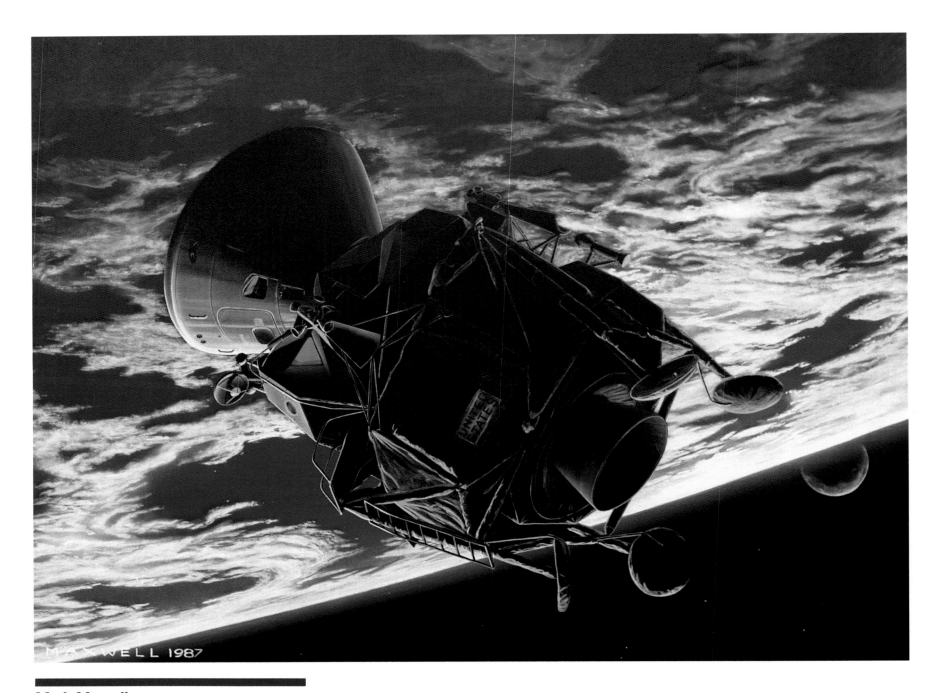

MAXWELL 1987

Mark Maxwell

Lifeboat/Apollo 13

Lifeboat/Apollo 13 was inspired by the ill-fated
Apollo 13 flight. After an explosion in the service
module on the way to the moon, astronauts linked
their conical command module up with their land-
ing module. Instead of landing on the moon, the
lander became their lifeboat, adding life-support
systems and allowing a loop around the moon and a
safe return to Earth. On return, the service module
was jettisoned, creating this unusual configuration.

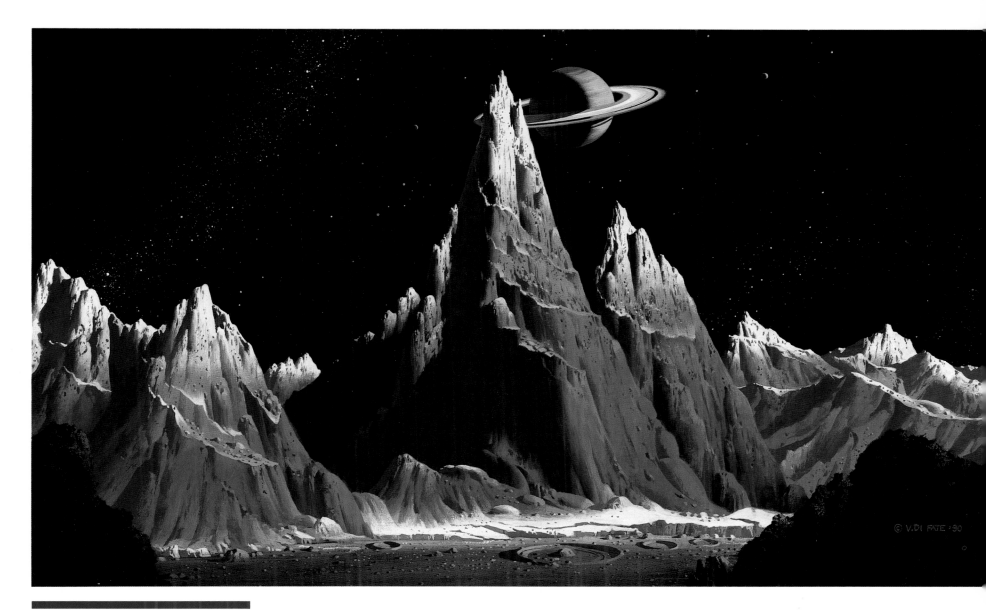

Vincent Di Fate

Saturn From Iapetus

Iapetus is an unusual moon in that it appears brighter in one hemisphere than the other. Some scientists theorize that the moon might have once been struck by a comet which left a layer of frozen methane over one entire half of the sphere.

Kim Poor
The Sword of Herschel

An unusual perspective of Saturn as seen from one of its inner moons, Mimas. The landscape is set in the huge crater Herschel, named for an early telescopic observer of Saturn, and located in such a way as to give a spectacular view of Saturn.

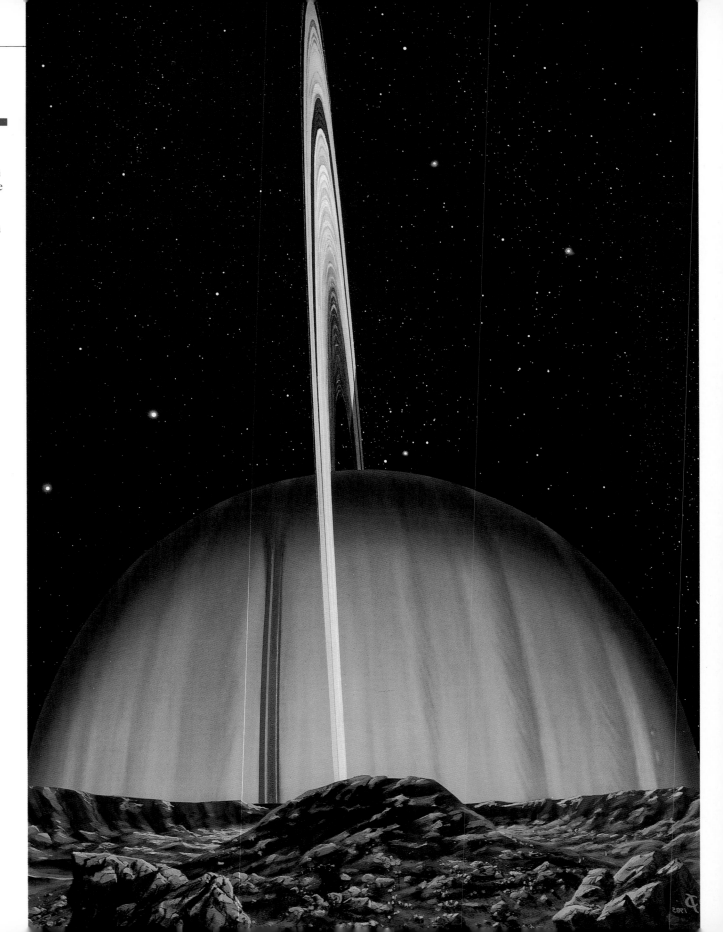

Ludek Pesek
Saturn as Seen From Its Satellite, Mimas

Saturn as Seen From Its Satellite, Mimas is a striking
composition by Czech-Swiss artist Ludek Pesek,
based on the closeness of Mimas to the giant plan-
et. The close perspective causes the cloud belts and
the shadow of the ring system to appear as curving
bands of color, filling much of Mimas's sky. Mimas
is in the same plane as the rings, so that the ring is
seen edge-on as a bright line behind the icy hills of
the nearby horizon.

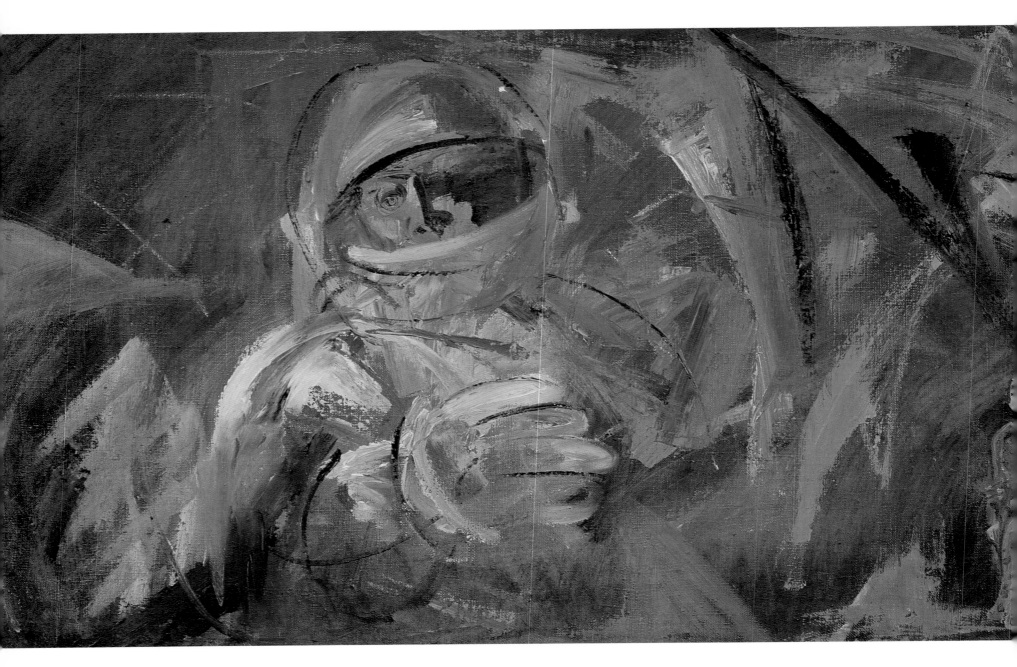

Andrei Surovtsev
Memory

A haunting image of a cosmonaut alone in the disorienting void of space . . . as alone as any human can possibly be . . . surrounded by the nebulous and confused images of Earth and family. "It seems that I am leaving the planet forever," wrote cosmonaut Valery Ryumin, "And there is no power that could bring me back."

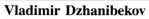

Vladimir Dzhanibekov
Portrait of Gagarin

Yuri Gagarin, the Soviet Union's and the world's first man in space, is portrayed by one of his most distinguished successors.

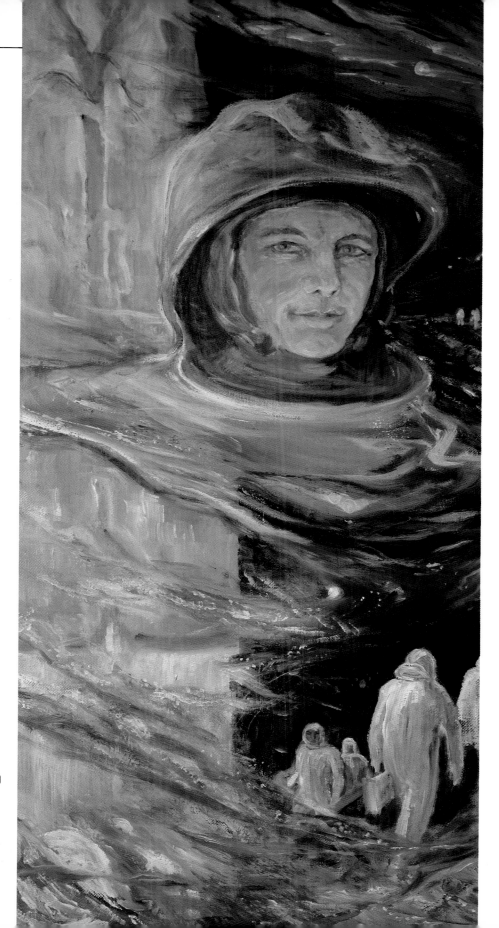

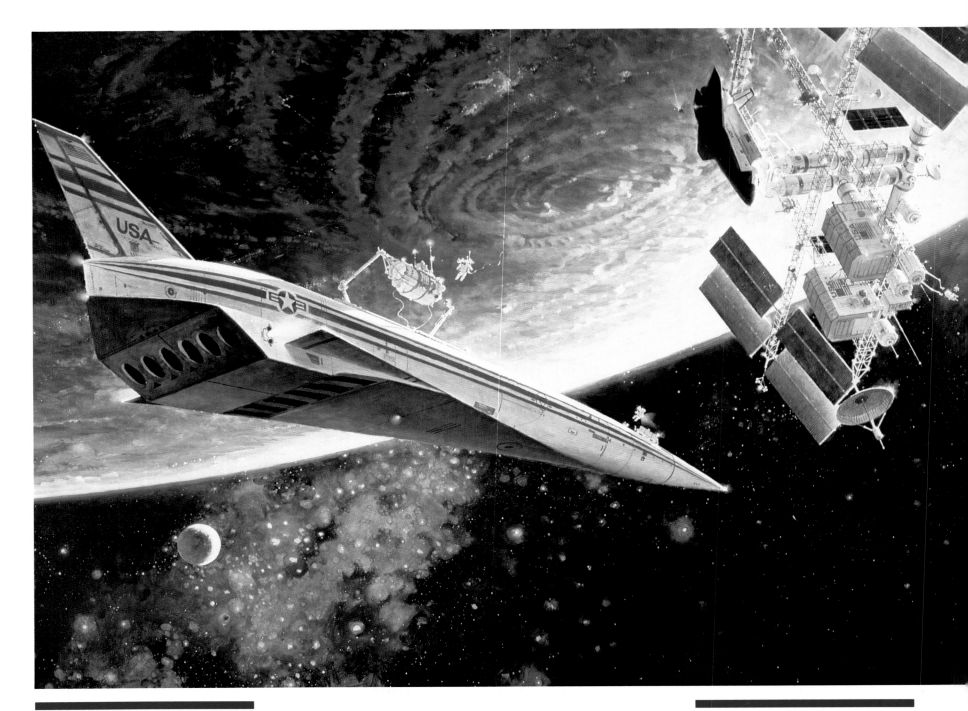

Robert McCall
Exploring the Space Frontier

Artist Robert McCall's visualization of an imaginary future docking with a space station is reminiscent of his conceptualization of the famous docking sequence for the film *2001: A Space Odyssey.*

Pamela Lee
Astronaut with MMU Above Solar Panels

Giant solar panel arrays, once erected, can collect up to 24 hours a day of "free" solar energy to power operations in space. Here, an astronaut in a mobile maneuvering unit inspects a panel array.

(© Time-Life Books.)

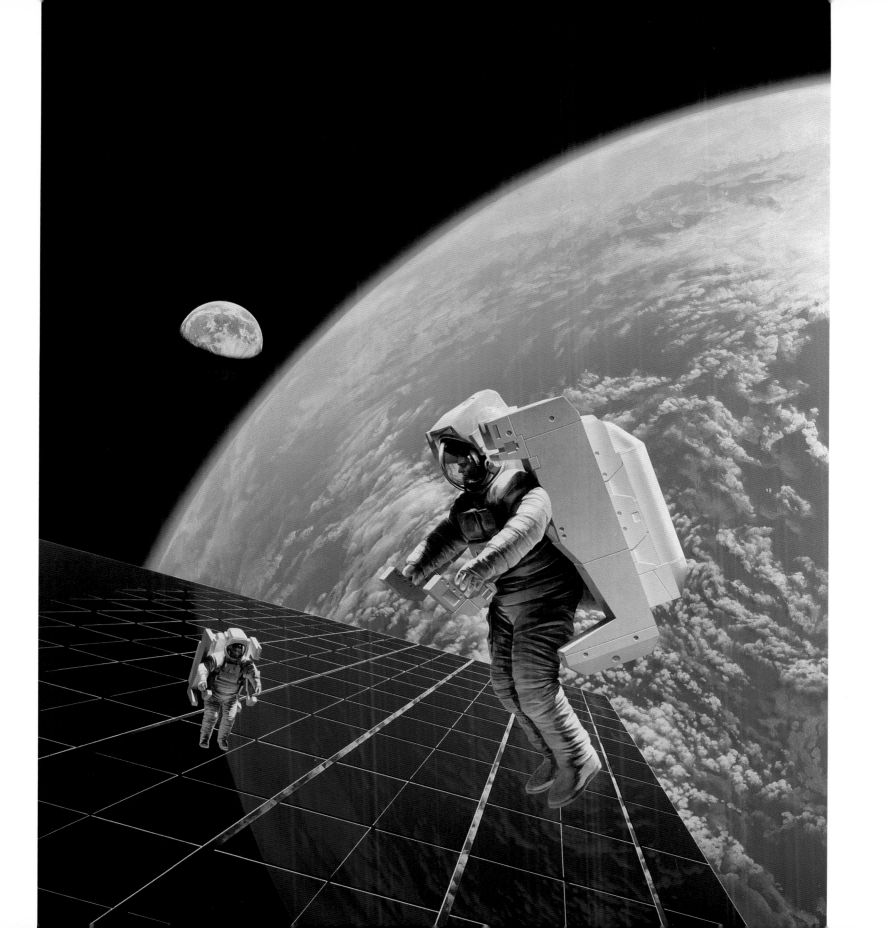

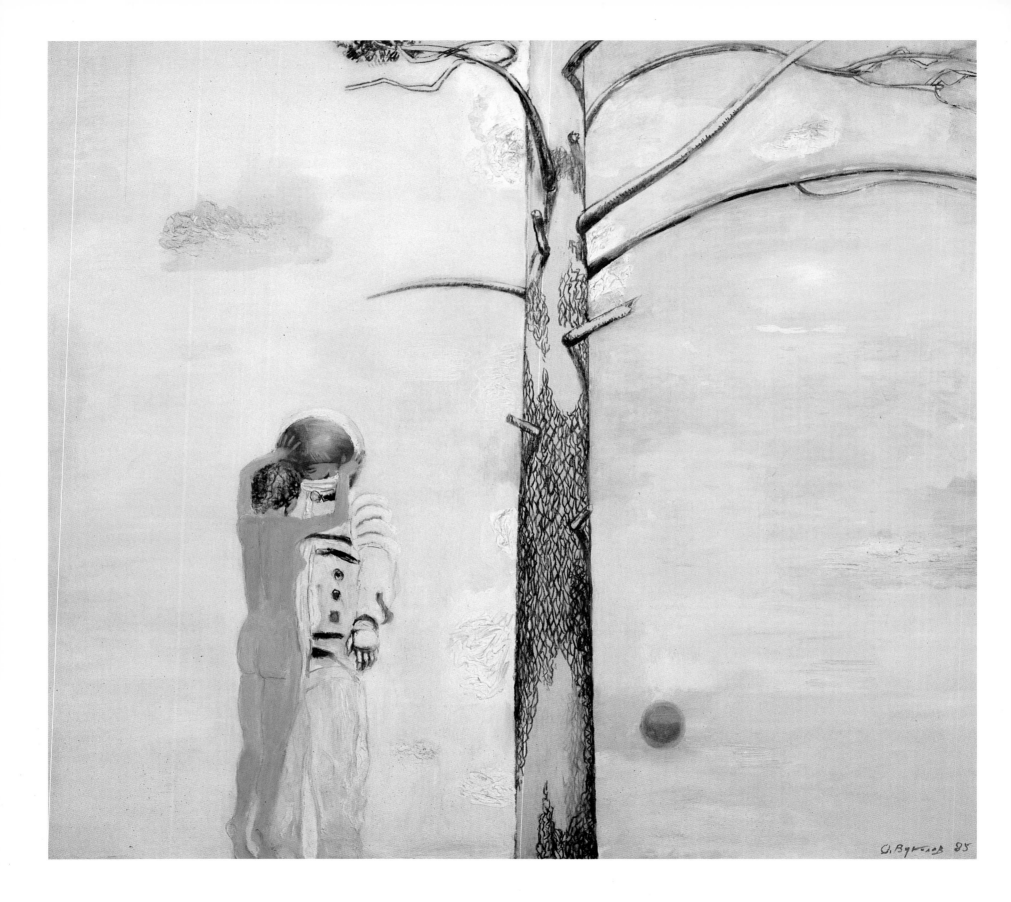

Oleg Vukolov
The Meeting

Artist Oleg Vukolov supports the exploration of space but at the same time expresses concern that it may contribute to environmental damage to the home planet. This confrontation between the need for a technological civilization and the need for nurturing our planet led the artist to depict this sweet and evocative encounter, which expresses, according to the artist, "Love, only love, nothing but love."

Yuri Tsirkunov
Untitled

Two of the most dominant themes of Soviet art are represented in this powerfully evocative painting: the traditional imagery of history and religion, and the new iconography of modern technology— specifically that of cosmonautics.

The apotheosized cosmonaut, spreading his arms protectively over the ancient Russian church, not only reflects the almost saintlike status accorded these heroes, but symbolizes the idea that cosmonautics is and will be the savior rather than the destroyer of the Russian motherland.

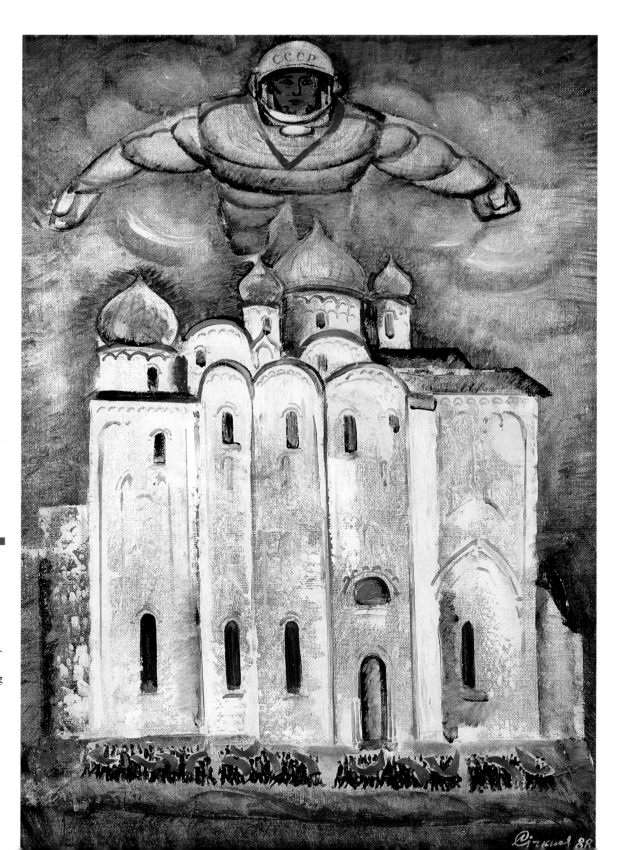

SPACE ART IN THE U.S.S.R.

By Vitaly Myagkov

The work of space artists in the Soviet Union is organized by the U.S.S.R. Union of Artists—a voluntary society of professional artists consisting of approximately twenty thousand members. Members are selected by a commission from applicants who have participated in several large exhibitions at a regional or national level.

The Union of Artists is a unique organization in that it is organizationally, ideologically, and financially independent of the government. The work of the Union is completely subsidized by funds which it receives from its own activities.

The Union's organization includes enterprises producing works of figurative art—monumental sculpture, murals, mosaics, decorative and applied arts, easel painting, graphics, and design—as well as exhibition halls and gallery stores which sell works of

Translated by Nathaniel Knight

art. The administrative board of the Union, which is elected at regularly occurring congresses, forms committees corresponding to creative interests. One of these is the Committee on Science and the Cosmos, which carries out extensive organizational activities related to space exploration.

Soviet space artists create some realistic works, but they also make use of romantic images and symbolism. Much attention is devoted to composition. The use of space as a theme is a natural insofar as the artists perceive themselves and all of humanity as parts of the cosmos. Most often the relationship to the cosmos is expressed through love for our native planet Earth.

The subjects of Soviet space painting are extremely diverse, covering the entire history of Soviet space technology from the launching of the first artificial satellite to present-day spaceflights. Portraits are painted of cosmonauts and scientists. In paintings based on technical documents and observation, Earth and outer space are portrayed exactly as they appear to cosmonauts

in orbit. Scientific data are also used in the depiction of spaceships and space stations on flights to the Moon, Venus, and other planets. In their paintings, artists refer to plans, photos, and other documents from past spaceflights and expeditions. They also fantasize, depicting man's scientific and technical works as they are displayed in orbit around the Earth, on the Moon, on Mars, and other planets. The paintings reflect various scientific hypotheses about outer space, about possible life in other worlds, about the structure of the universe, its evolution, and its diverse objects. Space painting makes visible that which exists in nature but is inaccessible to direct visible observation and photography; artists rely upon both scientific information and their own imaginations. Paintings of a philosophical nature are also created, expressing conceptions of human development in connection with the cosmos and with the broadening mastery of the expanses of space in the interest of science and economic development both on Earth and in space.

The U.S.S.R. Union of Artists subsidizes the development of space as a theme of figurative art. Artists are commissioned to create works which are then displayed in exhibitions and later added to the collections of various museums. Or they may create works which become part of the architecture—both interior and exterior—of public buildings, libraries, and urban ensembles.

The artist Andrei Sokolov, chairman of the Committee on Science and the Cosmos, first visited the Cosmodrome, or spaceflight launch center, at Baikonur back in the beginning of the 1970s. In various years after that, artists such as Yuri Pokhodaev and Aleksei Stepanov also went to Baikonur. These artists are all represented in this

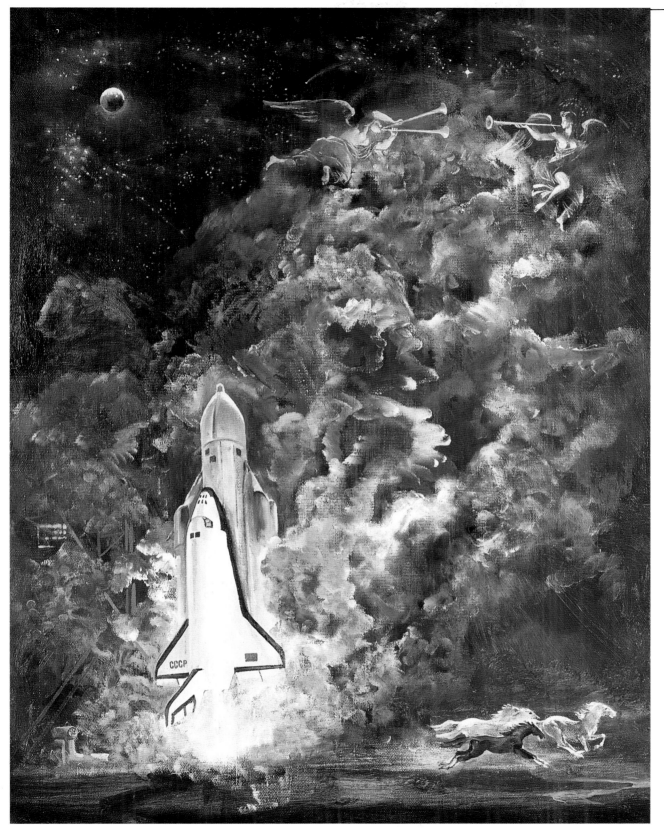

Vitaly Myagkov
Launch

The artist commemorates the launch of the Russian space shuttle Buran with his usual mixture of realistic images, mythology, and religion. Buran is being welcomed into the heavens by angelic trumpeters.

book. With the development of *glasnost* in the Soviet Union, the Baikonur space center became much more accessible to artists, and in 1986 a group of ten artists visited. This group was preparing the first Moscow Space Art exhibition, in honor of the twenty-fifth anniversary of the first manned spaceflight by Yuri Gagarin. The group visiting Baikonur Cosmodrome included Alexander Petrov, Gregori Poplovsky, Peter and Olga Kovalev, V. A. Artikov, Galina Pisalevskaya, Georgii Orlov, and others, also represented in this book. This trip, along with other trips to scientific and technical sites related to space exploration, was subsidized by the Union of Artists.

The U.S.S.R. Union of Artists owns art complexes throughout the country which are known as "houses of creativity." From time to time groups of space artists are sent to these complexes at the expense of the Union. There they participate in seminars, paint pictures, and prepare for exhibitions. When organizing exhibitions, the Union of Artists concludes agreements with the artists. They are offered a wide selection of themes, usually defined quite broadly. The artists interpret these themes in accordance with their own creative inclinations, working in whatever manner they choose. Artists can also offer works executed strictly on their own personal initiative for display in an exhibition. These works are reviewed by the exhibit committee and are usually accepted if there is enough space. Such works are not infrequently acquired by the Union of Artists, in keeping with its goal of providing moral and material encouragement for artists' creative growth. This process has significantly broadened and become more active in connection with the development of democratization and *glasnost* and the af-

firmation of pluralism in the artistic world and in society as a whole.

In providing assistance for space art, the U.S.S.R. Union of Artists helps artists establish close contacts with scientists and cosmonauts. Artists visit the center for the training of cosmonauts, the center for administration of space expeditions, and the U.S.S.R. Academy of Science's Institute of Space Research. They are able to ride on board the U.S.S.R. Academy of Science's oceanographic vessels and participate in the implementation of space programs. Klimuk, Savost'ianov, Popovich, and many other cosmonauts have a personal interest in figurative art, and Leonov and Dzhanibekov are themselves painters and therefore members of the Union.

The Union of Artists' Committee on Science and the Cosmos carries out its activities in contact with, and with the active support of, Glavkosomos and the U.S.S.R. Federation of Space Exploration. The artists receive from scientists the information and consultations that they need. Cosmonauts meet with artists to tell of their expeditions and share their impressions of space. This allows the artists to make the contents of their works more interesting and realistic. Conversations with scientists and cosmonauts also stimulate the artists' creative fantasies, helping them to peer more boldly into the future of space exploration. Of course, most Soviet space artists also produce works in other genres.

Vitaly Myagkov
Conjunction of Planets

A conjunction, astronomically, is the closest approach of two planets. Here, Myagkov shows also a world of the future confronting the world of the past.

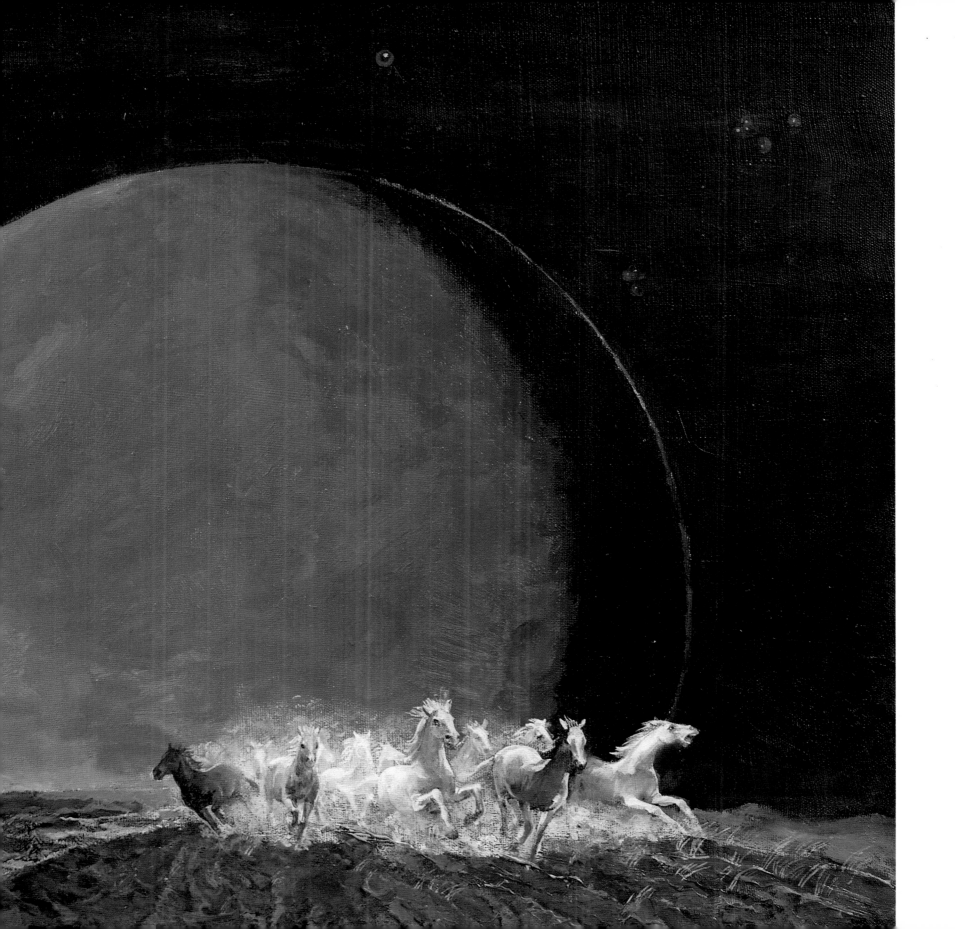

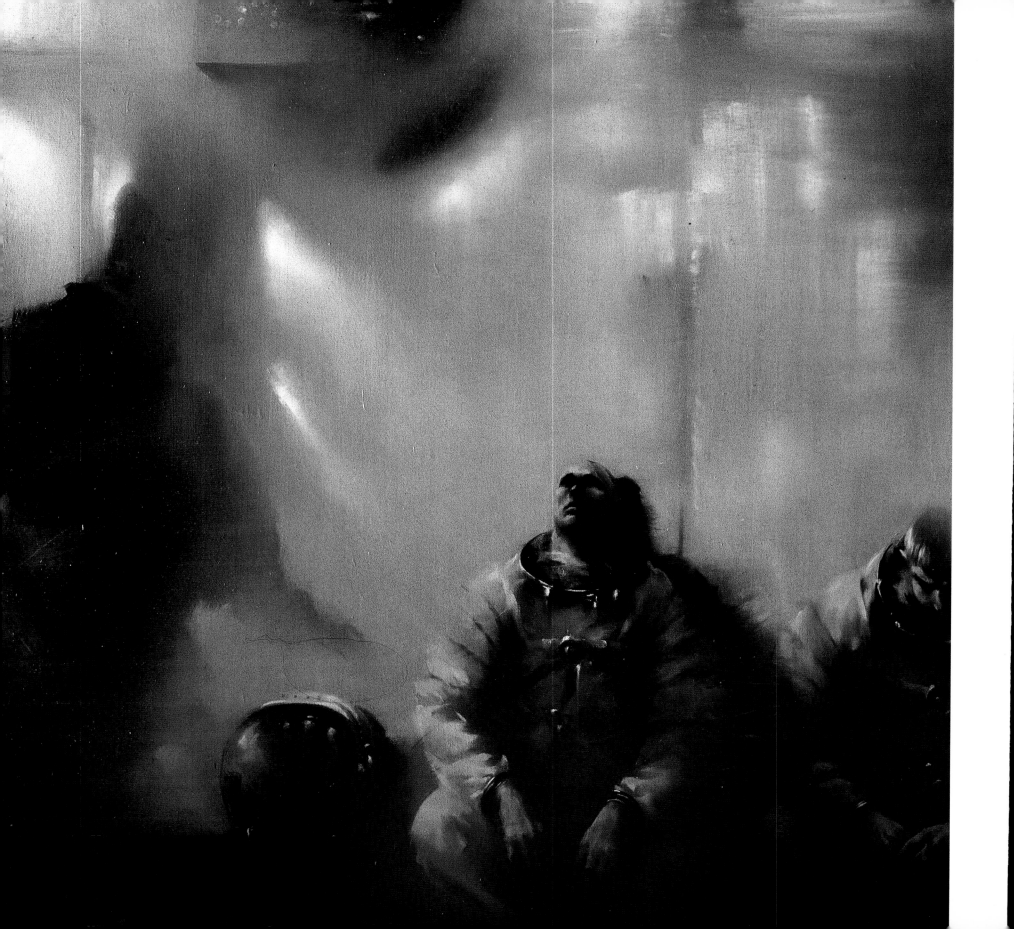

Vitaly Myagkov
Victory

Three cosmonauts approaching their waiting shuttle are superimposed over the classical figure of the Winged Victory of Samothrace, representing both space exploration's link with ancient aspirations of flight and the figure's original intended symbolism of conquest.

The development of space art in the Soviet Union contributes to the Union of Artists' ever-broadening international contacts. Important steps have been made toward making meetings, collective exhibitions, and joint expeditions of Soviet and American space artists regular and frequent, and much positive experience has already been accumulated. A milestone in this creative collaboration, supported by scientists of both countries, by cosmonauts and astronauts, will be the Soviet-American Space Exhibition of 1991 dedicated to the thirtieth anniversary of Yuri Gagarin's flight.

Space art is beneficial in that it allows works of various styles and tendencies to be successfully combined in a single exhibition that is interesting for the viewer, while providing the artist with freedom of choice in terms of theme, subject, form, style, and figurative language. The exuberance and boundless fantasy that result are as unending and diverse as the galaxies. ☐

Josef Minsky
Oh, God, How Tired I Am

Minsky's moody painting, left, of the weary cosmonaut strips away some of the glamor of spaceflight, revealing that space exploration for some is a job which is no longer romantic, but simply an everyday job that must be done.

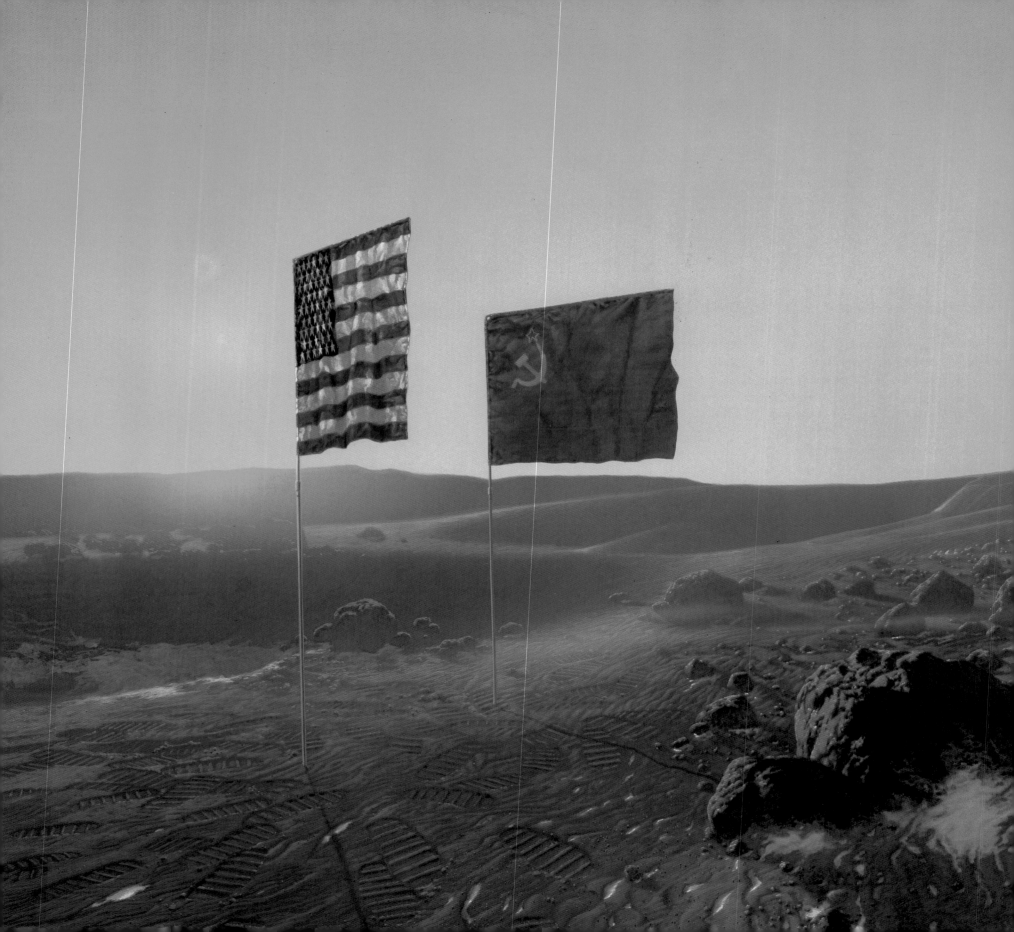

"Joyous we too launch out on trackless seas/ Fearless for unknown shores."

—Walt Whitman

Paul Hudson
Flags on Mars

Commissioned by the Orbital Sciences Corporation, this image symbolizes the possibility of Soviet-American joint exploration of Mars. Since the Soviet launch of the first artificial satellite, Sputnik 1, in 1957, competition has speeded both nations' efforts in space. Short-lived cooperation came in 1975 with the joint Apollo-Soyuz docking mission. Now many experts believe that financial constraints and a yearning for a common human adventure in space may drive international collaboration on land exploration of Mars.

Anatoly Paseka
Sunlight

Images sent back to the Earth by probes to other planets are broken down into very small elements—like the halftone dots that make up photographs printed in magazines and newspapers. These are called "pixels," short for *picture elements*. Left, one of the younger Soviet artists has taken the effect of enlarged pixels and has rendered an image of a patch of sunlight falling on the ground . . . an old subject of art in one of the newest visual languages.

Rafik Karaev
Progress (Part I of a triptych)

This explosively energetic Soviet painting, right, attempts to illustrate the "modern concept of the universe. A combination of cosmos and microcosmos." The artist, Rafik Karaev, has remarked that "the immediate task of space exploration is ecology."

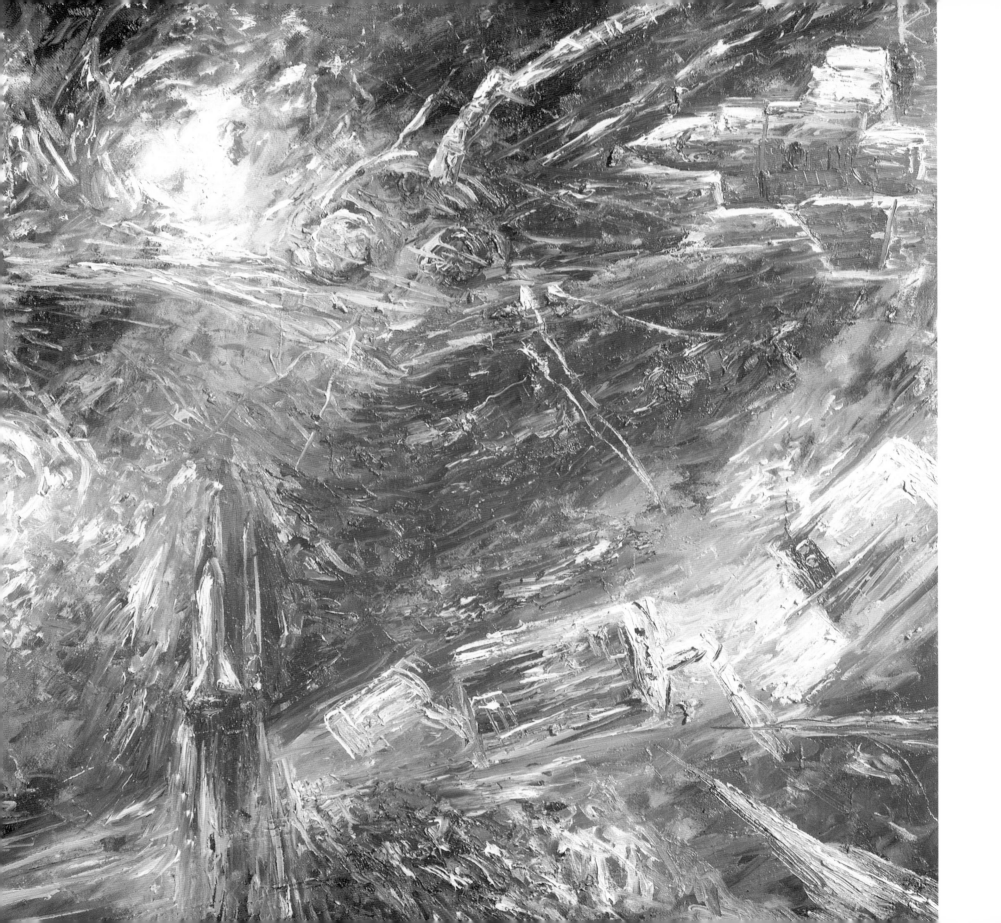

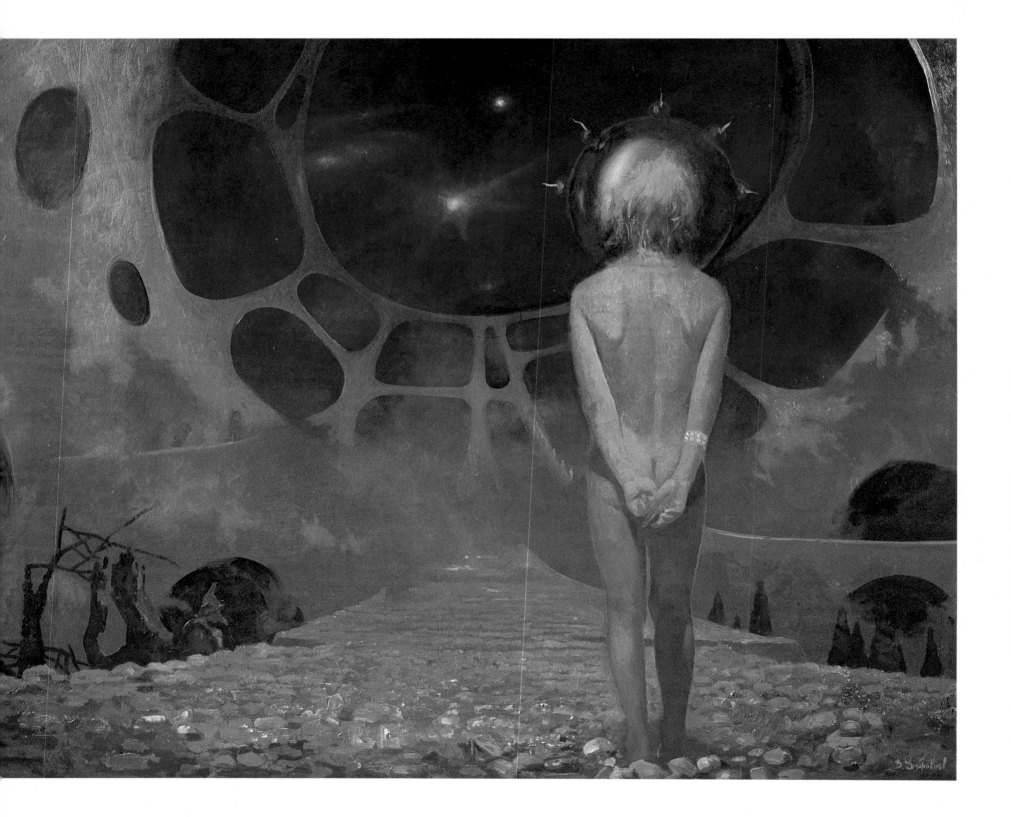

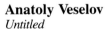

Victor Dubrovin
Light From a Far Star

In the painting to the left, a slim, youthful figure—perhaps representing our human race, stands amidst the rubble and decay of civilization, attracted by the call of a distant star. Victor Dubrovin's image reflects a common theme among Soviet artists who have been inspired by space— a sense of progress toward a future, tempered by a certain disillusion about technology and present conditions.

Anatoly Veselov
Untitled

In this elaborate graphic, right, artist Veselov has used a rich assortment of symbolic elements to reflect a Soviet artist's reaction to the space program of the USSR. In it cosmonauts are conducting both scientific observations and plant-growing experiments—wheat is flourishing in the background. Older-style and obsolete electronic instruments crowd the cabin while futuristic spaceships dock at the top of the image. By juxtaposing and blending the objective or rational and humanistic sides of science, Veselov is demonstrating his belief that space research ultimately benefits the Earth and its inhabitants.

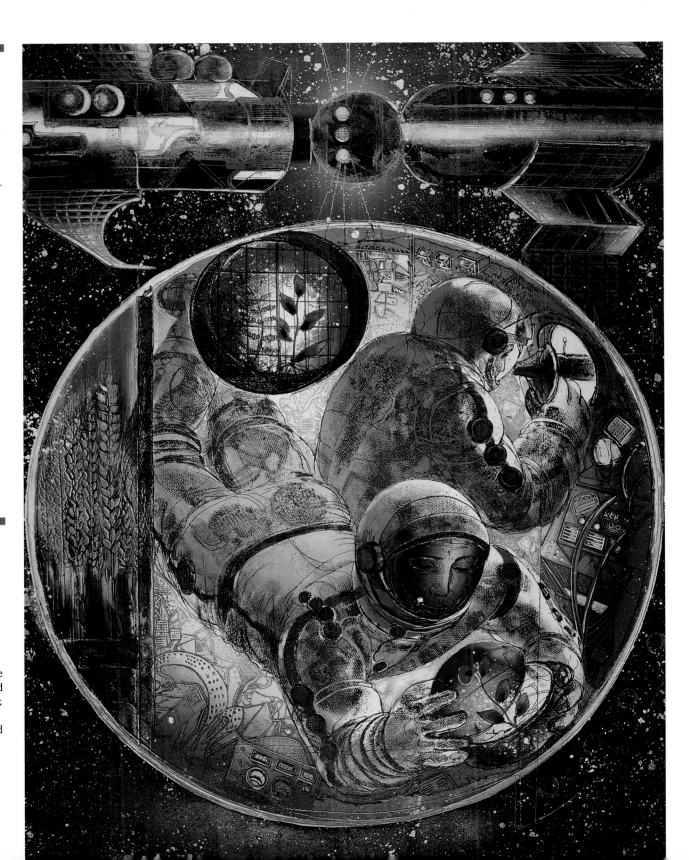

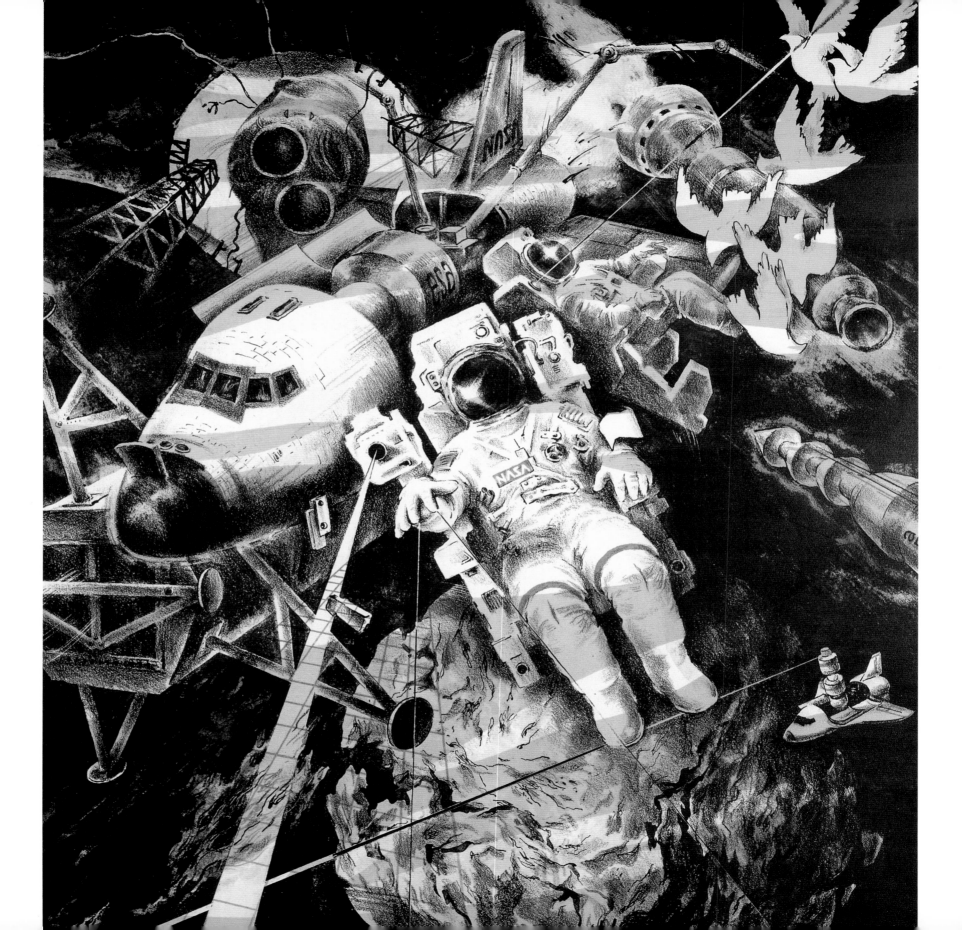

Igor Shelest
Moment
1986 color lithography

Shelest's lithograph, left, illustrates some of the artist's sense of wonder about the nearly infinite possibilities of the universe. "Space exploration," he explains, "has much in store for people. I hope human beings will come into contact with other civilizations."

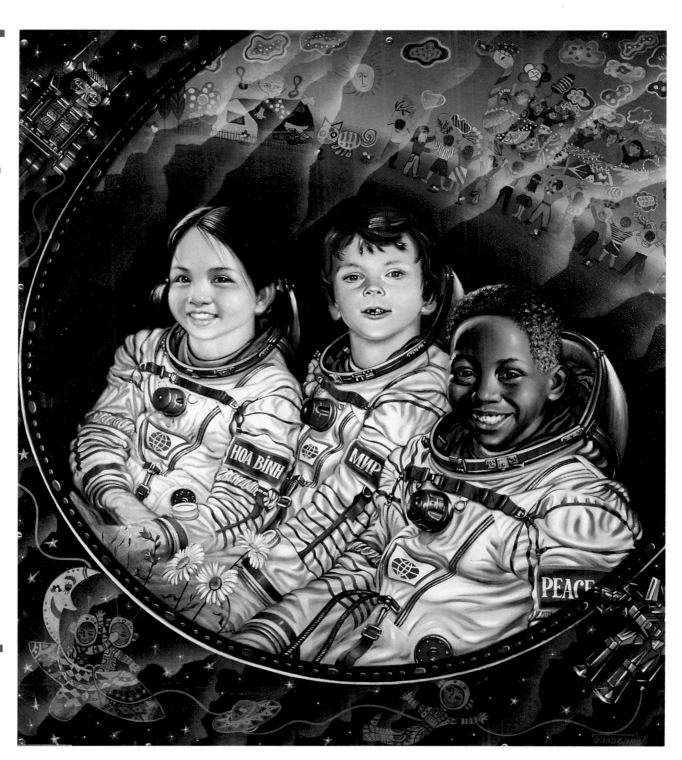

Valery Balabanov
Children of the World

The affection that Russians have for children is well represented in this cheerful and optimistic painting, right, by Valery Balabanov.

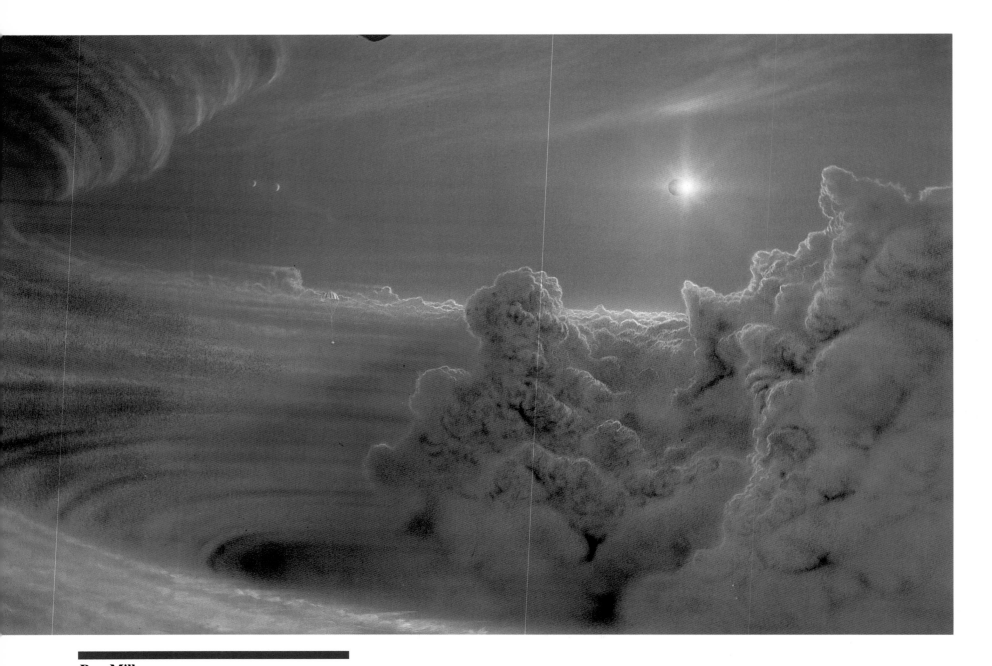

Ron Miller
Within Jupiter's Atmosphere

The largest planet, Jupiter, is covered with mighty clouds colored by organic compounds. Storm systems as big as continents, forming at different levels of the atmosphere, give artists a chance to depict surreal cloudscapes on a colossal scale.

Mark Maxwell
VEGA 1

A balloon probe of Venus was dropped into Venus's atmosphere in 1985 by the Soviet VEGA spacecraft, which was on its way to Halley's comet. The balloon drifted in Venus's yellowish clouds for about two days, 54 kilometers above the surface, making atmospheric measurements.

Ron Miller
Seismic Prospecting on Europa

Future explorers on Jupiter's satellite may set up an array of geophones and set off a distant explosion in order to generate seismic waves that would reveal the subsurface crustal structure. This would reveal whether the uncratered ice surface covers an ocean of liquid water—an ocean that Arthur C. Clarke speculated might harbor life.

Don Dixon

Binary Landscape

The possibilities of alien landscapes seem endless, once we leave the solar system behind. This world orbits in a system where the "sun" is not a single star but a binary pair of stars. Astronomical evidence suggests that over half of all stars are really multiple-star systems. Many such pairs, visible through backyard telescopes, have different colors.

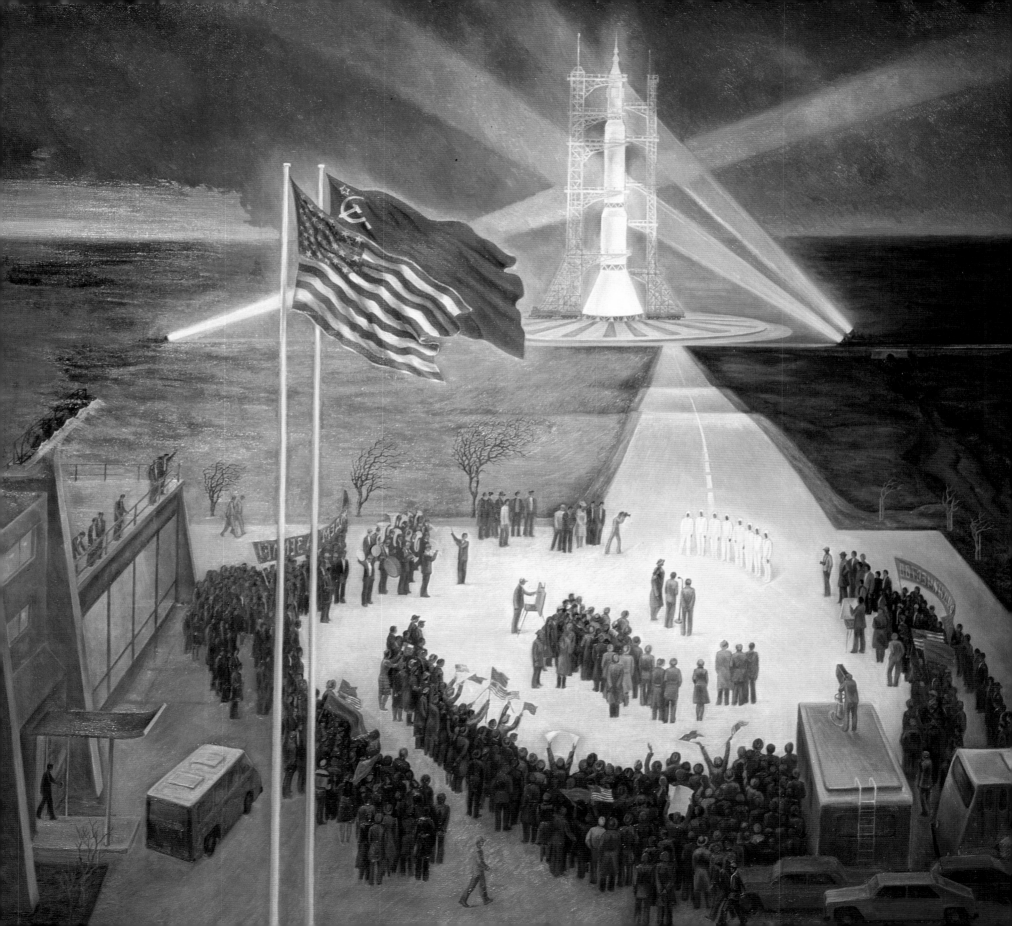

Vladimir Artikov
International Crew

The eight-member crew of the first joint U.S.-Soviet Mars mission are enduring last-minute speechmaking and fanfare before embarking on their years-long journey. Appropriately, a pair of artists (an American and a Russian?) are recording the scene.

Artikov firmly believes that "space exploration serves the progress of human society . . . both American and Soviet scientists have achieved much in space exploration. International crews have greatly contributed to mutual understanding."

Alexander Petrov and Elena Korennova
Before the Launch

Alexander Petrov was among the first group of artists permitted to visit the main Soviet launch site at Baikonur. He prepared sketches for this painting on location and finished it in collaboration with Elena Korennova. The pad shown here is a historic one: Yuri Gagarin began his famous flight from this same location in 1961.

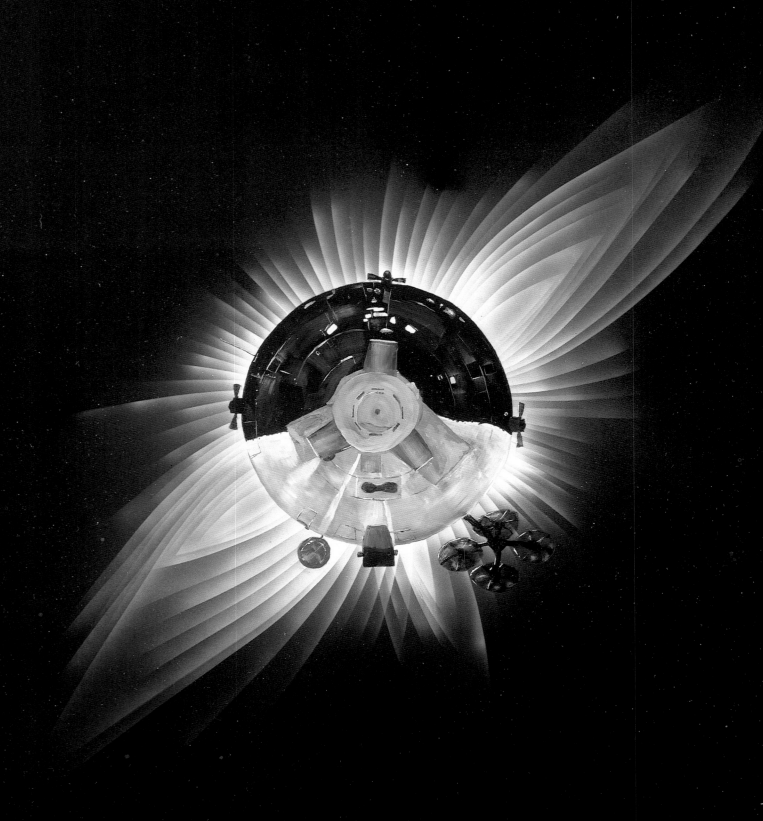

Tom Hunt
Apollo Eclipse

The artist depicts the last phase of the Apollo-Soyuz mission as seen from the Soyuz spacecraft. The Americans backed their craft away from the Soviets' and created an artificial solar eclipse for them. The Soyuz crew then took pictures which were used to study the structure of the sun's corona, or glowing outer atmosphere. Reflections of Earth and space appear in the Apollo module's shiny surface.

Georgii Orlov
New Year on Mars

Orlov's painting adds a needed whimsy to the normally serious genre of space art. But who's to say that not too far in the future some cosmonaut or astronaut won't relieve the tedium of his mission by constructing the first snowman on Mars? Even if the snow has to be frozen carbon dioxide.

Larry Ortiz
Pyramids of Elysium

This painting is one of a projected series showing different surface views of the Elysium volcanic region of Mars at 2 P.M. local time, based on Viking Orbiter photos. Here, the California artist shows cosmonauts exploring eroded cliffs and hills in this region.

VISIONS OF FLIGHT
THE NASA ART PROGRAM

By Robert Schulman

For over twenty-six years, some of the nation's most outstanding artists have been commissioned by the U.S. National Aeronautics and Space Administration Art Program to travel into the land of rocketry and astronauts and to produce from their impressions an artistic record of the United States' space program in all its diversity and historical importance. If art is about mystery, or beauty, or visions of power, then they've come to the right place.

The work of these artists, along with others from previous art assignments, is displayed in NASA's first permanent museum-quality art gallery at Kennedy Space Center, Florida, as well as in public display centers at several other NASA centers. In addition, NASA has been able to share this collection with museums around the world through collaboration with the Smithsonian Institution Traveling Exhibition Service (SITES).

Robert Schulman is director of the NASA Art Program

All of this documentary art conveys the awe and excitement that continues to characterize spaceflight. From test flights and lift-offs to splashdowns and space shuttle landings, the program makes it possible for artists to witness events that the public is seldom able to see. The artists record their personal views of these events for posterity and, through this space art exhibition, for all of us.

There are many precedents for asking artists to help document and interpret historic activities. For example, when John Wesley Powell went west in 1869 to explore the region around northern Arizona and the

Frank Germain
First Night Landing

First Night Landing is based on the artist's eyewitness view of the first night landing of space shuttle Challenger on the dry lake bed at Edwards Air Force Base, California, in 1983. High intensity xenon arc-lights illuminated the runway, casting an eerie illumination on the spacecraft. (NASA Art Program.)

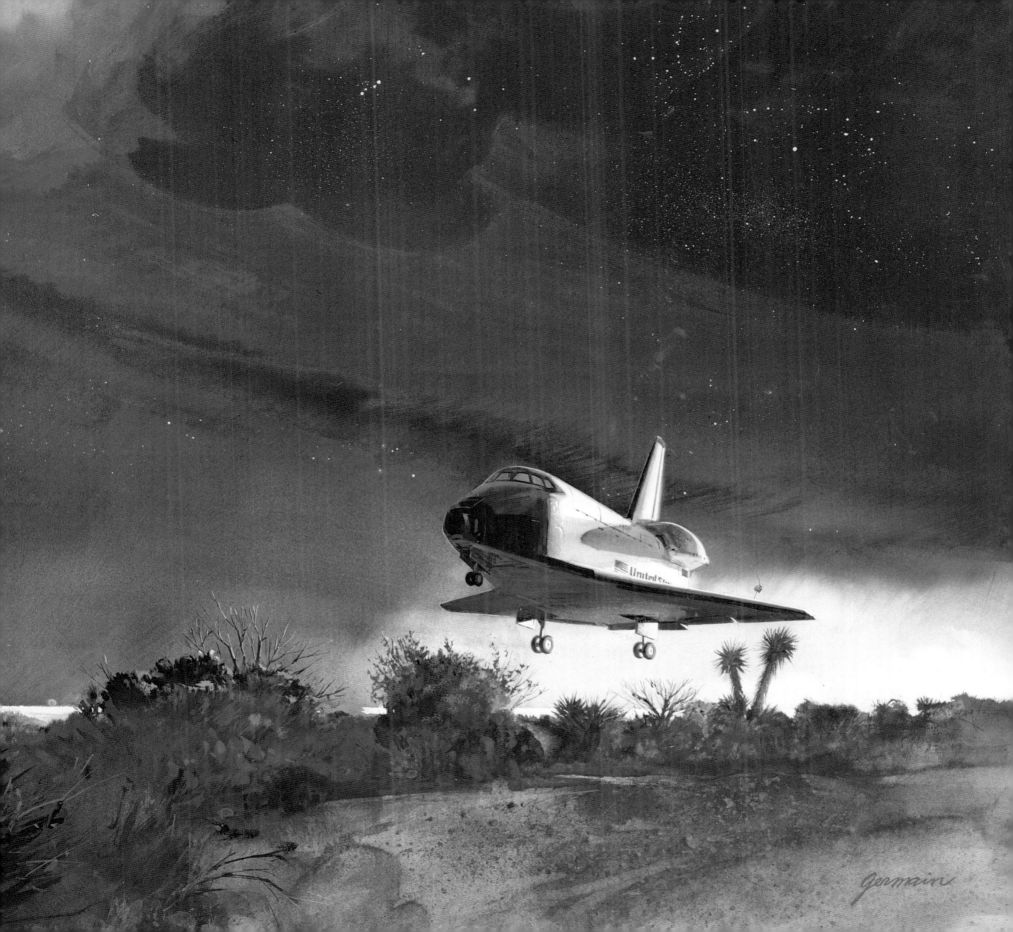

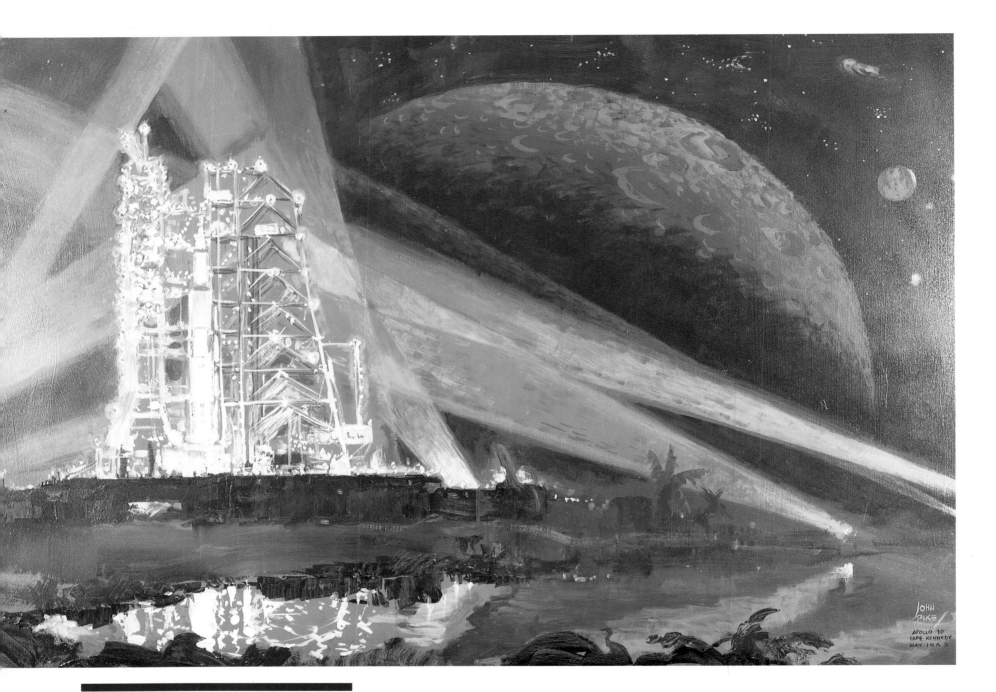

John Pike
Moon Jewel

Spotlights on the Apollo 10 rocket turn it into a
glowing monument at night. This view was painted
in 1969 during preparation for an around-the-moon
flight. (NASA Art Program.)

Andreas Nottebohm
Columbia Launch Fantasy—No. 2

The NASA Art Program includes abstracts such as this impression of the first launch of Columbia in 1982. The shuttle passes from the misty seaside launchpad into a high cloud deck. (NASA Art Program)

Grand Canyon, he saw many new and magnificent sights, traveling areas little known at that time, including the Grand Canyon of the Colorado River. When he returned to Washington, D.C., and told what he saw, people could not conceive of the grandeur he was trying to describe to them. Everywhere he went he was at a loss to express what was in the western lands. Eventually he decided to return with artists to paint and draw the new scenery of the Southwest. One of the artists, Thomas Moran, went on to become one of the most famous American landscape painters in our history.

Now, looking back on these momentous events, we realize how much our knowledge and appreciation depend on the sensitivity of the artist-on-the-spot. The artist's insight is unique, and the awesome events of our day are a worthy challenge to those abilities.

The NASA Art Program began in 1962 as the brainchild of then-administrator James E. Webb, who saw the need to use interpretive artwork as a means of documenting not only the sights of the Space Age but its spirit as well. In getting the program under way, the first group of artists was dispatched

*Editorial note: There was a marked decline in media coverage and public attention to space exploration throughout the United States in the years following the last Apollo flight in 1972.—W.K.H.

to cover Gordon Cooper's final Mercury flight in 1963. For the next ten years, through the Gemini and Apollo eras, the art program invited a number of highly talented artists, including Norman Rockwell, Robert McCall, Paul Calle, James Wyeth, and Robert Rauschenberg to contribute paintings and sketches.

The program lapsed after the last of the Apollo lunar flights.* However, in 1976, I

was asked to revitalize it for the Space Shuttle era. Today the program works much as it did in the sixties. The artist selection process is a two-way street. Many send requests and samples of their work directly to me. I also contact artists directly and invite them to participate.

All in all, we at NASA have been very pleased with the results. More than 800 pieces of NASA-commissioned space art

have been created in the quarter of a century that has passed since the inception of the program. The collection includes the work of nearly 200 artists.

Why should NASA, an agency known for *technological* expertise, have an *art* program? NASA decided to ask artists to supplement its record after reviewing the documentation of the first few years of the space age. Administrators realized that important aspects of the story were missing. When a major launch takes place at Kennedy Space Center, more than 200 cameras record every split second of the activity. Nuts, bolts, and miniature devices are photographed from every angle. The artist can add very little to all this in the way of factual record. But, as Daumier pointed out about a century ago, the camera sees everything and understands nothing. It is the creative individual who makes the significant difference in the resulting imagery. It is the emotional impact, interpretation, and hidden significance of these events that lie within the scope of the artist's vision. An artist may think he depicts exactly what he sees, but the image has still gone through the catalyst of his imagination and has been transformed in the process.

The effort we are making in space represents the frontier not only of technical achievement, but also of the imagination. The space effort in every way is a worthy

Fletcher Martin
Second Stage Apollo 14

Artists visiting the Kennedy Space Center are often overwhelmed by the monumental scale of the support machinery and the space vehicles themselves, as can be sensed in this 1970 work.
(NASA Art Program.)

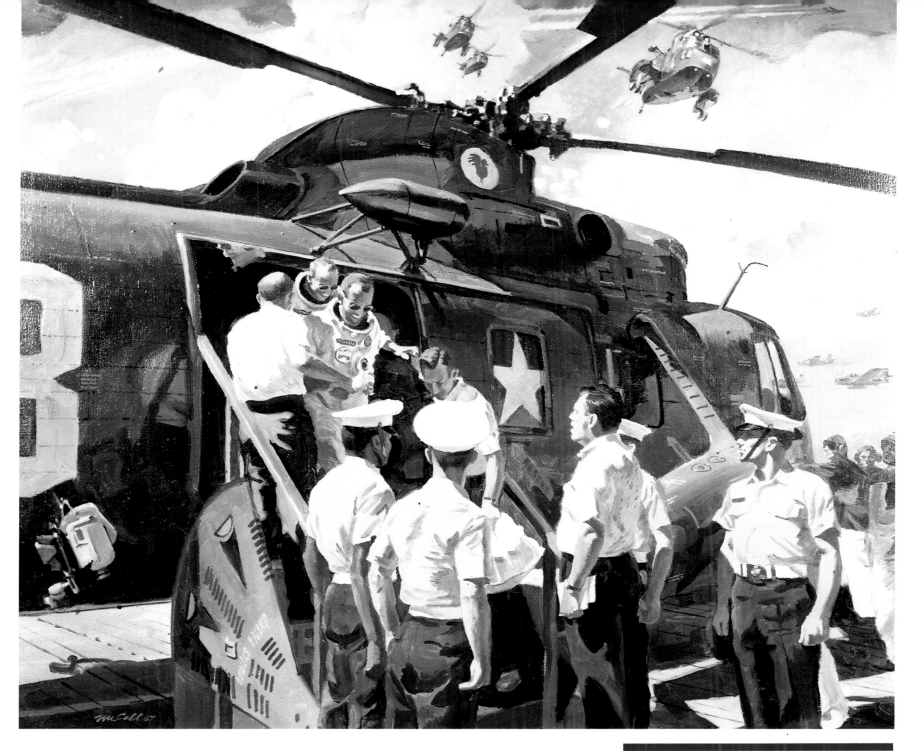

Robert McCall
Welcome Aboard

Artists from the NASA Art Program have attended
not only launches, but the conclusion of many
missions, such as this naval recovery of astronauts.
(NASA Art Program.)

Robert Schulman
After Touchdown

The artist portrays the poignant emptiness
of a shuttle landing site at a dry lake bed
in California, the day *after* a landing
in 1981. The impassive desert is indiffer-
ent to the momentous events. To the right
is the now-empty landing strip, and on
the left, the disappearing footprints and
tire tracks of thousands of spectators,
who have now gone home.
(NASA Art Program.)

theme for the artist. Space travel started in
the imagination of the artist, and therefore it
is reasonable that artists should continue to
be the witnesses and recorders of our efforts
in this field.

The artists come from all points geo-
graphically and stylistically. Some have
been assigned individually to cover space-
craft roll-outs from factories in California,
simulations in Texas, or hardware tests in
Alabama. Other groups are assigned to
launches and landings. No matter what the
location or the assignment, the artists are
given free rein as to what they can paint and
how they can paint it. The object is to get as
rich and complete an artistic chronicle of
the space program as possible, and to leave
for future generations a truthful record at all
levels of perception.

Many of the artists produce preliminary
color studies or paintings on location; some
work directly on watercolor blocks; others
work in oils and acrylics using makeshift
easels for support. The work environment is
understandably hectic with the noises and
movements of the crowds of observers,
cameramen, TV crews, and the press.

Style in the NASA art assignment is not
restricted. If the artist sees events in nonob-
jective terms, then he or she will represent
them this way. NASA is commissioning the
artist's imagination, and we want records of
fleeting impressions and poetic by-products
of thought as much as precise documents of
optical experience. What is important is that
the artist give us his or her personal and sin-
cere interpretation. The work is not juried,
judged, or evaluated when it arrives at
NASA, at least not by this generation, but
it will become a permanent record of an in-
dividual's talent and perception and, in this
way, a sliver of immortality.

Some of the artists strive to capture inter-
pretive images through their imaginations
and the use of symbolism. Sometimes they
use color in a completely abstract way, en-
tirely unrelated to the object being painted,
creating dramatic images of the subject.

Artists, through their paintings, strive to
express certain emotions they wish to con-
vey by giving people an opportunity to ex-
perience the color, mood, and beauty of the
art. Although viewing a work of art is
undoubtedly a purely visual experience, the
artist, through the use 'of color, light, and
texture in his painting, can stimulate senses
other than visual. Effectively used, the ele-
ments of color, light, and texture can arouse
the viewer's sense of smell, touch, and feel-
ing. In a landscape, the aroma of a lush
pine forest becomes almost perceptible . . .

Tom O'Hare
Apollo 7 Launch

Artists in the NASA Art Program covered launches of Apollo test flights even before the famous flight of Apollo 11. This view shows the launch of Apollo 7 from Kennedy Space Center in Florida, watched by NASA engineers, guests, and journalists. (NASA Art Program.)

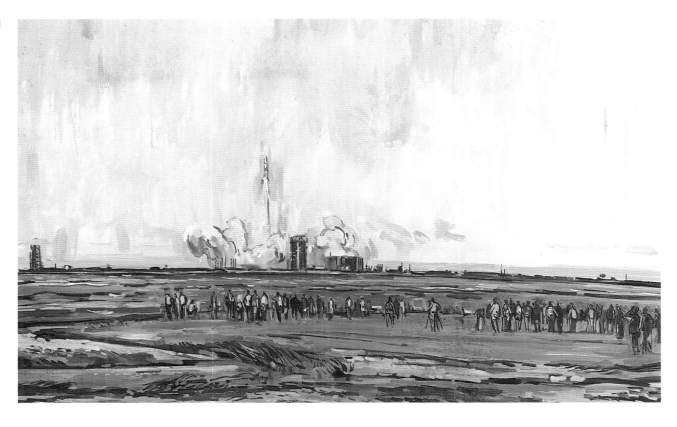

rocks and pebbles in the foreground are so real that you want to touch them and some people actually do . . . sunlight in an inviting beach scene is so golden and bright that you can almost feel its warmth.

Paintings such as these, because of their appealing realism, have a magnetic quality about them that seems to "draw" the viewer into the scene and make him feel a part of it. This can only be described as the ultimate communication between the viewer and the painting.

The effect of the artists' on-site visits is interesting. At first, space technicians regarded the artists with amused tolerance. Later, as they saw their space hardware converted by the artists' imagination and skill into images of fantasy and beauty, they increasingly became respectful. Today no

launch would be considered complete without artists hovering around the periphery.

True, the Space Shuttle and the other spacecraft captured on canvas would fly just the same without the artists. But we would lose something.

There is the historical record that their work provides. There is the mandate to keep the public informed about spaceflight progress, and then there is the artwork itself, artwork which satisfies the need to interpret the space program's high-flown technology on a human scale, one that people at large can appreciate.

Both young and old throughout the world can understand and appreciate the universal language of space exploration as seen through the eyes of the artist. This unique visual language transcends politics, reli-

gion, war, language barriers, and age.

Lester Cooke, former curator from the National Gallery of Art, who guided the NASA art program during the Apollo moon launchings, stated it quite well when he said, "Perhaps this will help to prove that the U.S. produced not only engineers and scientists capable of shaping the destiny of our age but also the artists worthy to keep them company."

As the United States looks ahead to the building of a space station in the 1990s in cooperation with Japan, Canada, and the European Space Agency, and to possible joint missions to Mars with the U.S.S.R. and other countries, artists will continue to document these efforts through their artistic interpretations as we once again push back the frontier of space. □

Paul Arlt
East to Cotopaxi

NASA artists have traveled far afield to cover the space program. This abstract view of a NASA tracking station was painted in Ecuador. In the background is the volcano Cotopaxi, memorialized a century earlier by Frederic Church. (NASA Art Program.)

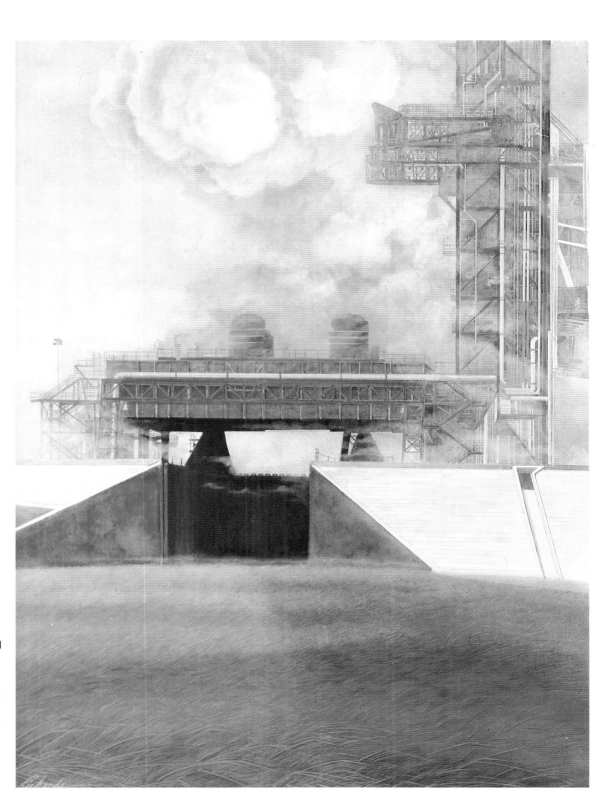

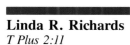

Linda R. Richards
T Plus 2:11

This watercolor captures an unusual mood at the gantry following lift-off of the Columbia space shuttle. From the atypical viewpoint of the flame-deflector trench, the artist examines the effects of heat and acid powder on the grass, gantry, and sky. (NASA Art Program.)

Nicholas Solovioff
Leaving the VAB

The most immense and impressive building at the Kennedy Space Center is the Vehicle Assembly Building, or VAB. So tall that cloudlike mists form near its ceiling, birds have reportedly lived out their life cycles within its walls. Built originally for the Saturn rocket of the Apollo program, it was modified for shuttle assembly. This 1979 watercolor shows a roll-out of the shuttle test vehicle Enterprise. (NASA Art Program.)

Arthur Shilstone
1:07:22 and Counting

This watercolor is a view from the press site of the space shuttle Columbia prior to a 1981 dawn launch. Spotlights on the shuttle turn it into an eerie — and transient — architectural monument to the space age. (NASA Art Program.)

107.22

DUNHILL

NASA

Arthur Shilstone 1981
Kennedy Space Flight Center

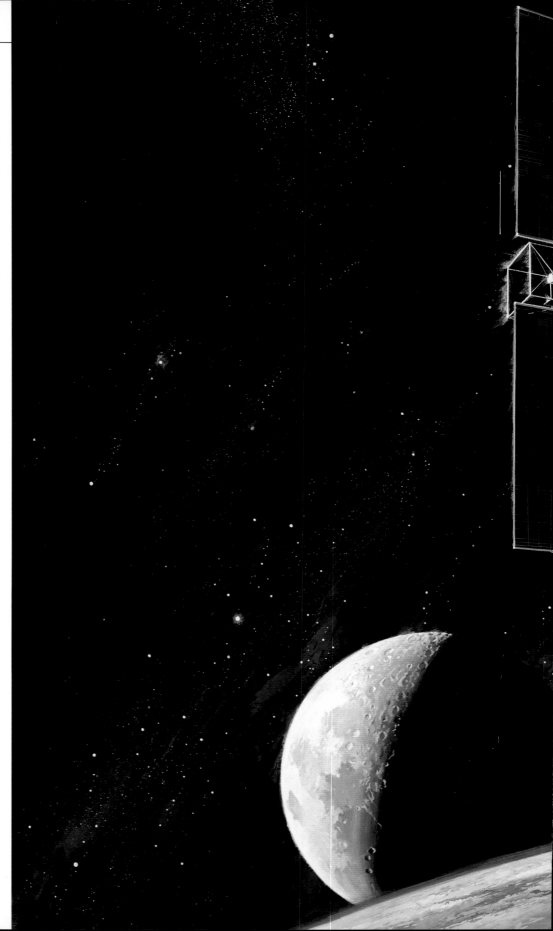

"Fantasy abandoned by reason produces impossible monsters; united with it, she is the mother of the arts and origin of its marvels."

—Francisco Goya

Vincent Di Fate
Space Station

The proposed U.S.-international space station may join the Soviet Mir station in the late 1990s. It is intended to serve as an orbiting research facility to enable scientific exploration, technological development, and private sector research in space. Ultimately it may serve as the staging base for continued manned and unmanned exploration of the solar system. In this 1987 design, the horizontal truss is 445 feet across, linking U.S., European, and Japanese modules, and a Canadian mobile service system. (NASA Art Program.)

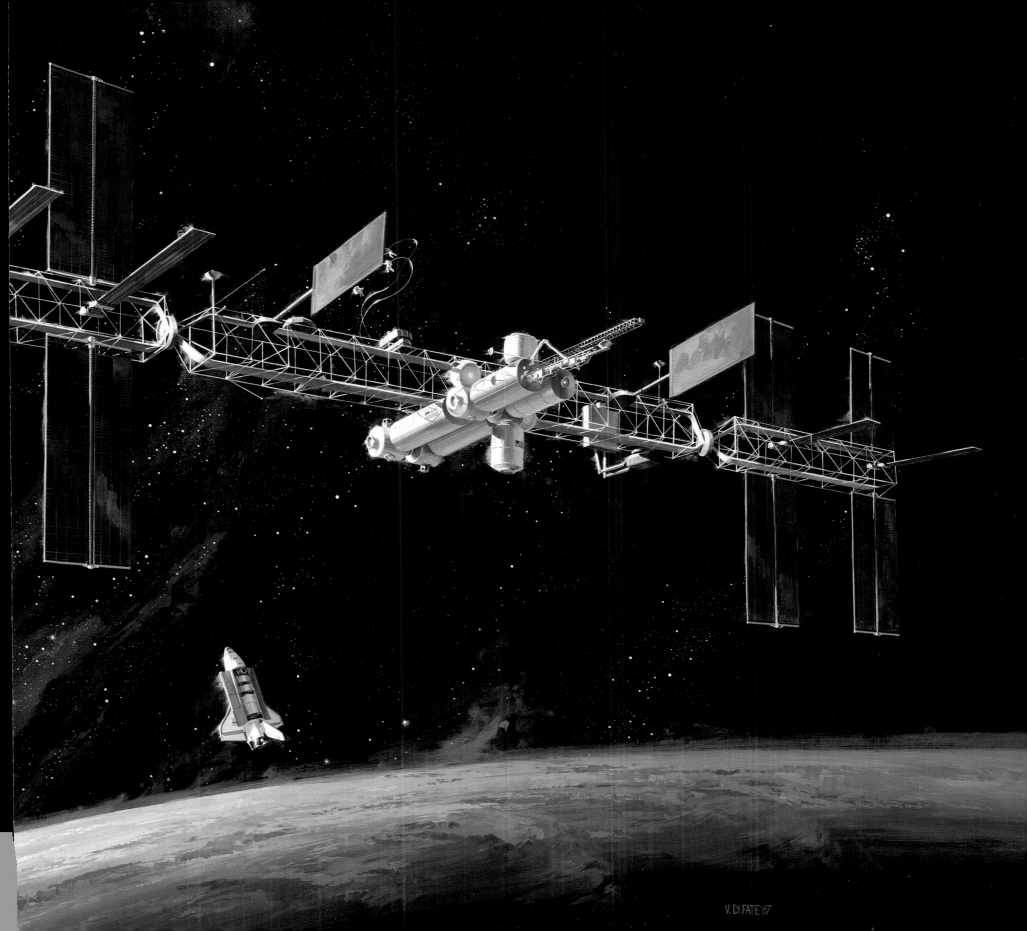

V. DI FATE '87

Brian Sullivan
Tribute to Challenger

This mixed-media image was the artist's response to the disastrous explosion of the space shuttle Challenger that resulted in the deaths of the seven crew members. The original hangs in the exhibit hall at the Hayden Planetarium.

Julian Baum
First Footsteps

"The machines have gone, the men have returned to Earth," the British artist writes of the Apollo 11 mission. "In the dusty soil, the imprints of a first walk across the land of another world lie still and untouched. Like the first teetering steps of a newborn child, the first steps on the moon hold promise . . ."

Andrei Akhaltsev
Meeting in Space

Soviet artist Andrei Akhaltsev com-
memorates the historic Soyuz-Apollo
mission of 1975, the first — and so far,
the only — joint Soviet-American space-
flight. American and Soviet crews docked
their spacecraft in orbit, opened the
common docking module, and carried out
joint experiments. Thomas Stafford and
Alexei Leonov are shown shaking hands,
watched by Valery Kubasov and Deke
Slayton.

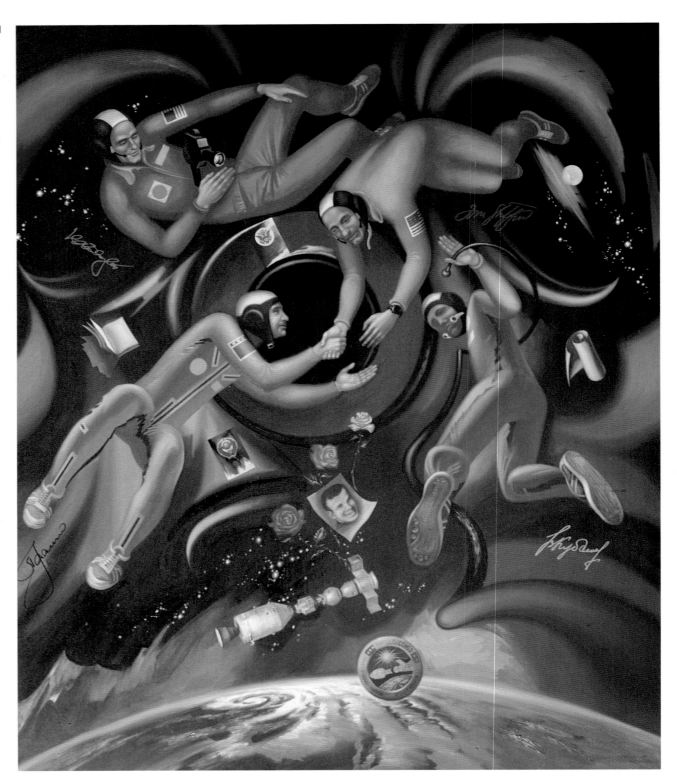

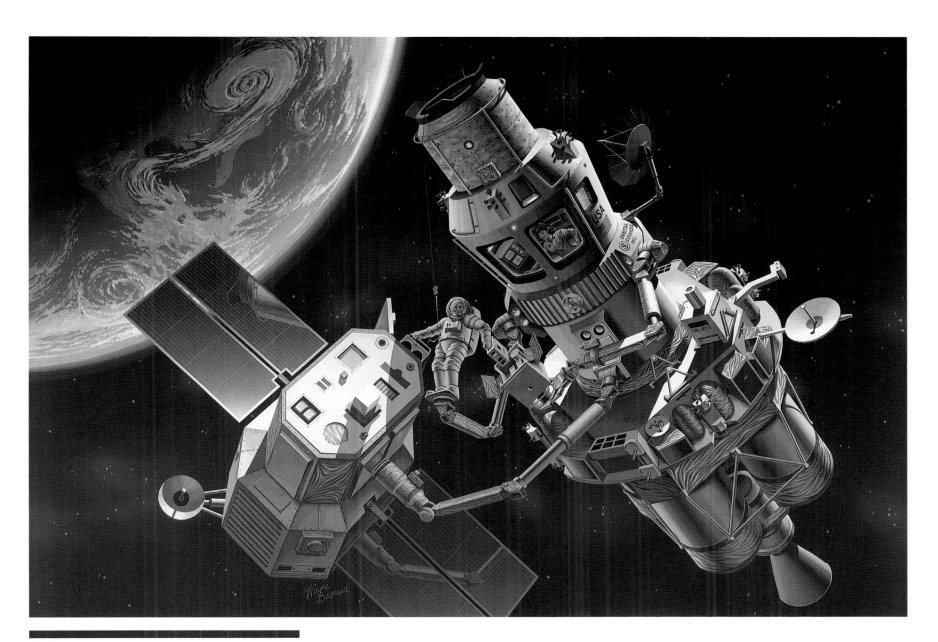

Wayne Begnaud
Manned Servicing and Assembly Vehicle

Space hardware often evolves in an engineering/
artistic iterative process: conceptualizations such as
this painting suggest design ideas that may be
worked into future engineering studies, which in
turn inspire more conceptualizations. This imagi-
nary vehicle could operate from a space station to
repair ailing satellites.

AN ARTIST IN SPACE

By Alexei Leonov

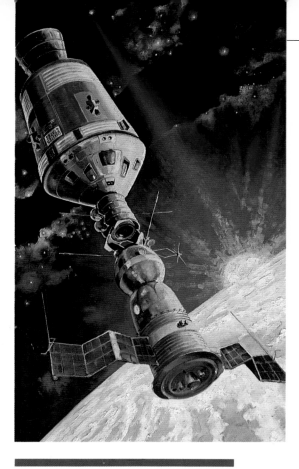

Alexei Leonov
Docking of Soyuz-Apollo

"This work," writes Leonov, "was made after signing the agreement for a joint Soviet-American flight. This canvas shows what the flight was for me." The highly successful 1975 flight, in which Soviet and American space fliers docked their craft and worked together in orbit, was widely regarded as a faltering pre-*glasnost* step toward global cooperation. To carry off the flight, engineers and astronauts from both sides planned, worked together, and studied each other's language.

We were orbiting high above the Earth in 1965. In accordance with the program of the flight, I began to prepare to leave the ship and enter the airlock chamber, the condition of which had been checked by the commander of the ship, Pavel Baliaev. Everything was fine. I took the pack which contained the automatic life-support system, inspected it, and gave it to Baliaev. He helped me to put it on my back, and then connected up the lifeline and checked the passage of electronic signals. Everything was excellent.

The commander opened the tumbler, and the gate of the airlock chamber gradually began to open, revealing a narrow, well-lit cylinder. I gently pushed off from my chair and floated into the lock chamber. The door closed behind me and I was alone. Only the

Alexei Leonov is a Soviet pilot and cosmonaut. He was the first man to walk in space.
Translated by Nathaniel Knight

thin walls of the lock separated me from outer space. I checked once more that my spacesuit was hermetically sealed, that my gloves were fastened, and that the gold-colored filter was properly attached to my helmet. In outer space the sun is extraordinarily bright. The filter helps to provide protection, cutting out 95 percent of the light.

Everything was in order. I signaled the commander: "Ready!"

The pressure in the airlock fell as the air rushed out with a whistle, but the pressure in the spacesuit increased. The spacesuit became stiff and elastic—as it would remain until the end of the experiment.

A total silence fell over the lock chamber. My attention was riveted on the exit gate. Then the lock was released and the opening mechanism began to turn. I started to lower the filter over my eyes. The gate quivered and slowly began to rise. Suddenly the sunlight—bright as the spark from an arc welder—penetrated the chamber. I lowered the filter all the way so that my eyes were fully protected. I floated up to the gate, poked out my head, and saw the endless black sky

and the stars. There were many more of them than could be seen from earth, and here they were brighter and didn't shimmer.

During this time, Pavel Beliaev was checking the ship's systems and the lock while carefully monitoring my breathing and heart rate. We were flying over the Black Sea when the command was given to exit. I lightly pushed off with my feet, grabbed on to the handrails, and pulled up my legs. Soon I was standing on the edge of the lock in outer space. It was so quiet I could hear my heart beating. I could hear the sound of my own breathing. The two television cameras stared at me as if they were alive. The ship, bathed in the bright rays of the sun, with its antennae needles unfurled, looked like some kind of fantastic creature. It was illuminated with equal brilliance by the sun and by the light reflected off the atmosphere of the earth—a blue sphere majestically turning below. But it wasn't just turning, it was furiously dashing by. The Black Sea had just been visible and now I was seeing the Volga.

The sun was reflected brightly off the surfaces of the oceans and little spots of light were dancing over the outside of the ship. I looked down at the Earth and saw threads of railroads and highways. Like spiderwebs, they came together at the cities and then ran off again in different directions. And then there was one thread that was longer than all the rest—the road from Moscow to Siberia

Alexei Leonov
Early Morning in Space

The atmosphere of the Earth is illuminated like a rainbow just before the sun is about to rise above the horizon, in this eyewitness view from space.

and on to Vladivostok. I wanted very much to see the place where I was born. Before the flight I had spent a long time studying the Earth's geography and I could even trace maps of certain regions from memory. In space I could easily determine our location at any given time. We were flying toward my birthplace. The foothills and spurs of the Altai Mountains appeared. But where was the river Tom, with its characteristic bend at the city of Kemerovo? No matter how hard I looked, I could not see the river of my childhood. It was under ice and snow. The taiga was clearly visible, like a velvet carpet stretching out to the north and east. I was struck by the immense size of the forests.

It was time to prepare the movie camera. I quickly took the cap off the lens. My first thought was that I should bring the lens cap back to earth—it was a very valuable souvenir! But it was awkward to work with, and so after a moment's thought I tossed it off to the side. It began to sparkle like a little star and then floated off into eternity. Having pulled out the lifeline, along with the radio installation, as far as it would go, I smoothly pushed off from the lock chamber. The ship slowly rotated, bathing in the stream of sunlight. Stars were everywhere: above, below, to the right, and to the left. Even with the sun out I could see stars in most directions. Of course, around the sun to a distance of about 20 degrees, the stars were invisible, suppressed by the sun's glare. And near Earth, depending on the direction of illumination, the stars were again suppressed visually out to a distance of about 10 degrees. But, during sunrise and

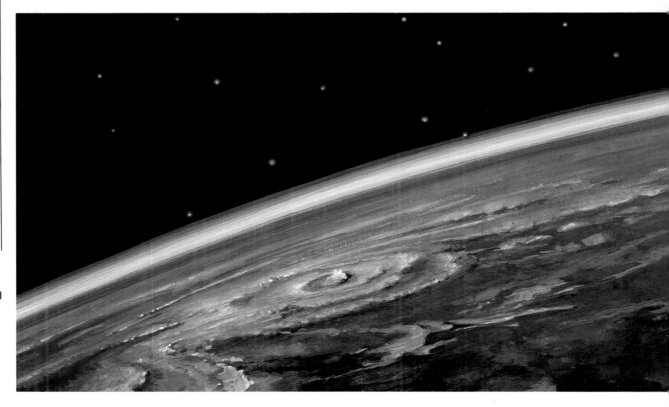

sunset, the stars are visible near the horizon or even sometimes shining through part of the atmosphere.

It's true that in space it's hard to say which way is up and which way is down. But in order to get any work done you have to invent these things for yourself. "Up," for me, was where the sun was, and "down" was the lock chamber of the ship. I was suspended about seven meters away from the ship with my face toward the sun. I felt the touch of its rays on my lips where there was no light filter. The sun was bright and very hot—not like anything on Earth. I saw our ship shining and could easily make out the small details and inscriptions on the retrorocket.

I pulled on the rope, which had stretched out to its full length, and quickly went back to the ship. As I approached the ship I stuck my arms out in front of me, and, when I touched the wall of the lock, pushed off with some force. Suddenly I began to turn about in a strange way: first head over heels and then from left to right. The line entangled me like an octopus until I was all tied up. But then the rotation slowed down, and I stopped not far from the ship. The line slipped off of me in coils and hung freely between me and the ship. I realized that sharp movements in space are counterproductive. I kept my mistakes in mind when I made the next departure from the

Alexei Leonov
In Open Space

In this painting Leonov the artist commemorates Leonov the cosmonaut's historic 1965 space walk. It is one of the first pieces of space art done by someone who was actually there.

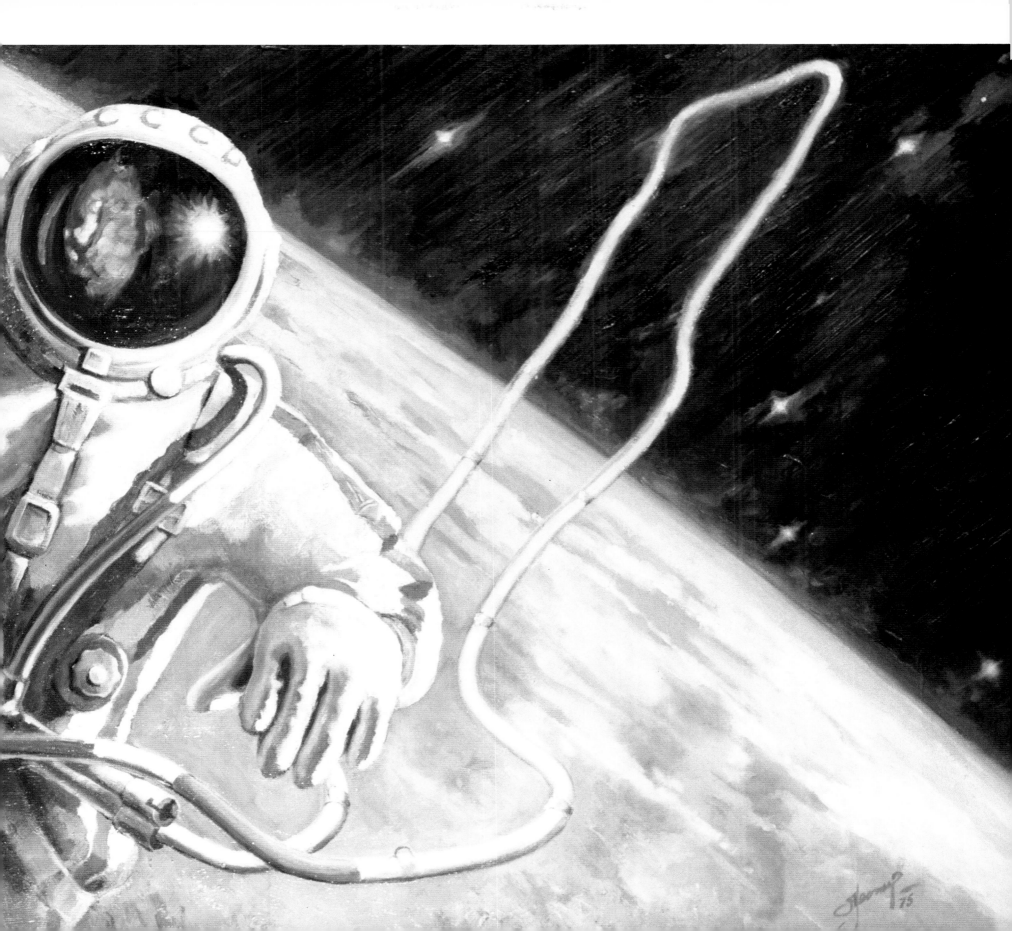

ship. I was gaining experience with walking in space. With every movement I was coming to an important conclusion: it is possible to live and work in space.

It was getting hot. I could feel a stream of sweat running between my shoulder-blades. My hands were damp and my pulse rate had increased somewhat. Time was passing. According to the program it was time to return to the ship. I pulled myself toward the gate of the lock, collected the line, and fastened it. This time it didn't get in my way. Then, holding on to the railing with my left hand, I pulled the movie camera sharply toward me with my right. The camera effortlessly wound up in my hand. At that moment I sensed the true meaning of weightlessness. The camera was lighter than a feather, and it would have been just as easy to let go of it without noticing as it would a feather. This disturbed me, and I grasped the camera's handle more firmly. Then I moved my legs from the edge of the lock inside. This required much time and effort, and I felt the sweat flooding over my eyes. It was very hard to hold myself with just one hand. Once I had succeeded, I shoved the camera into the lock and then quickly went down after it. I barely had time to enter the lock before I ran into the camera. It had bounced back toward me after hitting the opposite wall as a result of the shove I'd given it. Once more I pushed the camera away, only this time more gently. Entering into the lock, I checked the trapdoor, the cover of the gate, and I cleared away everything that might have prevented it from closing smoothly. But once again the movie camera drifted up toward the exit and I had to stop it with my legs like a hockey goalie. Finally the latch clicked—the gate had closed. I lay in the lock ex-

hausted, drenched with sweat, and satisfied: the principal task of the flight had been accomplished.

The passageway gate opened and I saw Beliaev's shining face. I barely noticed that the pressure in the spacesuit had dropped and it had become very easy to move my arms and legs. I only wanted to wipe the sweat off my face as quickly as possible. I opened the visor to my space helmet and began to wipe my eyes with my glove. This didn't help—the sweat just clouded over my eyes. Only when I had wiped my face and eyes with a napkin from the ship's first-aid kit did I report, as required by regulations, to the commander on the fulfillment of the assignment.

The flight continued. We went into night, and again I saw the black sky of space, the stars, the ashy moon, and the Earth's massive sphere. The cities at night were like the embers of a dying campfire. And during the day, when we flew over Russia, over its plains, I saw little specks of reflected light dancing along the melting March snow.

We exited from night into morning. We could see how quickly the horizon begins to brighten. A bright red strip surrounds the entire Earth, then turns into orange, the orange into light blue, the light blue through a blue half-tint into violet, and after that the black velvet cosmic sky.

And then the sun begins to rise—large and otherworldly. Above the sun's circle is a red triangle with rays emanating downward. It reminded me of a *kokoshnik*—a kind of headdress that women used to wear in old Russia. This astonishing sight lasted for a few seconds, and then the crown melted away. However, I was able to draw it with colored pencils. (For an artist working in space, colored pencils are the most conve-

nient medium. In weightlessness, liquid paints would run all over the ship.) While in space I had occasion to complete several such drawings as we were orbiting at an altitude of 500 kilometers above the Earth. The crews of other ships flew lower and did not observe this kind of crown on the sun. I continued my visual observations. The sun became smaller and smaller, but also brighter and brighter. On the Earth, Antarctica and the southern end of Africa—a yellowish, light blue continent. In the savannah a large fire was visible. And there was the Nile. I recognized it by its characteristic meanderings and the very sharp borders between the fields on the banks and the surrounding desert. The further north I looked, the wider the ribbon of the Nile and the strip of green fields appeared.

Incidentally, the colored pencils I brought along not by accident! It was thus during my first flight in 1965 that I was able to draw my first sketch in the cosmos. Watercolor in the conditions of weightlessness would have been impossible; the water collects in a ball! It might have been possible to work with oil in principle, but for this a special chamber would have been needed. Otherwise clots of paint might have flown out and landed somewhere unknown—for example, in the instruments! And pastels

Josef Minsky
Requiem to Those Who Have Gone Before

An endless procession of anonymous, space-suited cosmonauts parade down an equally endless corridor. "Space," writes the artist of this painting, "is not only the way to the future, but also to the memory of those who have gone before."

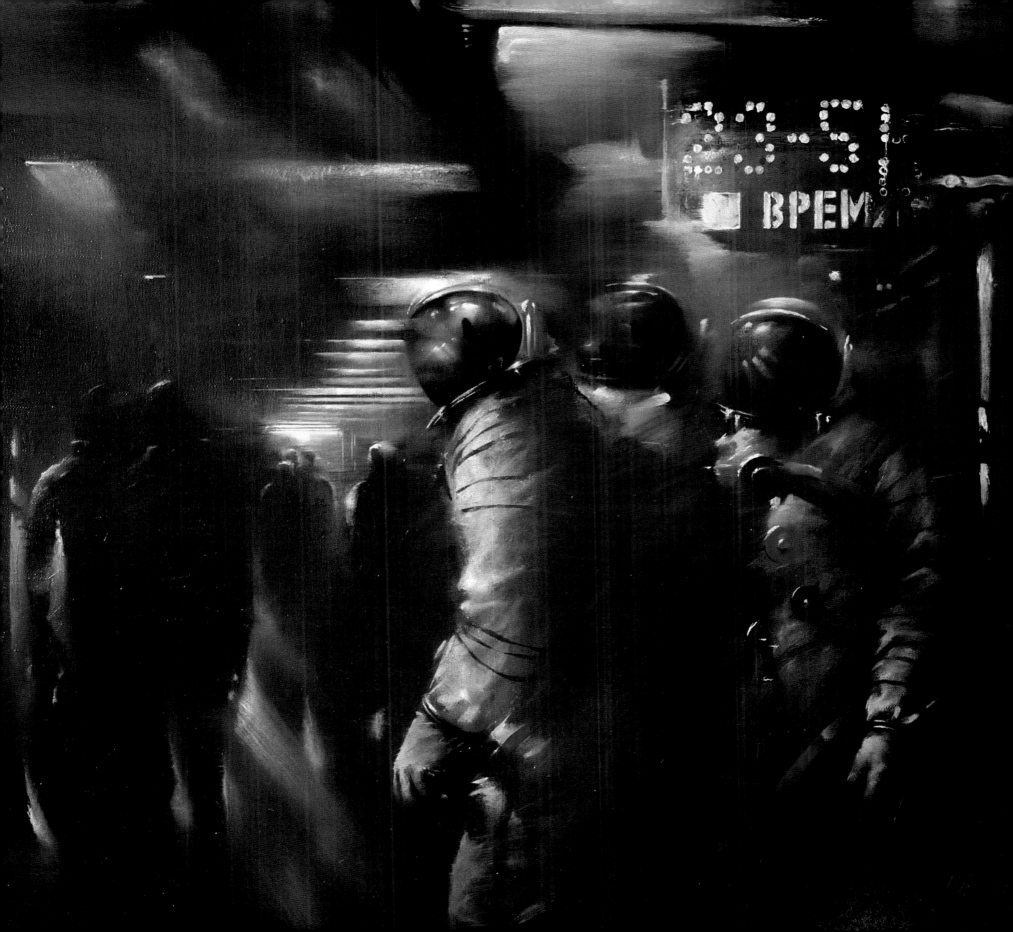

were no good either—too much dust from them. So, while preparing for the flight, I worked out a colored pencil technique.

Art during flight is still unusual. Time for painting in the cosmos is very short. The ascension is very fast (at a speed near 8 kilometers per second), and in orbit the spectator's situation changes rapidly. So my sketches turned out to be only a few streaks and only brief notes to help my memory. For example: "Here the color is dark blue, washed out . . ."

As I observed, I noticed that the colors of the sea were amazingly varied. They depended mostly on the direction of illumination (the angle between the line of sight and the solar direction), and the condition of the water surface (strong waves, ripples, or calm). The depth of the sea and even the color of the ocean floor affected all this. In very deep areas, the color was dark blue. In shallow places, the bottom shown through and lightened the water. For example, in the Caribbean, where the bottom was white sand, the color of the water was absolutely emerald.

The colors of Earth were surprisingly strong. It was saturated with color. An observer on the ground sees aerial perspective, or increasing haziness with distance, because he or she looks through tens of kilometers of the densest air. From space there is almost no aerial perspective, except near the horizon. The cosmonaut is located in a void, with no diffused light around him, and the thickness of the densest atmospheric layers is little more than ten kilometers. In spite of the strong colors, there are few bright, strong greens on Earth as seen from space. I agree with Alan Bean and others that the dark forest greens may be muted by the bluish light scattered by the atmosphere. Again, of course, the direction of illumination played a big role. Depending on this direction, the colors seemed more saturated away from the sun, and more washed out looking against the light.

It takes a spaceship an hour and a half to circle the Earth. During this time the Earth turns several degrees. Therefore every one of our orbits was shifted to the west, and we saw all new views of the Earth.

Another orbit and we were flying above the gigantic continent of America. From our altitude we could clearly make out the Panama Canal—a tiny thread separating two continents. I saw the plains of Texas and the North American Great Plains chang-ing into the forests of Canada. The Grand Canyon of the Colorado River looked like a gigantic ditch. And then there were the Great Lakes. I recognized them right away—they looked exactly as they did on the map. They reminded me of the giant head of an elk. Lake Michigan was its face, and the great blades of its antlers were lakes Superior and Huron.

Probably my strongest impression of the Earth was that it was not so big! It was finite. Earlier, before the flight, Earth had seemed to me endless, although, as I pilot, I had already seen it from great heights. What astonished me most of all was the thinness of our atmosphere, which seems so thick and full of power to the observer on Earth. If a model were made, the air would be no thicker than a film of tracing paper, covering the Earth. Now it seemed so thin, and truly it could be seen that the Earth is spherical—the curvature could be clearly seen.

The Earth, as I saw it from space, was splendid. I could look at it through the porthole for hours without tearing myself away. But the flight's progress was arranged very strictly. We had to prepare for landing. The Earth lay ahead. □

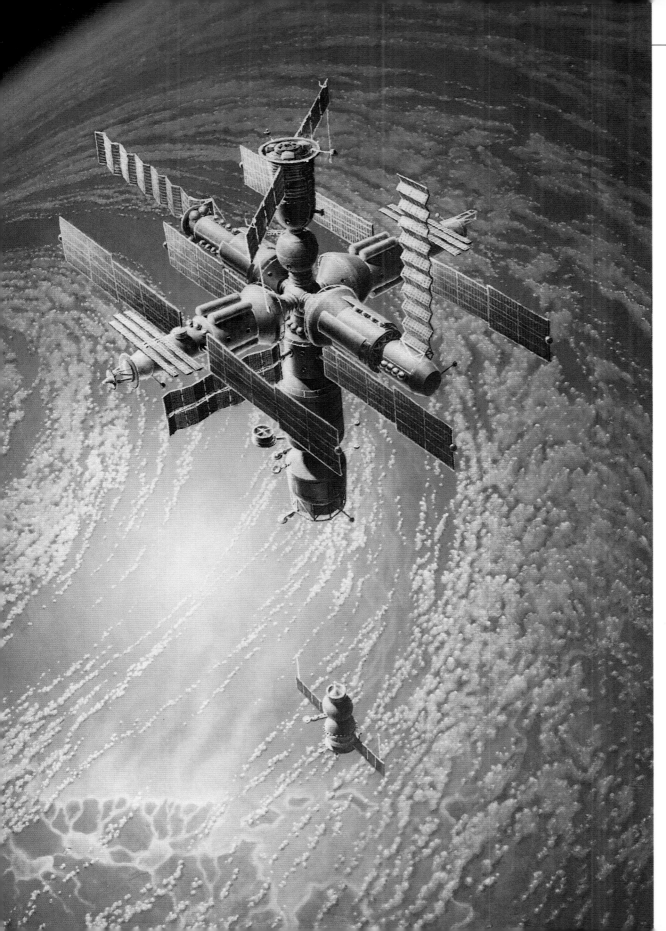

Andrei Sokolov
Mir in Orbit—1992

In this painting, Sokolov looks ten years into the future of the Soviet Mir ("Peace") space station, when it has grown from its simple form of today into a complex of manned modules. On the right is docked a personnel-carrying Soyuz spacecraft, while an unmanned Progress cargo rocket is approaching from the left.

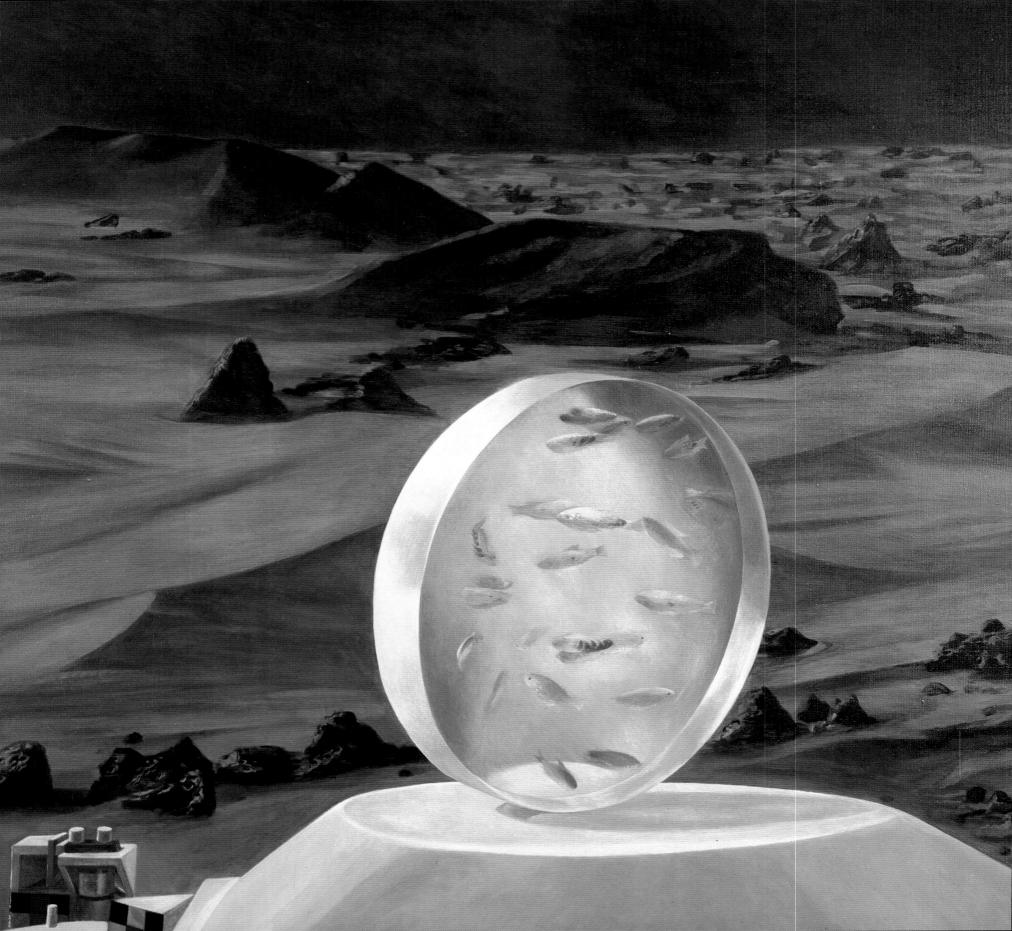

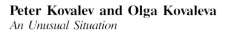

Peter Kovalev and Olga Kovaleva
Experiment

This surrealistic image, left, by Soviet husband-and-wife team Peter Kovalev and Olga Kovaleva combines the lifeless, red Martian landscape photographed by U.S. Viking spacecraft with a symbol of Earth's fecundity. "Mankind hopes that there is life on other planets and that it will be able to adapt itself to space." But who knows what we will eventually find?

Peter Kovalev and Olga Kovaleva
An Unusual Situation

Soviet painters have dealt less than Western painters with specific space missions. This is an exception. "A real-life situation has inspired this painting. In April 1987, the Qvant module failed to dock with the Mir space station. To make the docking possible cosmonauts Romanenko and Laveikin had to make a space walk." (This canvas was painted by the husband/wife team Peter Kovalev and Olga Kovaleva.)

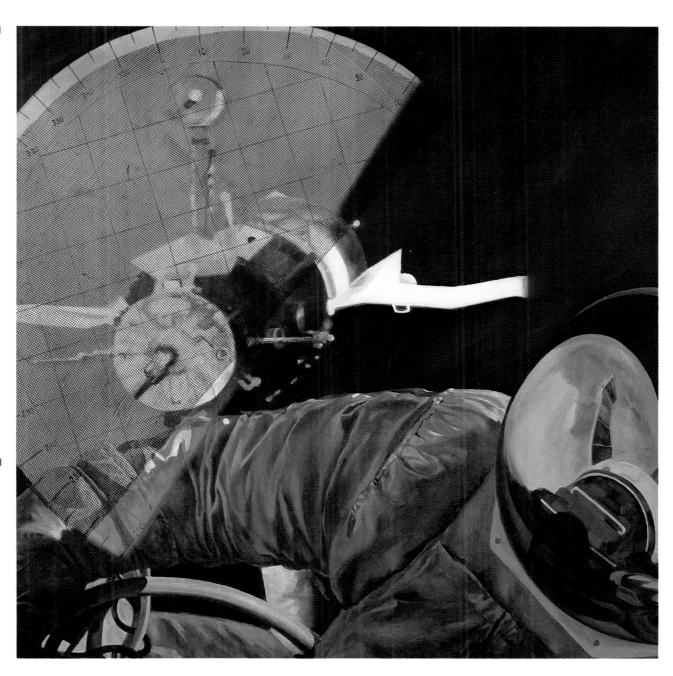

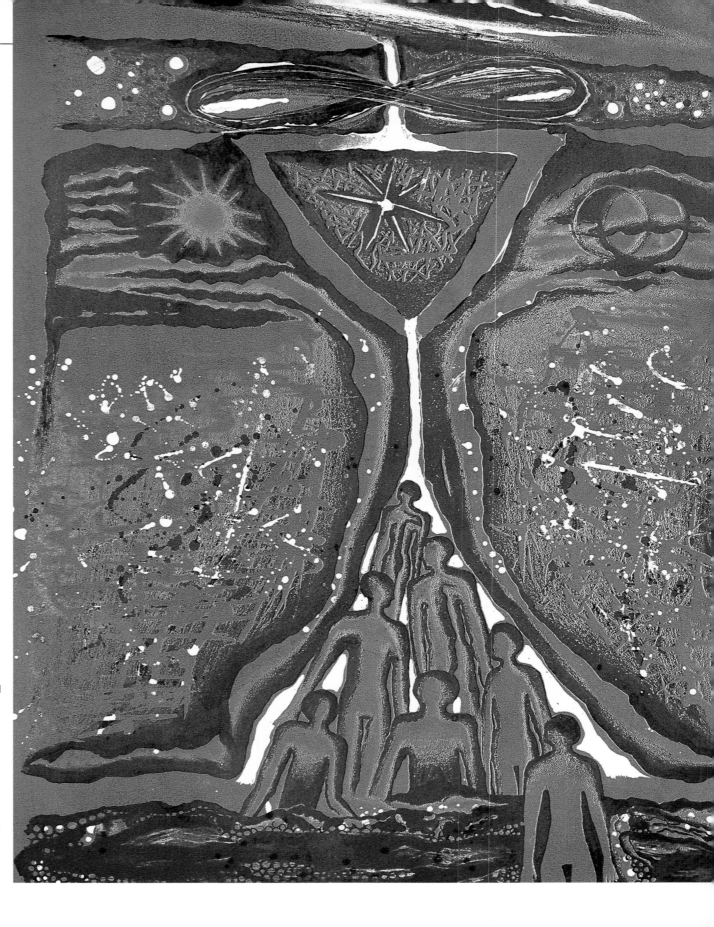

Nadezhda Devisheva
The North Star

"The North Star — *Iol* — is one of the
mysteries of the old Russian heathen
mystery-plays," explains artist Devisheva,
"In them dead people do not die, they fly
away in the form of radiation energy to
the North Star . . . the center of the uni-
verse. The mysterious Iol-star is a station-
ary point in the skies, the mouth of a
funnel, a narrow way into the heavens."

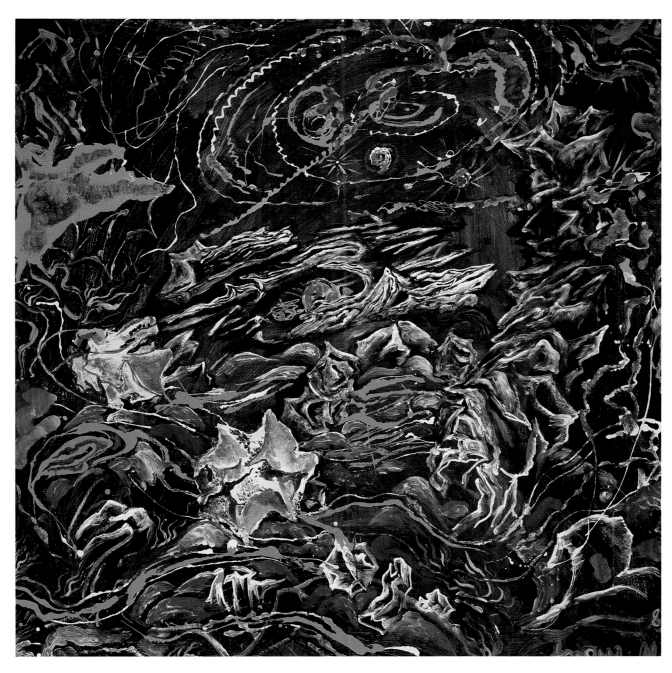

Togrul Narimanbekov
Metamorphosis of the Galaxy

Narimanbekov successfully mixes the images, colors, and stylizations of traditional Azerbaidjan art with his own highly personal style and sensitivities to produce a unique perspective on the cosmos. He mixes his imagery in a swirling maelstrom of bits and pieces to illustrate his idea that the "artist is part and parcel of nature," and that "artistic imagery is inherent in space. Scientists," he is convinced, "may not have yet seen it, but that only means that they should look for it." His improvisational technique may, according to the artist, reflect the creative processes of nature. It "produces unexpected color and plastic effects which, thanks to their aesthetic harmony, may be proved scientifically to be natural phenomena."

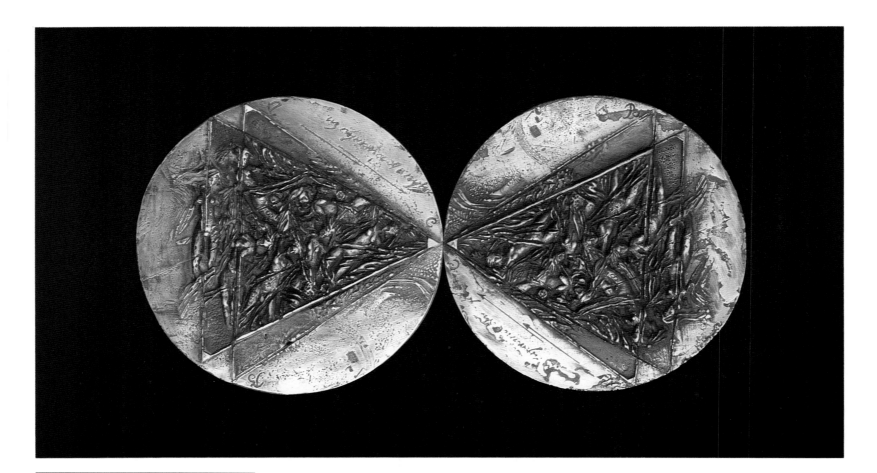

Mikail Skvorzhov
Star Hour

Two sides of a bronze sculpture are shown. "The theoretical sense of space," says Soviet sculptor Mikail Skvorzhov, "is what inspired my work, in which I am trying to show the infinity and eternity of space, its independence from any measurements." The sculpture was exhibited in the 1989 show Dialogs/Starway of Humanity in Moscow in 1989.

Jean-Michel Joly
Terre!

This photo shows a sculpture by French space artist Jean-Michel Joly, installed in a floral park in Nice, France. The sculpture shows Earth and moon at a scale of one to ten million. Joly writes that the installation is intended to convey not only the sense of scale of our planet and its moon, but also the history of life on our planet, thus evoking an emotional response about our whole environment in space and time.

AN ARTIST ON THE MOON

By Alan Bean

WITH WILLIAM K. HARTMANN

We landed on the Ocean of Storms, a broad, rocky plain. Although most of the surface rocks are dark, basaltic lavas, it is worth emphasizing that subjectively the surface looked incredibly bright!

I recall particularly that downsun—with the sun behind me—the gray rocks lit fully by the sun looked almost white against the surface. Jack Schmitt, who landed in the Taurus Littrow mare valley, spoke of mountains downsun giving the place the appearance of a snowy alpine valley.

Probably a major reason for this impression of brightness is that the sky is completely black. We are used to Earthly landscapes where the sky is usually brighter

Alan Bean flew to the moon with the Apollo 12 mission.

than the surface. But on the moon all the light in the scene reflects off the ground, not the sky. In the same way that a dark asphalt parking lot looks bright if you stand under a streetlight at midnight, this surface looks bright.

When we were at the Apollo 12 site, the sun was only 10 degrees to 17 degrees high, and the surface was lit at a slanting angle. Downsun, the rocks and mountains reflect this intense sun back and so they look very white. In between the rocks downsun, I saw a warm, light gray color on the horizontal surface.

But as I turned and looked upsun then I saw a brighter, more brownish gray surface with richer color than downsun. Looking cross-sun, I saw tan. It was so very bright upsun that it almost hurt the eye, even with my best squint!

The richer brownish tint looking upsun may involve an effect known to artists as far back as Leonardo da Vinci. If the shaded

side of the rocks and pebbles gets illumination bounced off neighboring rocks and soil, this multiplies the color intensity on the shaded side even though the shaded side is darker. This is especially pronounced in the red rock canyons of the southwestern U.S., where red light from a sunlit wall reflects onto shaded red rock surfaces; red light reflecting a second time off red rocks multiplies the red. In the same way, the tan or warm tint of the lunar materials may be multiplied as you look upsun, into the shaded sides of lunar rocks.

The lunar surface was very bright, but when I paint the lunar surface, I have to be very careful that I don't paint it too bright. Then it would lose any color intensity and wouldn't look like a lunar surface. I believe that as I stood there on the lunar surface and looked around, I knew I was looking at sunlit, dark gray material, and so my eye could see it that way. But if I had not known in advance that these were dark gray materials, I don't think it would have been possible to say what color the soil was, because the light reflecting off it was so intense and washed out. As an artist, when I paint the moon, I adjust the values to make the moon look like it appeared to my eye.

Alan Bean
Fast Times on the Ocean of Storms

"I felt strong!" astronaut Bean writes of his lunar walk. "When I pushed off with one foot, there was a long pause till landing on the other foot, like running in slow motion . . . I seemed to float just above the surface. I was always in a hurry to get to the next exploration site, because, like so many things in life, there was so much to do and so little time to do it."

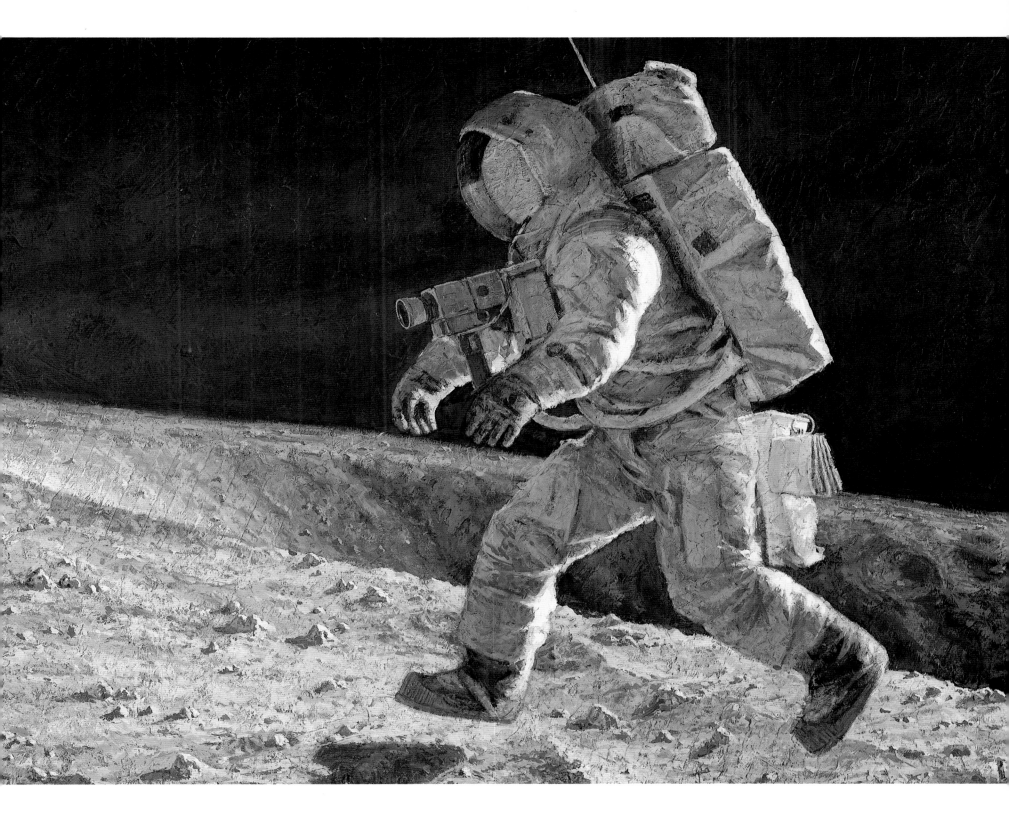

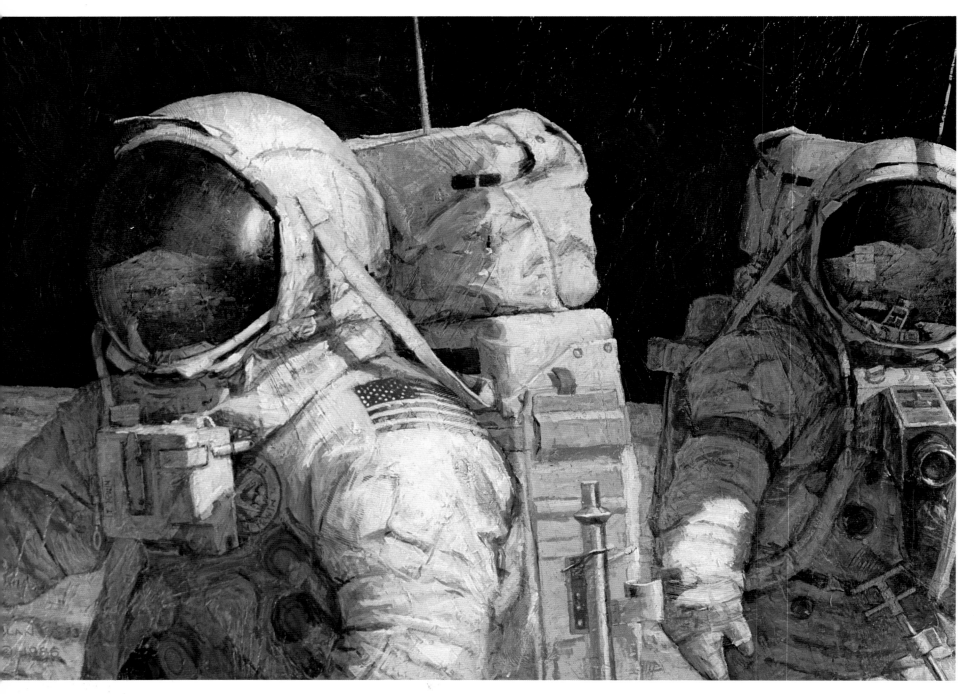

Alan Bean
Conquistadors

"When the conquistadors came to the new world, they used their society's highest technology," says Bean. Here humans use their highest technology to visit another "new world."

It's important to remember that we landed in the so-called mare, or lava plains, and I didn't see any uplands on my flight once I was on the surface, so I can't make any direct comparison of the colors of the dark plains and the brighter upland surfaces.

The biggest and most interesting color difference I noticed had to do with sun angle. The first time I got out on the surface, it was under a fairly low sun, maybe 10 degrees, and the whole lunar surface, every rock I picked up, seemed to be gray. When I got out the next day, which was maybe twelve hours later, I picked almost the first rock I saw, and said to myself, "My goodness, here is a tannish gray rock; I

didn't see anything like this the other day." I walked a little further and grabbed another one; I hadn't seen anything like it, either. Then I realized that *all* these rocks were tannish gray. The same effect that I mentioned seeing from orbit was at work: as the sun angle got higher, the rocks took on a more tannish or more brownish or warmer appearance.

I've been talking a lot about color and value, but I want to describe *texture* of the lunar surface, too. I would advise a painter not to make the surface look as smooth as a fresh snowfall. Some areas of the moon are silted with smooth dust, but the general impression is one of rocks and craters. Little craters, big craters, little rocks, big rocks—the surface is very rugged. Often I'll see paintings of the lunar surface looking almost like a billiard table with craters with circular rims dug in the middle of it. That isn't the way the moon really is. The moon's craters are a result of lots of meteorites running into it. And each time a meteorite hit, it would tear up some smaller craters, or parts of big craters, and throw dirt on some littler ones and then the next meteorite would hit and partially fill up the first crater. So up there, the terrain has a generally rolling quality, but it is very uneven.

Study a lunar photograph and you'll see that the outsides of craters aren't at the same angle as the insides of craters, and this crater's side runs into that crater's side. It has a strange, non-homogeneous look. It was always being jumbled about. I think that's the biggest mistake people make when painting surfaces where there were a lot of impacts. They make it look as if someone ran a grader over it several billion years ago and then people knocked little holes in it. But that isn't the way it is.

Lunar soil banks against things, particularly rocks. Almost all the rocks had a little fillet down at the bottom where soil had been built up near it. Now, I don't think any wind blew the soil over there! I think what happened is, over the centuries, little meteoroids hit the rock and the pieces of dirt from the little craters on the rock flew off, and slid down and made the little fillets.

In a related vein, Gene Cernan remarked to me once that he thought lunar rocks had rounder edges than most rocks we see on Earth because of the erosion caused by the little meteoroids hitting them.

In Lunar Orbit

If you look at lunar surface rocks in a museum on Earth and compare them to terrestrial rocks, you'll find they are generally rather dark, reflecting around 8 to 15 percent of the light, like lava on Earth. But most Earth materials are brighter: granite and sandstone may reflect around 20 percent, sand around 30 percent, and snowfields around 50 to 90 percent. Therefore, you might expect the moon to be a dark, foreboding place, at least as you get close to it.

In spite of this reasoning, the moon looks extremely bright from orbit. It was especially bright in certain spots, and as you look down from orbit, some peaks or surfaces would give you a direct glare from the sun (seeming to reflect at an angle equal to the light's incidence angle). Those didn't reflect like metal, but they certainly looked as white as snow. I don't think a painter would want to paint them like snow, though, because then it makes the planet look cold. As

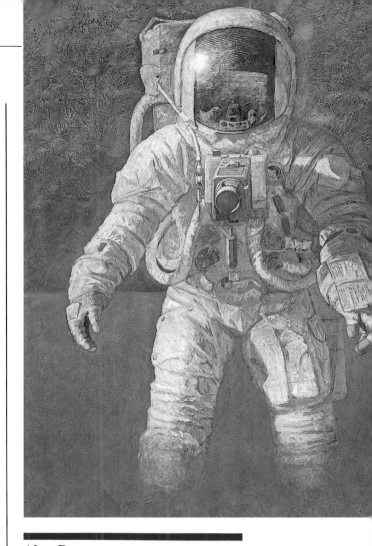

Alan Bean
That's How It Felt to Walk on the Moon

"I've tried a lot of words over the years, but I don't think I've ever completely expressed my feelings about that incredible experience," the artist writes. When Bean initially completed this picture, he set it aside for several months, studying it every day or so, and eventually reworked the colors. "A new vision emerged that elicited happier and more exhilarating thoughts and emotions, ones closely related to how it actually felt. This is that painting."

a result, I think that painting it even a neutral gray is not a good idea. It should be shaded more to the warmer yellows or oranges or reds, to give the feeling it's hot down there, which it really is. From lunar orbit, the moon appears fairly uniformly gray at any sun angle. At low sun angles, it's almost neutral in color, while at higher sun angles, the surface becomes a little more tan. There are lights and darks, of course, because of craters and mountains and the like, but still it stays about the same hue.

Now when you're in Earth orbit, there's a lot of difference in color below you; you can see all the hues you can think of. They're all tinted toward blue, though, because you are looking back through the atmosphere that scatters the blue light. The oceans are mostly blue; the clouds look white but if I had held up a white piece of paper next to them, I think I'd have said they were a little blue-white. Then if you look down at Florida, let's say, at vegetation that's green, it *looks* somewhat blue-green. Deserts are a dull yellow, or perhaps a greenish yellow.

This overall blue cast also harmonizes all the colors, and that makes a lot of difference. It's a very pretty sight.

Another effect that's pronounced, at least from a distance, is that when I looked at the Earth, I could faintly see a specular reflection point, from the sun. After all, the Earth is a wet and shiny sphere. On the other hand, if I looked at the moon, no matter where the sun was relative to the moon, I didn't see this point. We all know that the ancient Romans thought that the moon was a shield and never imagined that it was a sphere, because of the way the light backscatters from the edges almost as much as from the middle. In the full Earth, if there were no clouds or atmosphere, I suspect that you would see some darkening toward the edges—an effect you don't see on the moon. However, the Earth does have clouds and atmosphere, of course, so that the edge, or "limb," of the Earth is generally brighter, because you are looking through more atmosphere, haze, and clouds in the line of sight to the surface.

I've seen paintings of the Earth where the Earth looks flat because photographs of the Earth look flat. I think an artist would begin that way, and then since I would still want the Earth to look round I would do some darkening near the edge away from the sun, and maybe paint it slightly brighter right in the center—not cheat too much, but use some artistic license to make it look spherical.

Impressions While Flying to the Moon

I've been asked about visual and other impressions of the flight to the moon. People are especially interested in what one would see during the firing of the engines—whether it made a visible glow or illuminated surfaces of the spacecraft. Unfortunately, I can't give a good answer because every time we burned the engines, I had to be watching my dials and gauges to make sure everything was going okay! In the event some other problem arose during the burn, I had to be ready to do something about it, so it wasn't a time when I could just look out the window and observe.

However, had there been a drastic value change out the window, I imagine it would have attracted my attention despite the instruments. My feeling about the engines, therefore, from looking at the photographs and discussing the question with other astronauts, is that the engine exhaust is not luminous; however, if you happened to be looking right up the bell of the service module (or the Lunar Module when you are orbiting the moon), then you would see the inside of the bell lit up bright and orange. But this would not be the flame itself. You'd be seeing the metal heated up and glowing.

During the landing on the moon, there was no glow at all from the engines illuminating the surface. The sun was too bright on the surface for the engine to affect it. And of course the dust didn't billow up, because for dust to billow, you need an atmosphere. On the moon, with no atmosphere, fine grains of volcanic dust are blown away from the engine like little projectiles. The effect is more like a sheet of water out of a firehose that goes straight down, hits the surface, and then sprays out. These particles travel radially out from the lander, about a foot or less off the surface. (I estimated this height against lunar surface rocks that stuck out of the spray and remained stationary.) In fact, one of the techniques used by Pete Conrad and other astronauts while landing on the moon was to avoid concentrating on this radial movement of soil away from the descent engine, and try instead to pick out big rocks that didn't move. If you watched the movement of the dirt going away from you, you felt like you were going backwards and there was an irresistible instinct to make a control adjustment to correct this. That's not a good thing to do! So, Conrad and other astronauts making the landing had to look at the rocks that were sticking above this surface movement and watch them to

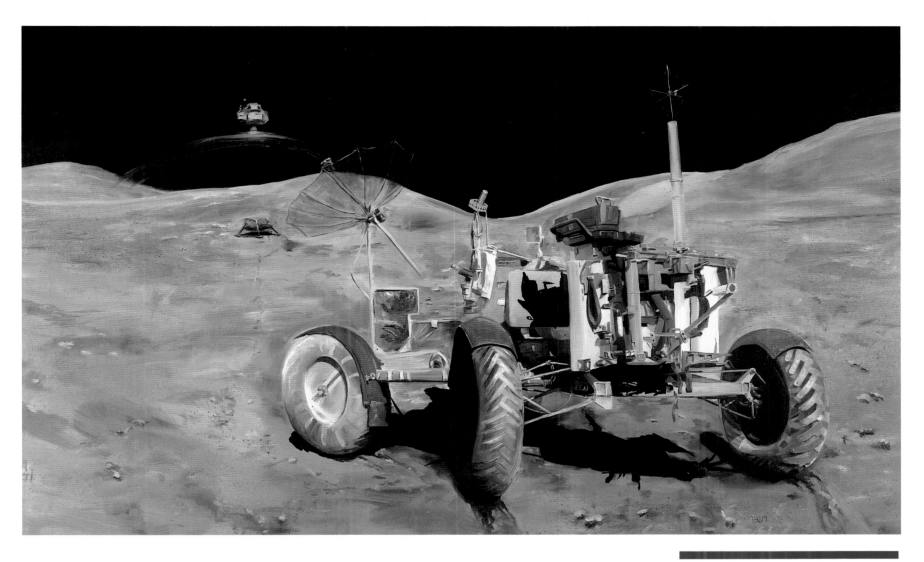

get a good reference to set down.

During lift-off, I didn't see any dust being sprayed out. There probably was some, but not quite so much, because the descent-stage, which remained on the surface, was in the way. The most notable aspect of lift-off from the moon was that the ascent engine blew a lot of the foil off the descent-stage and this could be seen from the lunar module. When I looked down, there were little pieces of silver, orange, gold, and black radiating in concentric cir-cles out from where we were rising. It re-minded me of dropping a rock in a pond. It was quite beautiful and it appeared that we rose out of the middle of it. I did a painting that shows this, at least a side-on view, called "The Eagle is Headed Home." There are also several pictures taken from the Rover TV as Apollos 15, 16, and 17 launch from the moon, where you can see all these bits of foil looking very pretty as they blow away from the descent-stage. From the van-tage point of the rover TV, of course, it

Tom Hunt
Last Step

This view of the blast-off of Apollo 17 from the moon in 1972 is, in the artist's words, "a fond farewell to an exciting time." The rover's TV camera sent back live pictures of the last lunar blast-off.

doesn't look concentric.

People also ask about sound. During an engine-firing maneuver in the landing module, you don't hear a noise like a normal rocket engine. There is kind of a "thump" sound when it starts. I'm not sure where it comes from, whether it's the valves slamming or things inside the spacecraft settling—things that had been floating a few inches off the surface in a bag or on a shelf. But I heard a thump, followed not by a loud roar but by a faint buzzing sound. I don't know whether it's the fuel flowing to the engines or some sort of electrical drive to the service module (it has electrical drive and so does the ascent engine), but you have to listen carefully or you won't hear it at all.

The same thing occurred when the SIV-B was burning and sending us to the moon. There was a little buzzing, whining sound off in the distance and I could feel the acceleration. So, engine-burning in space is a "thump" and then just the feeling of pressure on the body. There's not much in the way of sound that accompanies it.

General Thoughts on Painting Space Missions

When we talk about actual observations in space and how an artist might portray these sights, I personally believe there's no single answer. Each artist decides how close to the actual sight he or she feels the art should be. I think this is the key question in any art. First you have to understand exactly what *is* true for a situation, or what you see as true, and then decide in your art how close to adhere to that truth. Do you make a distant object *exactly* the right size? Do you give it *exactly* the same hard edge? Do you make it *exactly* the same value? The same color? Do you make it *exactly* like it was? Or do you make it what you consider more artistic, or beautiful? Or more interesting? Or more dramatic?

These are the questions that the artist has to ask, all the time. I believe this is the primary reason art from different people looks so different. Everybody has a different answer to those questions. I personally believe there is no right answer to those questions, because in art in general there is not a "right" answer. Any painting will show only how that artist wants to portray a subject, how he or she feels about it. An observer of the painting can either connect with that and like it, or not connect with it and not like it.

That's how art is different from science. As we know, in science everyone should be able to repeat the same experiment about gravity or electricity and get the same results. But in art you don't want the same results. You want your own feeling for it.

Paul Hudson
Lunar Utility Vehicle

This painting depicts a design concept for a small vehicle allowing future lunar explorers to fly to remote scientific sites or even to rendezvous with lunar orbiters.
(Concept by Boeing space station designer Brand Griffin; © Time-Life Books.)

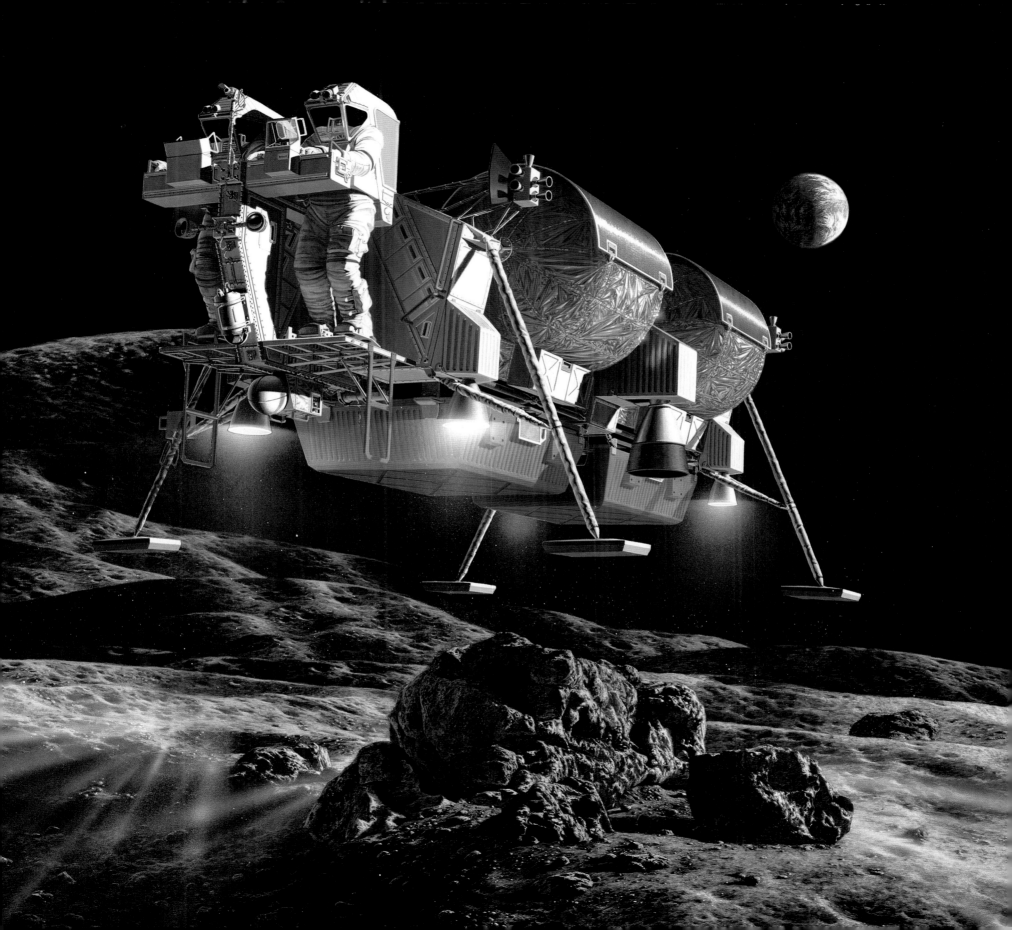

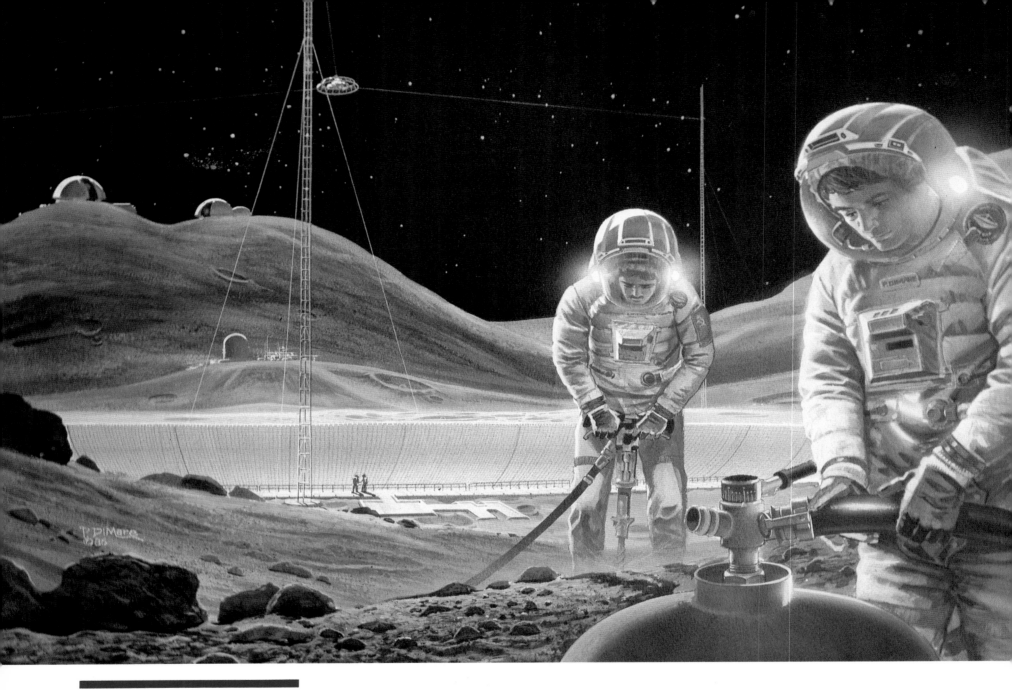

Paul DiMare
U.S./U.S.S.R. Radio Astronomy
Observatory on the Moon

One scientific goal for a lunar base would
be to construct a large radio telescope on
the radio-quiet far side of the moon, free
from interfering transmissions from Earth.
Here, a Soviet-American team has con-
structed a giant radio dish, taking advan-
tage of the bowl shape of a lunar crater.

Responses to the Lunar Experience

One of the biggest problems that I struggled with when I turned to painting the moon was how to deal with the lunar gray tones. I decided to find out what colors other astronauts perceived in the lunar surface, so I read all their mission reports and made a table of what each astronaut had to say about color. I had categories on the sun position, low sun, general surface, high sun, disturbed surface, rocks, distant objects, and other observations. I got data from Apollos 11, 12, 14, 15, 16, and 17. Then I talked with Neil Armstrong for 11, and Ed Mitchell for 15, Dave Scott for 15, John Young for 16, and Gene Cernan for 17. I got some additional comments from each of them and verified roughly what I already had. For instance, Ed Mitchell said the surface was grayer cross-sun and browner upsun and downsun. He also pointed out that there was a bright halo around the shadow of his own head. It appeared two or three inches wide with a slightly darker edge around the bright halo. You can see it on Apollo lunar surface photos where the photographer's shadow is present. It is due to a strong backscattering called *heiligenschein* (from German for "holy glow," after the glow painted by medieval artists around saints' heads). On Earth, the heiligenschein shows up only on certain surfaces, such as porous dust, or a grassy lawn, especially with dew drops on

it. The lunar dust shows this effect very prominently.

When I talked with Neil Armstrong, he mentioned that when he got back from the moon, *National Geographic* sent them a variety of NASA photographs with different color processing for them to select a color. The remembered the moon as a sort of brownish tan downsun, a darker brown upsun, and a gray-brown cross-sun. So the color in the December 1969 *National Geographic,* he felt, was pretty good. He said there was a sort of violet-brown gray cross-sun. So again there is some agreement and some difference, just as there would be here on Earth.

Gene Cernan once said he felt that when you're looking at something so bright and neutral, it may be saturating your eye in such a way that you're not able to keep your "zero reference" and identify true colors. He said that what was needed was a color chart with different color grays printed near each other: a greenish gray, a violet gray, a brownish gray, a yellow gray, etc. Then you could make a better judgement. The Soviets have used similar charts to judge Earth colors from their space stations. (See Sokolov's article.)

After I had finished making my chart of various astronauts' color and value estimates came the most difficult consideration— how to paint what my fellow astronauts and I saw. In my first few paintings, I picked some of these grays and painted the moon with them, and, sure, I could make it look like the moon—fairly gray—but it also looked fairly boring. Then I would paint an astronaut in there with a white suit on. When you've got those two items together, a dull gray terrain and a white astronaut, you haven't got a very exciting painting.

I had to make a choice. Was I going to paint these paintings as an astronaut-engineer-scientist would do it, literally following my chart, or was I going to paint this adventurously, as an astronaut-artist would? These are two very different philosophies.

I decided to do the painting in such a way that a viewer who looked at it up close would see all sorts of beautiful colors in it; but from a distance, the viewer would perceive astronauts in white space suits on a gray surface. However, to provide artistic variety and richness, I would also shade one painting to the green and another to the orange, and another maybe to the violet. I would key the painting artistically, yet I hoped that if I asked a viewer what color the moon was, he'd decide it was gray. Once I made this decision, I could go back in and play with the color tones, cooling the shadows with green or violet, for example. I could fool around with the white of the suit, give it reddish orange or yellowish orange tints, and maybe add still other colors in there.

An important consideration here is that in a painting you're dealing with relative things. For example, with a pure neutral gray surface, I can't come in and make a white suit colorful. It will look funny, not like a white suit, but like a suit of many colors. But if I give the surface some color— then I can make the white suit have many tints, and somehow the whole thing reads right: "white suit, gray surface," even though there are all these other colors in there. It's a subtle thing. Above all I want my paintings to suggest accuracy but be beautiful to look at.

I'm a big fan of Monet, and friends have asked me how Monet affects my methods of painting lunar or other scenes. Monet

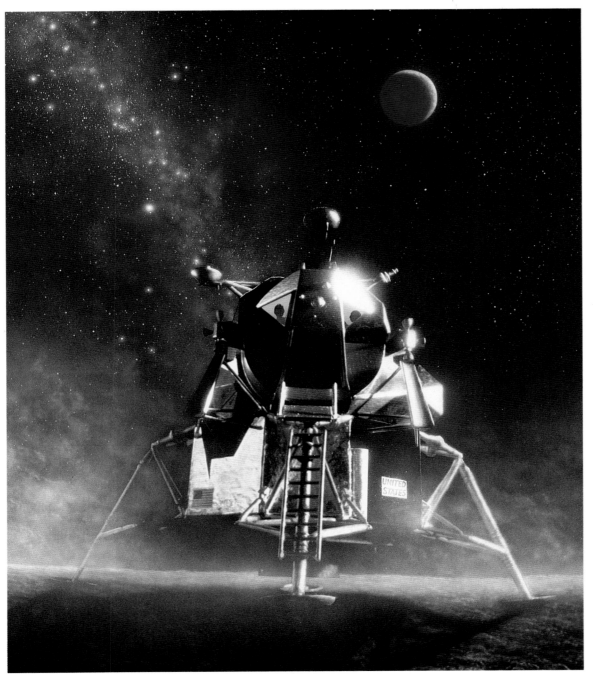

Julian Baum
The Eagle Has Landed

Amidst the settling lunar dust, the Eagle stands like a shimmering jewel in this mixed-media piece. Above hangs a crescent Earth, and intersecting the land is our Milky Way galaxy's ghostly swath of stars, symbolizing our continuing aspiration to explore.

was the one who looked at straw-colored grainstacks and painted them with every color there is on the palette. The grainstacks still look like grainstacks, but they've got all these different colors in there. I'm sure that nobody on Earth has ever seen a grainstack that looked in real life quite the way he painted them. But Monet said, "As an artist I want these grainstacks to be more extreme in color than they are." So he painted them that way. Now I'm not that extreme in painting the lunar surface, but I do try to go somewhere between plain, dull gray and what Monet did to a grainstack.

I feel that the artist's job is not to reproduce nature so much as to make something beautiful and memorable and exciting that pleases the artist's soul and connects to other people. We may fall short in what we attempt, but we can keep trying.

I've also been influenced by Monet's brushwork. I've tried to have the variety of little brushstrokes and be as casual about colors and brushstrokes as Monet, but it doesn't seem to work on my paintings. It may work in areas of soil and rock, but I find if I try to paint a camera, for example, with casual strokes it comes out like a bent and dented camera! Then it begins to look like a lack of craftsmanship in the painting. I find there is a certain tradeoff between

what things I can make impressionistic and what things I have to keep fairly realistic. With any piece of metal, like a core tube or a camera or parts of the lunar module, if I get too casual about it, they don't look like precision metal parts anymore. The lunar surface itself, however, provides much latitude for experimental and impressionistic techniques.

I've been asked whether my love of Monet had any effect on the way I actually perceived the moon when I was there. I don't think it did. I was a true astronaut-engineer-scientist in my approach and in my reporting. However, when I was making the table summarizing each astronaut's observations, I realized that my reporting had more comments about colors and shadows and things like that than anybody else's in Apollo, not because I was smarter than anybody else (because I sure wasn't) but, I think, because those kinds of things just interested me more. That is the same interest that made me become an artist. Other astronauts also had special interests or patterns of responses. For example, Jack Schmitt, on Apollo 17, made more comments on rock shapes and positions because he was interested in geology. It just depends on the person. I think to some degree being interested in art made me observe different things.

As for an overall aesthetic response to the lunar surface, I believe the words Buzz Aldrin used, "magnificent desolation," give a perfect description of the moon and certainly seem to be consistent with what we all saw. It's beautiful to look at and it's an amazing place that's not at all Earthlike. I never for a minute thought I was somewhere on Earth. I always felt I was on another world, and it wasn't just because the

Yuri Pochadaev
Phobos

This painting was done to celebrate the brave but ill-fated pair of Phobos spacecraft that were sent to Mars by the Soviet Union in 1988. This was one of the most ambitious undertakings ever attempted in the USSR's unmanned planetary exploration program, and the Phobos spacecraft was among the most sophisticated. Unfortunately, one of the probes was lost when a computer error shut it down, while the other stopped transmitting after it had achieved Mars's orbit but before it had begun its primary goal of exploring Phobos. It did, however, transmit back to Earth a great deal of valuable and new information about both Mars and its moons.

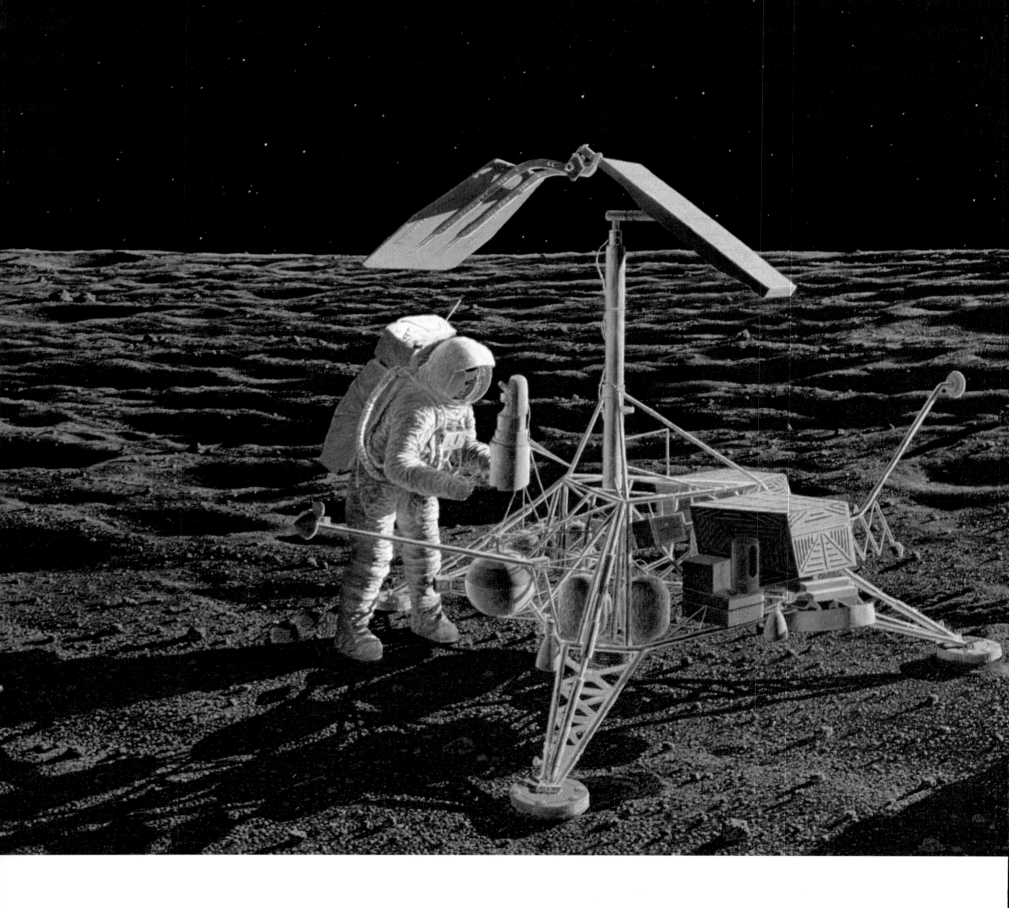

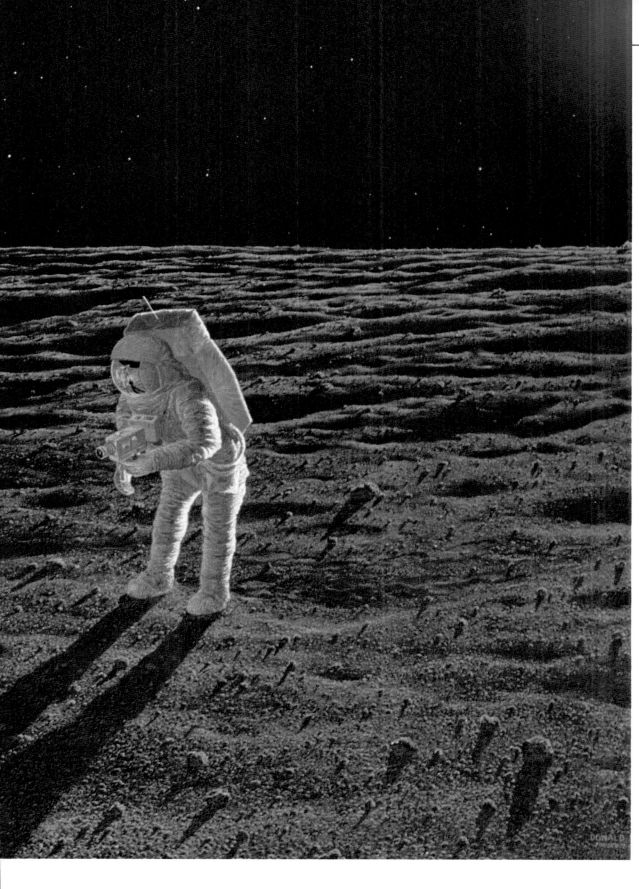

sky was black instead of blue. It was an otherworldly place.

At the same time, I've been to places on Earth—for example, the Grand Canyon—that I thought were a lot more amazing than the moon, at least in terms of the topography, the outcroppings, the color variety, and the different angularity and fracture patterns shown by the rocks and shadows. Certainly if a person went to the Grand Canyon and walked down to the bottom and looked around, it's a more amazing sight for those reasons than the surface of the moon. At the same time in the Grand Canyon, I feel I am on Earth . . . in a beautifully strange earthly place, and this feeling is different from being on the moon.

So aesthetically, I believe that paintings of these unearthly landscapes should be beautiful and rugged but they shouldn't look like Earth, because I don't believe that these places do. I've noticed a lot of astronomical art that looks too Earthlike. I believe that, as artists, we need somehow to learn not to do that. It's hard because Earth is all we really know, and certainly most of the paintings we see are Earth paintings so it's hard to get away from that. I'm not sure I do it either but I do try. I look at my surfaces and if any surface is parallel to an adjacent surface, I try and go back and change one or the other.

Don Davis

Apollo 12 Astronauts Examining Surveyor III

In 1969, Apollo 12 landed about 600 feet from the Surveyor III robotic probe that had landed on the moon in 1967 during pre-Apollo reconnaissance. Here, Alan Bean and Pete Conrad inspect the Surveyor.

Pierre Mion
Apollo 11 Lift Off

The Apollo 11 ascent stage carrying Neil Armstrong and Buzz Aldrin blasts off the moon to join Michael Collins in the orbiting command module after the first human lunar exploration. Lanes of disturbed soil will forever show the paths created by the lunar pioneers.

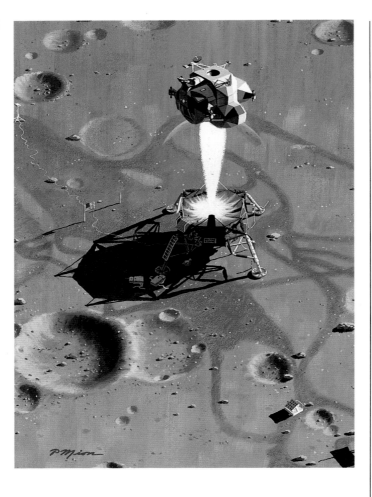

Another aspect of the surface I noticed was that the bootprints appeared lighter than the surface itself. I think that's because the boot compresses the soil and flattens the rough surface texture. Then the sun reflects with less randomness. The material doesn't change color at all; it's just that it is now packed down and able to reflect the sun more uniformly. But mixed in with these bright bootprints is another effect, particularly if you look upsun or cross-sun. There are usually some shadows in the bootprints that are caused by the original surface adjacent to the footprint. This gives it a somewhat broken up look from almost any direc-

tion. All this is true with the Rover tracks as well.

If there is any evolution in my lunar surface paintings since I started, it may be an increasing effort to break up surfaces to depict this variety of values and hues. This gives a more realistic, rugged look and a less machine-made quality to the surface—as if there's a smooth surface that has been carefully struck by a crater and over there is a nice neat rock. I think it's easier to paint neat, tidy craters and neat, tidy rocks than it is to paint realistic random craters and realistic strange-looking rocks. I believe I'm learning to do the other better. When I look

back at my earlier paintings, I see a more mechanical, harmonious moon, and the later paintings are a lot more rugged. Even the footprints add to this effect, breaking things up. There are more footprints around in the later paintings, and everything is broken up. You might say that doesn't reflect a change in artistic purpose but rather the fact that I'm able to see that my first paintings were too neat and smooth. When I painted them they seemed right, but not now. I suspect that ten years from now the ones I'm doing now will have some other characteristics that I'll think need to be refined. It's not necessarily that the first ones are worse than the later ones, but rather the way I see the painting now is certainly different from ten years ago. I'm very careful to go back and study actual Apollo photographs frequently and just look at my work and compare them and see if they are drifting apart in any way. I think it's possible for that to happen if I'm not careful.

Just to emphasize that not everything is settled about how to paint the moon, let me mention differences of opinion about the sky. When Gene Cernan came over, he mentioned the sky as a stark flat black. I remembered it as represented better by a deep, varnished glossy black. He didn't remember it as looking this way at all. So there may be many individual views of the moon, and that is the way art should be. □

This article was developed from a list of questions prepared by W.K.H. A.B. taped his response, and the tape was transcribed and edited into an annotated interview format by W.K.H. We then concluded that the material should be further edited into an article format, and this was done by W.K.H. with A.B.'s final approval. Generally, we tried to preserve the original informal, conversational style of the original interview responses. Our aim was to record sensations of color, general landscape appearance, and relative "values"—the artist's term for shades of lightness and darkness—by an eyewitness trained in artistic perception. —W.K.H.

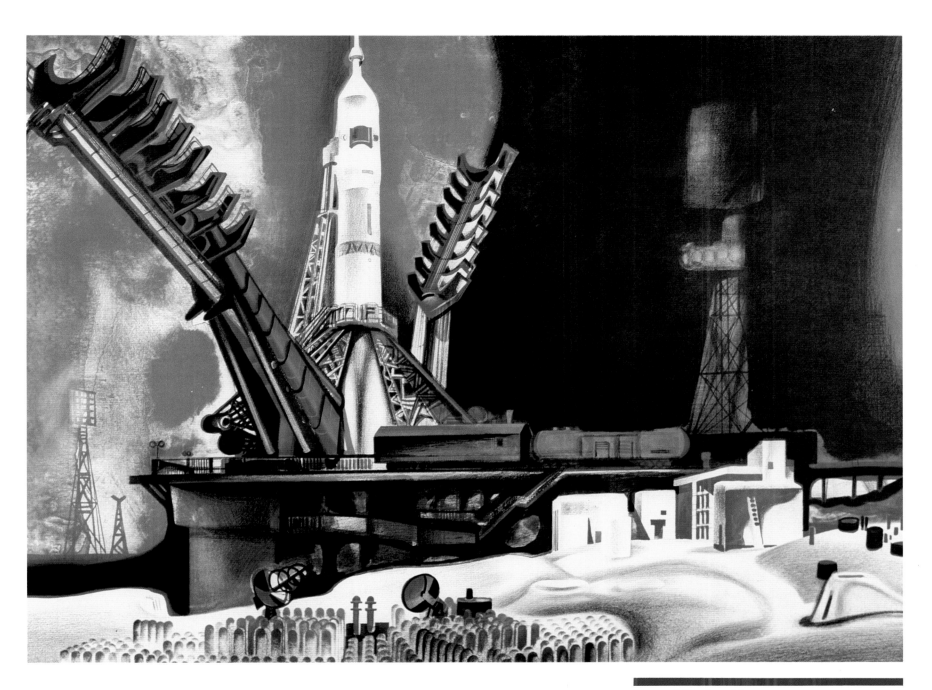

Georgii Poplavski
Countdown

Only moments before launch, this lithograph shows
a massive spacecraft about to transform the snow-
bound Russian landscape with a storm of fire.

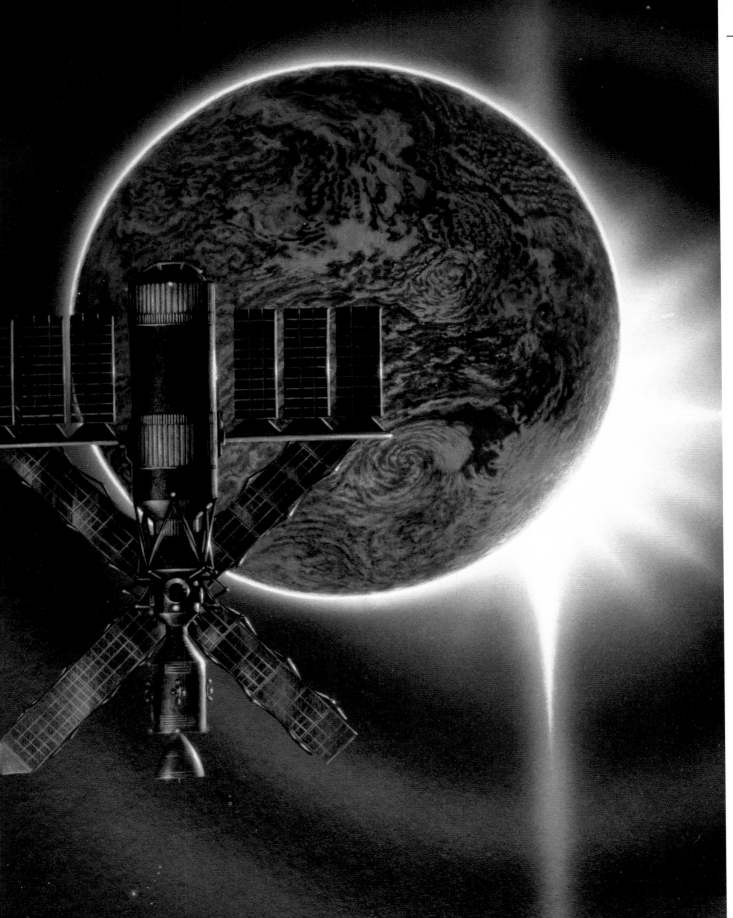

Kelly Freas
Skylab

The painting at left was adapted from the design the artist had created earlier for the crew insignia on Skylab 1, the first American space station. The use of the outline of Skylab in the illustration emphasizes the shape which, in silhouette, mimics old Norse runes that translate to mean "the family of man."

Vladimir Arepiev
It Was an Ordinary Morning

"In my paintings," writes Soviet painter Vladimir Arepiev, "I only try to touch the problem. Sometimes I am slightly ironical, sometimes sad—but more often I am wondering how real life seems to create a painting in such complicated ways." Some of Arepiev's irony is illustrated here, at right. It might be an ordinary morning on the moon, but for a human to walk there is still an exotic experience.

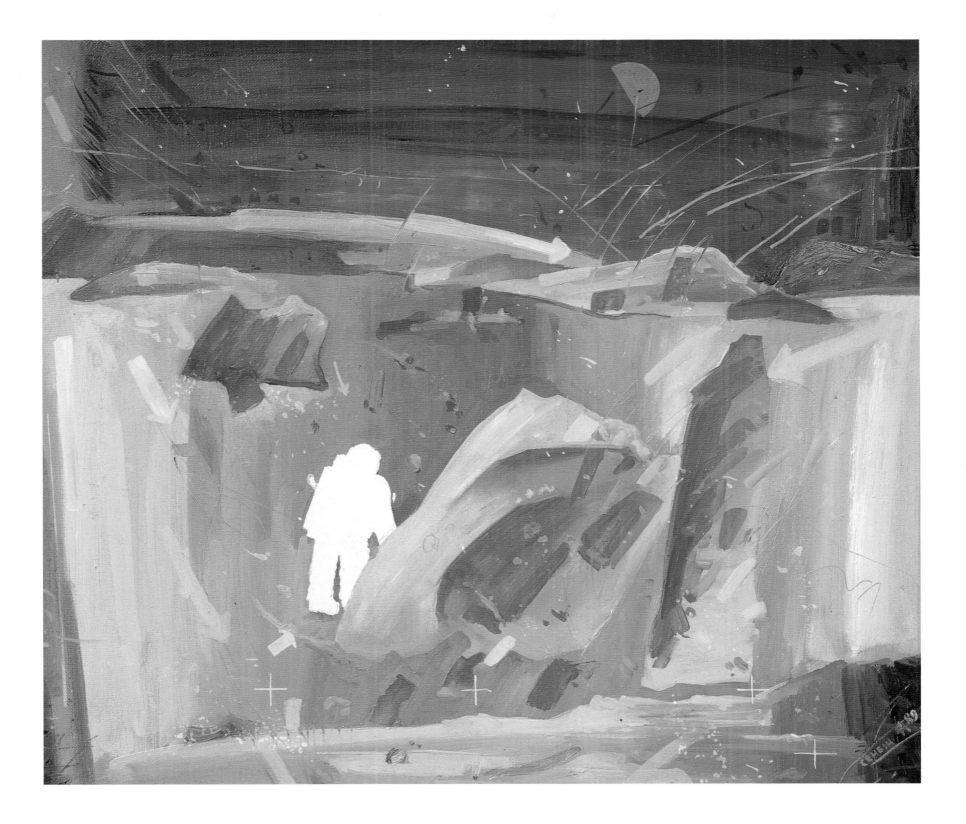

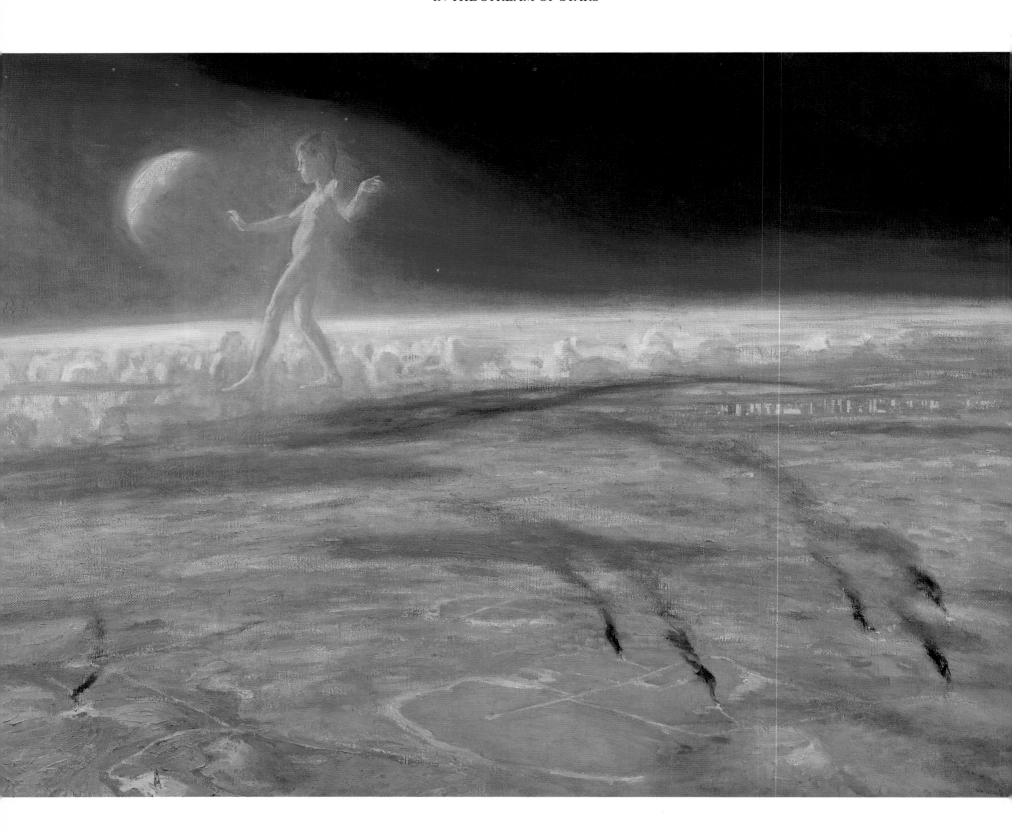

Boris Okorokov
The Milky Way

Okorokov has created a simple image with a disturbingly simple message. Mankind—in the form of a graceful child—is walking a tightrope suspended between the clean, unpolluted heavens (the hazy moon, just beyond his/her grasp, leading the child on) and the dead or dying Earth below.

Okorokov's concern for the future of our planet, and the idea that the answers for that future lie in space, are common themes among Russian space artists.

Ron Russell
Dominus Illuminatio Mea

This painting in lacquer on glass is a representation of the relationship of planets to the universe, with religious overtones. The artist speaks of the "romantic/symbolic" content of his work, which attempts to go beyond the realistic in evoking a sense of the spiritual side of the universe, and humans' reach for "the experience of beauty."

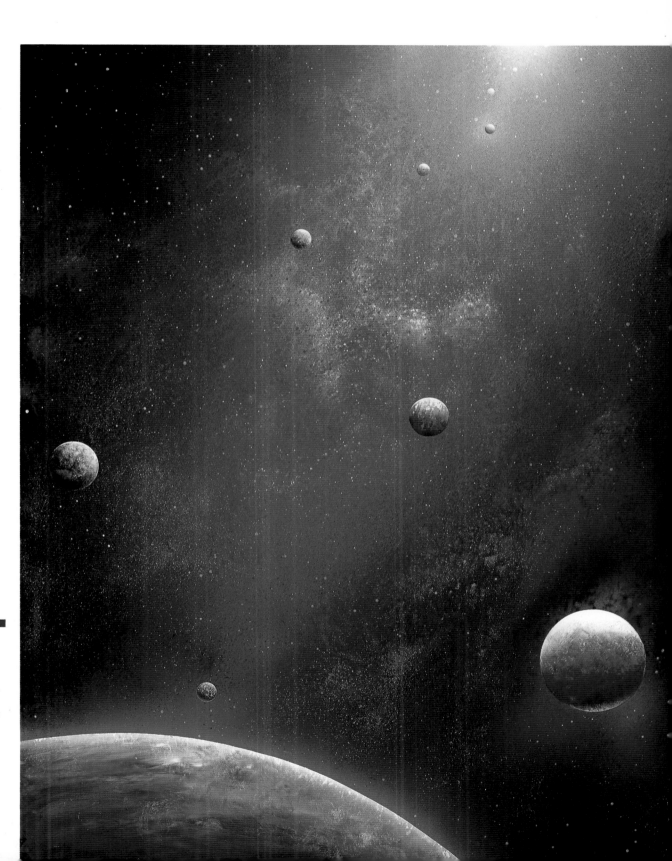

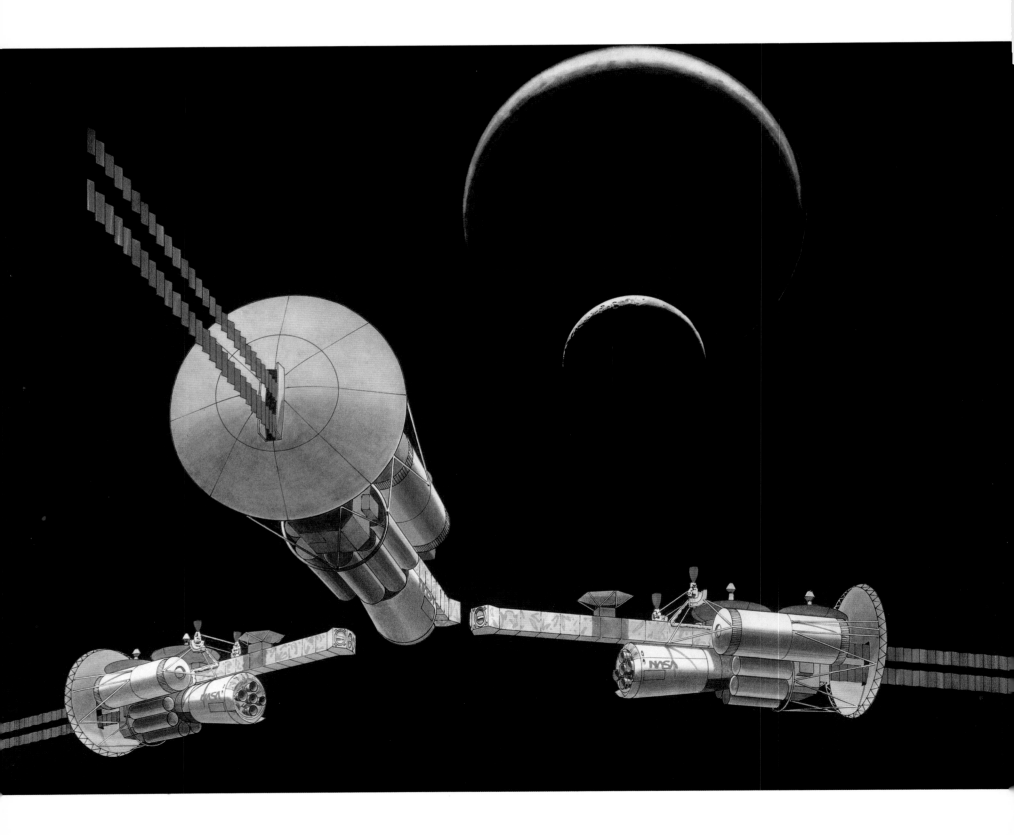

Carter Emmart

TMI Plus Three Days; Rendezvous and Docking

TMI Plus Three Days; Rendezvous and Docking is Carter Emmart's view of an early stage in a mission to Mars. Three days after firing their engines to leave Earth for Mars (so-called trans-Mars insertion) the three ships of the Mars expedition are passing the moon, and are docking to form a pinwheel configuration. Once secured with tension cables, the configuration will be spun to produce artificial gravity that will maintain a healthier astronaut environment than weightlessness. Large disks are aerobraking systems to slow the vehicles; accordion structures are radiator panels that can be extended to cool spacecraft subsystems.

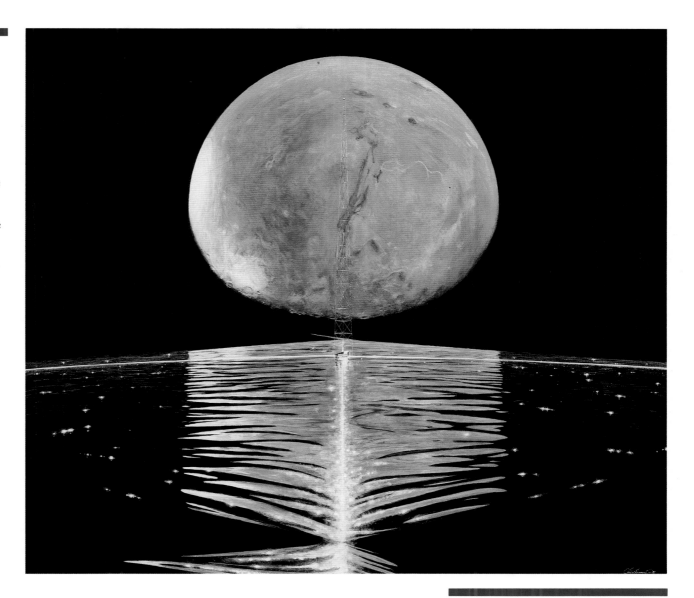

Carter Emmart

Mars Reflected in a Cargo-carrying Solar Sail

As a Mars expedition nears its destination, the red planet looms larger in the sky. Here, Carter Emmart creates an almost abstract pattern from a very realistic rendering of Mars and its reflection in the crinkles of the reflective mylar sail material.

EXPLORING BY PAINTBRUSH

By William K. Hartmann

Space art represents an age-old fusion of science and art, which goes back as far as Leonardo da Vinci. Leonardo saw little distinction between art and science. Together they were a pathway to learning more about the universe around you. Leonardo said, "painting s the way to know the maker of all marvellous things . . . great love springs from the full knowledge of the thing that one loves." Painting was a way of observing, re-creating, and worshipping, all at the same time.

The art of the space age extends this heritage. The American frontier experience of past generations continued the blending of art and science: painters were naturalists, and many naturalists were painters. As Barbara Novak chronicled in her book *Nature and Culture*, the American landscape movement of the 1800s, with its luminist and heroic-nature painters such as Thomas Moran, Albert Bierstadt, and Frederic Church, grew out of a national feeling that the American wilderness was a vast Garden of Eden, a divine gift spread across the new continent for us to explore, revere, and exploit. The prevailing thought was that all three activities—exploration, reverence, and exploitation—were possible at once, if a rational approach to nature prevailed. Many painters made trips to the western frontier as members of major geographic and scientific survey expeditions. Kensett went in 1854, Bierstadt in 1859, and Moran in 1871. Church, who had become wealthy from his early paintings, organized his own expeditions to nature's most exotic locales, including South American volcanoes, tropical jungles, and Arctic seas.

These artists made pictures that acquainted the folks back home with the natural wonders of the New World. They were cousins of the scientists: they wanted to know how things looked, and why things were the way they were. Studying the luminous glow of sky and cloud under different conditions, conveying the swell of the prairies, or depicting newly discovered geysers, they changed the national view of the land from foreboding to inspiring. Some of their paintings were on a scale to match the land's grandeur; Moran's famous 1873 painting of the Grand Canyon measured 7 by 12 feet.

Such art additionally played a role in preserving North America's natural wonders—a role now largely forgotten. For example, Moran's paintings of the Yellowstone wonderland during the expedition of 1871 so enthralled the public that Yellowstone was designated the first national park by President Grant in 1872. Moran became known as "Thomas Yellowstone Moran," and he adopted a monogram designed from the letters TYM.

These artists encouraged exploration and adventure. Moran used the "Artist's Adventures" column of the popular *Century Magazine* to chronicle his arduous 1892 trip to Wyoming's gigantic pillar of basalt called "Devil's Tower." The article appeared in 1894, and partly as a result, Teddy Roosevelt made Devil's Tower the first national monument a dozen years after Moran's article appeared. (The site was later made dear to space buffs and film fans as the alien landing site in the film *Close Encounters of the Third Kind*.)

Even though painting as a means of interacting with nature has been unfashionable for more than half a century, it was the dominant outlook in nineteenth-century American art as well as during the European Impressionist flowering. The roots of space art can be traced back to that view of art and nature. Landscape artists of the last century spoke of "the sublime"—a term used for scenes that evoked wonder, awe, and even terror. Erupting volcanoes, jagged ice chasms, flaming auroras, and crimson sunsets bearing portents of storms—these were sublime. In today's somewhat cynical society, the term has all but disappeared. Yet in this decade, we have seen the silent explo-

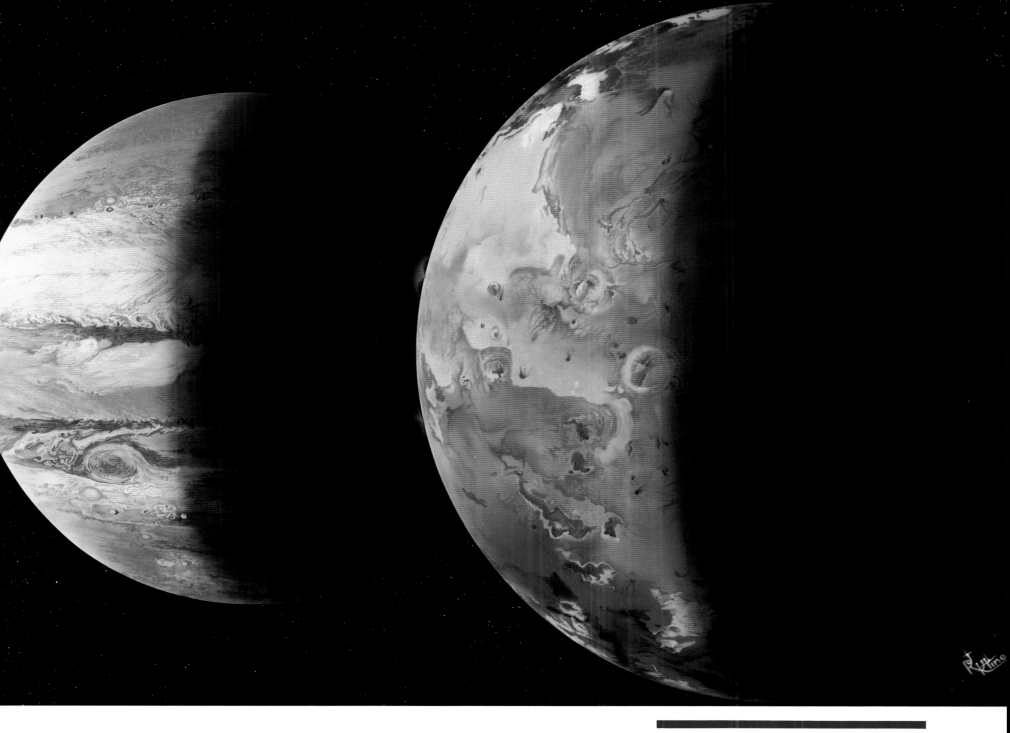

Robert Kline
In the Shadow of Giants

This spectacular view of the largest planet, Jupiter (in the distance, left), and its bizarre satellite Io (foreground, right) was inspired by the Voyager 1 and 2 space probes. An erupting plume of debris from one of the volcanoes is silhouetted on the limb of Io toward Jupiter.

sions of Io, the orange smog layers of Titan, and the desolate polar dune fields of Mars, and (if our hearts are right, as the Pueblo Indians would say) we know that they are truly "sublime" in the sense meant by the Beethovens, Shelleys, Bierstadts, and Morans of old.

Today's space artists are heirs to this artist-naturalist tradition. Arriving at Kennedy Space Center to witness a launch, painting in the wilderness with foreign colleagues, or consulting with scientists, they are having their own "artists' adventures."

The space frontier beckons us. Space artists use materials from today's scientific expeditions—space probe photos, maps, and telescope data—to depict exotic places on the new frontier. They rely on their creativity to make these depictions at once realistic, aesthetic, and dramatic. By bringing these places to folks back home, they can inspire a new generation of explorers. Perhaps, like their forebears, they will even inspire a future system of international preserves in space, as hinted by Canadian-American artist MariLynn Flynn's views of future parks among the canyonlands of Mars.

Here, then, is one role of space art in relation to science and exploration: to encourage it. Space art makes us want to interact with, understand, and conserve the beauty of the universe around us. This is just the first of four such roles that I want to discuss. This inspirational role is just part of a larger role of art in general: to affect feelings, and through feelings to become absorbed into our philosophies and thus to affect attitudes. Art depicting other planets has long affected our attitudes toward space exploration. It has conveyed a sense of excitement, drama, mystery.

A second role of space art is to record history. This occurs in two ways: by recording actual events, and by recording scientific knowledge. NASA runs a visionary art program, currently administered by Robert Schulman, who describes it in more detail in a companion article in this book. The program is a remarkable facet of NASA: it recognizes that space exploration is not just an obsession of wild-eyed engineers but a human endeavor shared by all of our society. It gives artists grants and special access to space launches and other events, and has produced a marvelous collection of paintings on display at various NASA centers. The program comes under periodic fire from bureaucrats who wonder why photography can't do the job. The answer is in the paintings produced by the program, especially in the permanent exhibition of the artworks at the Kennedy Space Center in Florida. The painters' eyes record events of space exploration with a wider range of emotional mood, a more intimate human response, and more unexpected perspectives than the abundant photos in the NASA collections.

Zacqueline Souras
Orion

This painting is derived from infrared images of glowing clouds of dust and hydrogen gas in the constellation Orion. The Greek-American artist, who has helped process spacecraft data, was inspired by "false-color" images from the Infrared Astronomical Satellite (IRAS) that combine data from various infrared wavelengths not visible to the human eye. The image emphasizes warm dust clouds where new stars are forming rather than the familiar stars seen in visible light.

This second role has been stressed by another artist who commands special respect both for his paintings and his travels. He is the only space artist who has actually visited another world. Alan Bean walked on the moon during the Apollo 12 mission; later, he retired from the astronaut corps to take up full-time painting. Bean is an admirer of Monet and a keen student of the play of light on the grays and tans of the lunar surface, which he conveys miraculously in vivid arrays of pale violets, greens, blues, and pinks. Growing at his Houston condominium amidst the paraphernalia that have been to the moon are plants grown from cuttings out of Monet's garden! Bean (who writes elsewhere in this book) states that one of his motivations is to capture not only the sensations and visual perceptions but the special human events that were not recorded by the Apollo photography.

Another part of the historical function of space art is that it provides a unique record of how scientists envisioned other worlds, decade by decade and year by year. For example, until the Viking mission in 1976, scientists predicted that the very thin Martian air would produce a deep blue sky like that perceived from the highest jets. Therefore, most Mars paintings before 1976 show

Michael Carroll
PHOBOS-2 Mission at Phobos

PHOBOS-2, a new generation of Soviet interplanetary probes, was intended to make laser-based measurements of Mars's small moon Phobos. Although it got interesting new photos, density measurements, and other data, it unfortunately malfunctioned before it got close enough to fire the laser. The painting shows the mission that might have been.

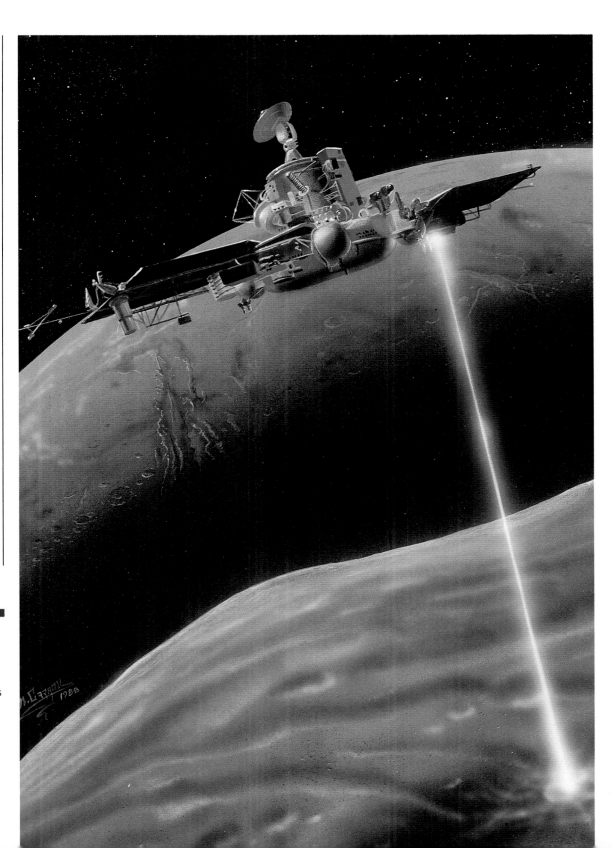

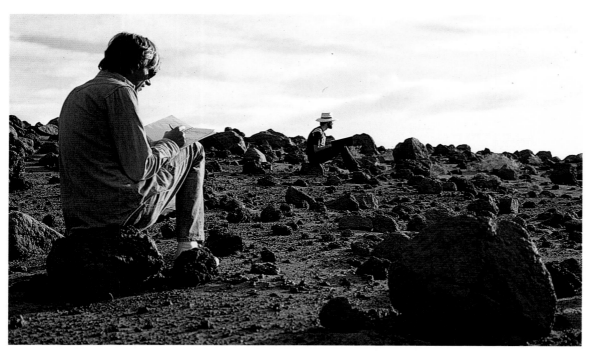

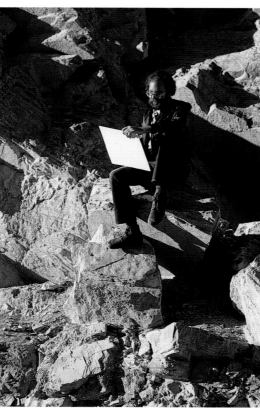

a blue sky. So ingrained was this thinking that on July 20, 1976, the day of the first successful Mars soft landing, Viking technicians adjusted the sky tones on the first Martian photos to give a bluish color. The first color pictures handed to the press showed a blue sky. Only a day or so later did Viking scientists recognize that the Martian sky was unexpectedly bright and dominated by the color of windblown Martian dust. There was more skylight in the red-filter pictures than at other wavelengths, so that the true Martian sky color is pinkish! The "blue skies of Mars" disappeared only days after the Viking landing!

My point is that museum directors and collectors who own pre-1976 Mars paintings should not throw them in the trash because they turned out to be inaccurate. Rather, these pre-Viking paintings provide a priceless record to future generations, showing how scientists and artists *of our era* perceived the planet from the best data available. Planets, *as we think we know them*, evolve from year to year. Artists analyze scientific information to create the most accurate representations of other worlds. This information is often very hard to recover in later years, since scientists are trained to specialize. One scientist publishes on mineralogy of a planet, another on spectra observed in a telescope, another on atmospheric calcula-

Workshop Scrapbook

Space art workshops take IAAA artists to exotic sites. (Top) William Hartmann and Michael Carroll sketch a Mars-like boulder field in Death Valley, California; (lower left) Josef Minsky sketches otherworldly rocks at Myadalur, Iceland; (lower right) Ron Miller perches on rocky debris in a canyon in Death Valley.

tion; rarely do they try to put it all together to imagine how the planet would actually be perceived by a human visitor. This is the role of the artist, who can synthesize all the data into one picture.

To take another specific example, Dutch-American astronomer Gerard P. Kuiper published the discovery of the thick atmosphere around Saturn's moon Titan in 1944. Immediately Chesley Bonestell (the "father" of space art) realized that an atmosphere, through the process known to physicists as Rayleigh scattering of blue light, could create a blue sky. Here was a unique chance for a painting: Saturn, hanging in an ethereal blue sky over the snowfields of Titan. Bonestell published such a painting in *Life* magazine in 1944. It is one of his most famous works, and appeared on the back cover of *The Conquest of Space* in 1949. But around the early 1970s, astronomers found evidence that Titan's atmosphere was cloudy, not clear. Saturn would not appear in a clear blue sky as seen from the surface. Artists such as Ron Miller, Kim Poor, and David Egge responded with new views of Saturn peeking through the clouds. But a few years later, the evidence indicated that the clouds of Titan were so thick that little light might get through to the surface. Ron Miller responded with one last nostalgic look at Titan's surface with a misty Saturn dimly glowing through the thick haze. Then Voyagers 1 and 2 arrived at Saturn in 1980 and 1981. Scientists had hoped that a few thin spots in the clouds might give them a look at the surface of Titan (or, conversely from the artist's point of view, a look at Saturn from Titan). But alas, Voyager showed that a thick, smoggy haze completely envelopes Titan. The amazing Voyager measurements indicated a thick nitrogen-methane atmo-

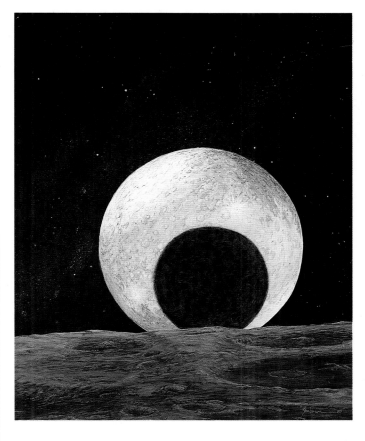

Joe Shabram
Pluto with the Shadow of Charon

A series of unusual mutual eclipses of Pluto and its moon, Charon, occurred between 1984 and 1990. Although Pluto is smaller than our moon, it has an unusually large satellite relative to its own size. The resulting geometry permits unusual views. In this view, based on the artist's consultations with Arizona astronomer Mark Sykes, a specific eclipse observed by Sykes is seen from a point above the surface of Charon. The shadow is very sharp because Pluto and Charon are so far from the sun that the sun acts like a point source of light.

sphere, and a gloomy surface pelted by snows and rains of various complex organic compounds. Soon there were new paintings of dark skies, storms, and possible rivers and oceans.

My point in recounting this sequence is that the paintings provide a unique record of this fast-changing visualization of Titan. Where else can we get an image of how scientifically literate humans envisioned Titan in 1944, 1965, 1972, or 1981, and get an aesthetically pleasing work at the same time?

Meanwhile, artists mourned the loss of Saturn in a blue sky. Then they noted that an observer might still see Saturn in a blue sky from the layer of Titan's atmosphere just above the smog. Discussing this one night at a space art workshop in Death Valley, California, the artists proposed that meteorologists should extend their list of atmospheric terms such as troposphere, ionosphere, and magnetosphere. They suggested that the blue-sky layer above the haze be called "Bonestellosphere," in honor of Bonestell's classic painting.

While we experience amazement at the strange worlds actually found by our probes, we can look longingly at the old paintings of planets-that-might-have-been. On the one hand no one expected active volcanic eruptions on both Io *and* Triton, or an icy, billiard-ball Europa, or a thousand shadings, gaps, and wavy edges in the rings of Saturn; and yet we miss those swamps on Venus and canals on Mars and spires on the moon.

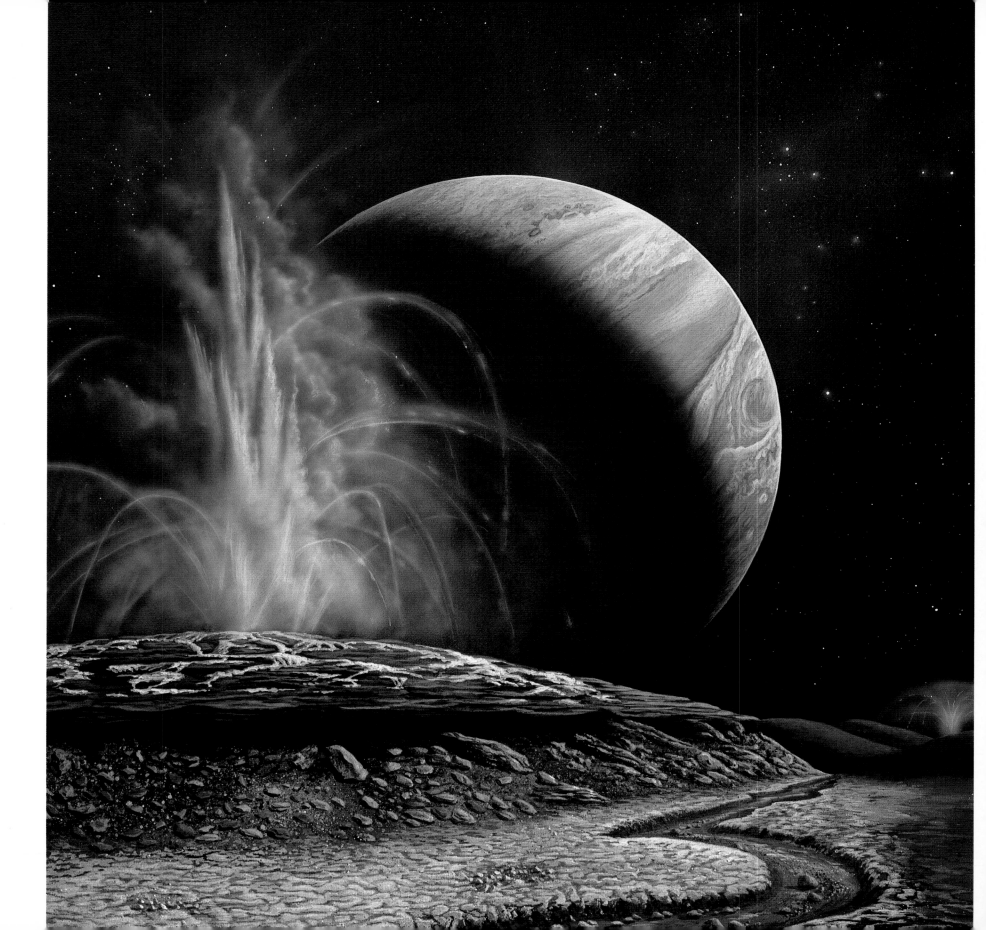

A third and quite different role of space art is its ability, in its own small way, to direct society toward a new future. It can bridge international gaps more easily than political, scientific, and technical initiatives. Discussions of joint space ventures such as Soviet-American Mars expeditions, are hindered by lack of political vision. Cautious bureaucrats in state departments worry about "technological transfer" of computer technology, infrared technology, or some other technology—a transfer that they fear would make life in the future more difficult instead of more exciting. For example, a NASA science administrator recently discussed nervousness by State Department and Defense Department officials decrying supposed technical leaks to other countries from traveling scientists. Citing these influences, he mailed out a newsletter stating that "neither travel to the U.S.S.R. nor the organization of related workshops and conferences will be approved (for funding), except in rare cases." He proposed "a small meeting . . ." to develop guidelines for scientist-to-scientist activities, in order *to bring the enthusiasm I observe in this area under control . . .* (emphasis W.K.H.). In spite of such institu-

tional timidity, American and Soviet technicians as early as the 1970s mounted the highly successful Apollo-Soyuz Project, in which American and Soviet spaceships docked in orbit. The astronaut/cosmonaut team, who had trained together and studied each other's languages, carried out joint scientific observations.

Space art can foster this sort of future. While political wheels turn slowly, artists can work together relatively freely. All the participants of our joint workshops in Moscow, Iceland, Cenezh, and Moab spoke excitedly of a vision we all had: students walking into our exhibition, seeing the joint projects of international artists depicting cooperative, international exploration of our cosmic environment in a post–Cold War future. To paraphrase Jules Verne, what artists can imagine, engineers and politicians can accomplish.

T he fourth role of space art is to connect the worlds of art and science—not in a petty academic sense, but in a practical working sense. Some years ago, C. P. Snow spoke of the gap between the "two cultures," art and science. Space artists bridge this gap. Or rather, they see no gap. Space artists and space scientists are both naturalists, although they ask different kinds of questions. By philosophical tradition, scientists are dividers: they subdivide phenomena until they isolate areas where quantitative measurements can be made. In contrast, space artists are synthesizers; they combine all this knowledge to consider the *experience* of an alien planet. What would it

look like? What would it feel like?

I once attended a scientific meeting where a speaker described the newly discovered, yellow-glowing cloud of sodium vapor around Jupiter's volcanic moon, Io. He expressed his measurement of the glow's brightness in the proper but obscure scientific units, "kilo-rayleighs." Sensing an interesting potential view of yellow auroral glows in the sky over volcanic plains on Io, I asked him if this value was a brightness perceivable to the human eye. He hadn't considered this and didn't know. Later we found another researcher who remembered how many kilo-rayleighs corresponded to visible auroras on Earth, and we concluded that Io's yellow glow would sometimes be visible to a human visitor. But it struck me as odd that we scientists can spend months measuring the intensity of something, and then have no idea whether that intensity could be perceived by our senses! Space artists help forge that missing link in our interaction with the universe.

They deal, too, with answerable questions that are close to the normal scientific arena, and yet outside the province of hard science, primarily because nobody has defined a number to measure this or that particular quality. For example, how did the lunar surface *look* to the astronauts? What was its visual texture? How bright did it *seem*? Astronomers know from direct measurements that the lunar surface has low reflectivity. Many of its lava rocks are about as dark as a blackboard. Asked to depict the moon, a scientist might pick tubes of the darkest gray pigments, in order to get the "correct" reflectivity that matches the numbers measured for the moon. How surprising, then, to read Alan Bean's comment that the subjective appearance of the lunar

MariLynn Flynn
Chalybes Regio Geyser

Jupiter's bizarre moon, Io, is dotted with erupting volcanoes, giving space artists a unique landscape to depict. Inspirations for the painting came from the 1988 IAAA/USSR workshop in which the artist visited the famous Icelandic "Geysir."

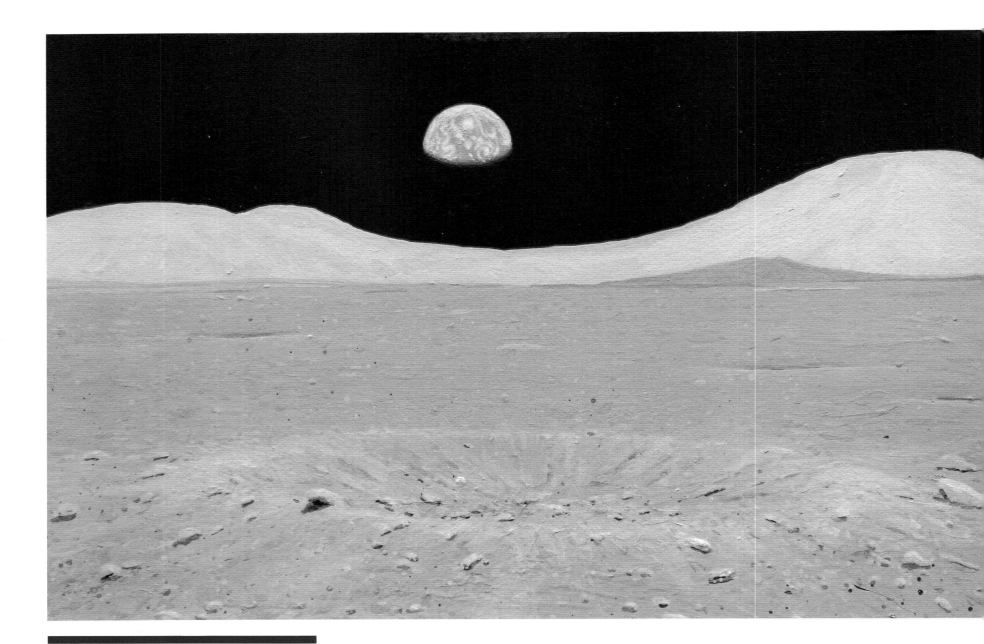

William K. Hartmann
Midday on the Moon

Many traditional lunar views emphasize the dramatic shadows cast by rocks and craters under low sun. Here, the artist paints a lava plain under the flat lighting of high sun at lunar noon.

lava plains at the Apollo 12 site was "incredibly bright." Similarly, the landing site of Apollo 17 was described as looking as bright as a snowy alpine ski valley. Why does the human perception seem the opposite from the scientist's "true numbers"? It is because, in contrast to the Earth where the sky is usually brighter than the ground, the lunar landscape is canopied by the utterly black sky of space, so the surface *seems* bright by comparison. An artist choosing to depict the *human perception* of an alien planet must draw on a larger scale of reality than what is provided by the most straightforward measurement.

Artists have long been partners of scientists in a few fields. For example, anatomical illustrators were crucial in transmitting information when scientists first began to study the bodies of humans and other animals. Similarly, painters and sculptors collaborated with scientists in reconstructing dinosaurs from dusty fossil bones. Today, this ability of art to synthesize what different scientists measure is having a new impact. One example is the increasing use of space art slides by planetary scientists in presenting their new conclusions, not only to the public, but even in scientific conferences. These include slides of giant colli-

Ludmila Bulatnikova
According to the Theory of Probability an Explosion May Make the Venus de Milo, But to Do That the Whole Solar System Must Be Destroyed

Bulatnikova has in mind a notion similar to the old cliché that suggests that a monkey left banging away on a typewriter, if given enough time, must eventually type out all the works of Shakespeare. Here the artist has carried a similar idea to cosmic proportions.

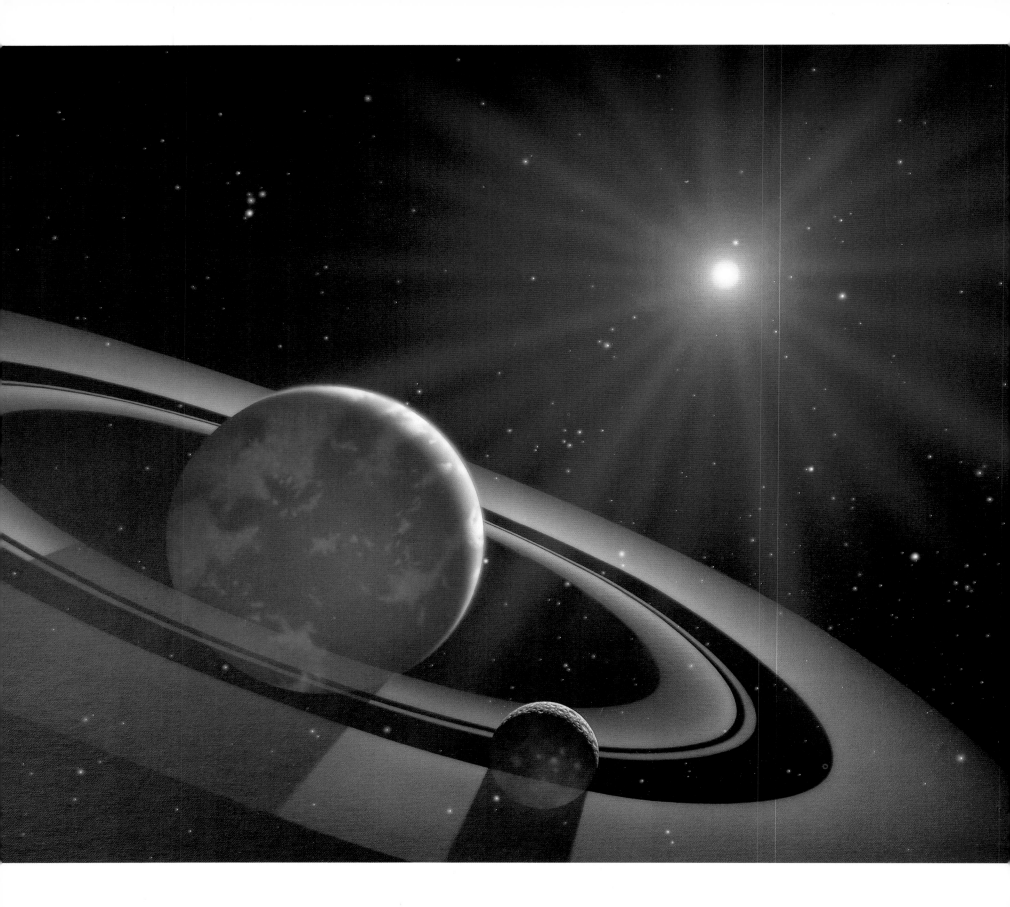

sions between "planetismals," slides of tidal waves kicked up by the asteroid impact that ended the Cretaceous period sixty-five million years ago, slides of possible ancient lakes on Neptune's moon Triton, and computer graphic simulations of the flight of Voyager past the rings of Uranus and Neptune.

I have been especially pleased by the role of space art as a partner in scientific meetings. For example, I put one of my first paintings of the surface of a comet nucleus on display at an international scientific conference on comets, and asked for critiques. A group gathered around and found themselves asking questions that most comet scientists had rarely thought about. Is the coma of a comet visible to the naked eye from the surface? If so, is it bluish like the sky because of Rayleigh scattering, or does the reddish color of the dust predominate, as on Mars? Are big chunks lofted off the surface as the comet erupts? Would erosion of ice by sunlight leave pedestals behind, capped by protective chunks of soil, as I had shown in my painting? Although the scientists knew there was a solid, dirty iceberg at the heart of each comet, they were by tradition astronomical spectroscopists, not geologists, and few of them had thought about the physical conditions of the comet's solid surface.

There is an amusing and instructive story about the pedestals in my painting. I had conjured them up in order to suggest that

Joe Tucciarone
New Moon

The satellite of a recently formed Earth-like planet is in the final stages of growth. From a thin ring of material orbiting the planet, the moon sweeps up material from its own path.

peculiar structures might arise on a comet nucleus surface as the ice eroded away by exposure to the sun. I had seen such pedestals of snow in nature, protected from the sun by cap rocks or chunks of dirt. The painting in which I showed them, now in Michael Carroll's collection, was widely reproduced, and within a year, similar pedestals had sprouted on a number of other paintings by other artists, including those in NASA brochures promoting missions to comets. To me, the quirky aspect of this story was that a cometary landform had become "gospel" in astronomy magazines and NASA literature, even though it had never been seriously proposed in the scientific studies!

In fact, I later learned from a respected planetary geologist that he had tried to publish a paper in 1985 suggesting similar structures on comet nuclei, complete with photographs of peculiar ice spikes and platforms in Alaska and Antarctica, only to have the paper rejected by the scientific journal because it was perceived as being too descriptive and qualitative—not "real" science. Scientists at that time tended to think of comet nuclei structures as theoretical abstractions, to be studied by calculations, not by observation of possible analogs in nature. A year later, the European Giotto probe returned closeup pictures of the nucleus of Halley's comet. There was not enough resolution to show whether pedestals and spikes existed, but they did show a weird, peanut-shaped body with vents and hills, forcing scientists to begin to think in terms of realistically complex geological processes. At that time, another distinguished planetary scientist reviewed my friend's rejected paper and wrote to the journal that "it is a great pity that this paper

could not have been published *before* the Giotto encounter . . . the time has come to pay attention to the geological processes that govern the evolution of the surfaces of comet nuclei." The point of the story is not whether or not pedestals exist on comets, but rather to illustrate the degree to which some scientists resist potentially stimulating input from visual exploration.

Artists may soon play a more direct role in scientific research. The respected journal *American Scientist* for November 1989 reported a growing move to form "renaissance teams" for scientific studies. "Renaissance teams" typically consist of one or more scientists, an artist, and a computer programmer. The role of the artist is to help design ways to present the information, not only to communicate facts to other scientists, but to stimulate visualization of complex situations. If we stimulate visualization in science, new ideas usually follow.

The article about renaissance teams brings us back to Leonardo da Vinci, because it starts by paying homage to him. This pioneer naturalist-artist began much of modern science and engineering with his insistence on integrating artistic representation of nature with analysis of natural processes.

This close early link between science and art was interrupted in the twentieth century, as the dominant currents in art moved away from external nature and toward internal feeling. This was a contributing factor in the separation of Snow's two cultures. Scientists were now in charge of studying nature; artists, in many cases, isolated themselves from nature by studying only themselves. But space art begins to rebuild the bridge between the two cultures, and returns artists to the role of celebrating our interaction with our environment.

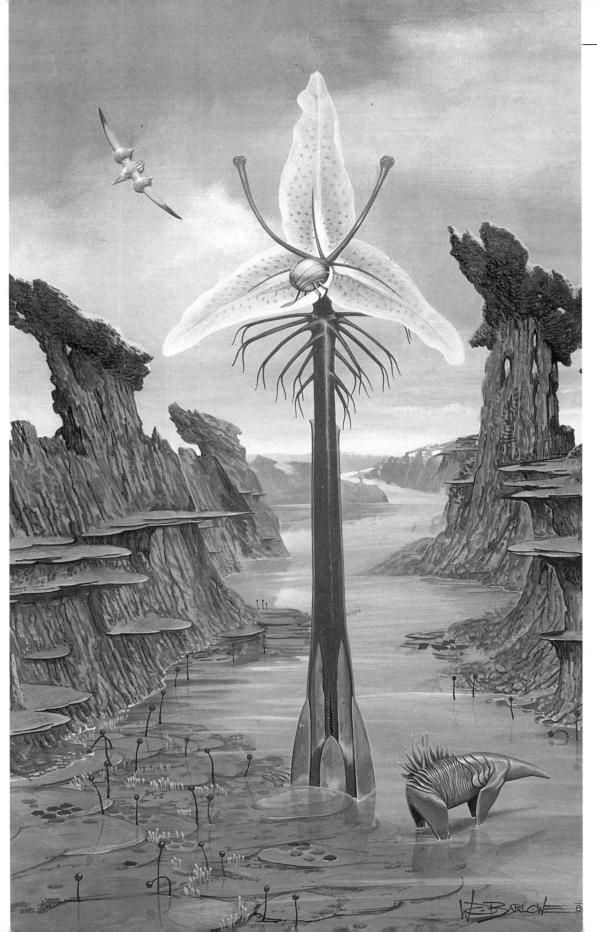

We've described four roles of space art: encouraging scientific exploration; recording historical evolution of planetary exploration; promoting international cooperation; and synthesizing information to stimulate new ideas about the universe and our relationship to it. But what about the *art* of space painters?

As shown in this volume, space art covers a spectrum, from the "hard" scientific realism of the Bonestell tradition to the "softer," more subjective and symbolic images that reflect inner responses to the cosmos. Interestingly, as remarked in the preface, our international collaborations revealed a geographic correlation of these two ends of the spectrum: the Americans gravitated toward realism, and the Soviets tended more toward symbolism. This gave a fascinating diversity to the collections of paintings in our shows and in this book. At one end of the spectrum, it is hard to tell where space art leaves off and "pure" abstract art begins. There has been some argument among space painters about how much *knowledge* about the cosmos is needed. Leonardo said, the more you educate yourself about something you love, the more love you can give it. And we hope that the paintings in this book display a love for the expanding horizon, for the adventure of

Wayne D. Barlowe
Alien Flora

This artist specializes in extraterrestrial "natural history." Here we see an alien flower along with some additional lifeforms on a hypothetical planet.

exploring beyond the limits of Earth to see where we fit in the grand scheme.

Many of the artists represented in this volume present a practical artistic concern for the physical universe. They ask pragmatic questions. How does light interact with various rock and soil types? Are they specular and glossy, or dull and matte-finished? When an astronomer reports the "red minus blue," or "R-B," color of so-and-so many magnitudes, how does that numerical measure of color correspond to hues perceived by the eye? How is light colored by various atmospheres? While even the most hard-edged realistic space art remains aesthetically motivated, all space painters require more knowledge of interesting physical phenomena than many contemporary mainstream "gallery" artists possess.

Some examples include different-size haloes around the sun produced by ice crystals of different compositions; sky colors of pink (produced on Mars by reddish, rust-stained airborne dust), yellowish tan (produced on Venus by light filtering through a perpetual overcast of sulfuric acid clouds), and blue (produced on Earth by Rayleigh scattering of light among gas molecules); and questions of the colors and textures of snows, oceans, and ices on worlds of liquid and frozen methane, ammonia, and carbon dioxide.

Of critical importance in rendering alien events or landscapes is the geology of the landforms. Snapshots from probes flying by other planets show impact craters, volcanic cones, lava flows, dunes, active volcanoes and geysers, and dry, arroyo-like channels. There are few craggy peaks, or V-shaped and U-shaped valleys, because these forms are produced on Earth by water and glacial erosion.

Victor Dubrovin
Birth of Life

In search of landforms like those photographed on other planets, most of the space artists in this volume have ventured into unusual terrain on Earth. This was the origin of our workshops at remote field locations, described in the preface.

Orbital photos have shown many more rugged and exotic areas on other moons and planets than we have seen yet from surface

The lifeless, barren icebergs of some distant, frozen planet seem to bow in respect, homage, or awe in the presence of the dazzling birth of a new star. Is it possible that Victor Dubrovin's new star is in fact a nova? If so, then we are not witnessing the simple birth of a new star, but the death of an old one. Ironically, however, life as we know it here on the Earth may only be possible because of the elements created in the shattering, gigantic explosions of dying stars.

Joel Hagen
Europa

Many scientists believe that the strangely smooth, marbled surface of Europa (right) is underlain by a hidden ocean of liquid water, and Arthur C. Clarke, in his novel *2010*, speculated that such an ocean could harbor the evolution of life.

photos. Recall that astronauts' lunar landings and the Viking landings on Mars occurred at rather dull, flat sites, chosen to ensure spacecraft safety. And the Venera photos on Venus's surface were at random sites. It is as if a few daguerrotypes had been snapped at random spots on the plains and hills of the West in the last century, and we had still to witness the Half Domes, Old Faithfuls, and Devil's Towers sought out by Moran, Bierstadt, and others. The giant "fresh" lunar crater, Tycho, for example, is sure to contain dramatic landforms. So far, our space vehicles haved not ventured to these most spectacular sites. But, as Arizona space artist Kim Poor says, painters can swoop down where engineers fear to tread. And as for the pulsars, black holes, and binary stars that lie far beyond Pluto, we have not even the prospect of photographing them at close range; only artists can "visit" them.

What of space art's future? At present it seems to lie in the gray area between "fine art" (art for art's sake, usually aimed at gallery audiences) and "illustration" (art to show or explain something, usually published in magazines and books). In emotional approach, it is more like fine art, but in technical background it is more like illustration. Discussions among artists have revealed some frustration with this state of affairs. Art editors who commission "illustrations" for many commercial magazines are better trained in design than in content. Artists have told stories of expending great effort to achieve realism during an assignment, only to be asked by the art director to change the color or put in grossly incorrect landforms. On the other hand, awareness of astronomical paintings as fine art has increased, and a number of exhibitions have occurred in the Soviet Union, Europe, and America.

Is there really enough subject matter for space art to grow and evolve? Some critics suggest that because there are so many airless rock-strewn worlds in the solar system, space painting is doomed to be a repetition of endless scenes of "rocks and balls." Admittedly, Earth has more varied landscapes than many other planets because of its checkered geologic history. But there are about two dozen worlds in our solar system alone that are bigger than 1000 km across, and experience shows that worlds above this size are big enough to have their own distinctive personalities. Thus, we have the volcanoes of Io, the orange smog of Titan, the geysers of Triton, the mustard-colored

light of clouded Venus, the colored swirls of Jupiter's atmosphere. How many scenes are still untapped among the crystal-strewn, moon-swept rings of Saturn or Neptune? If our single world has inspired several centuries of landscape artists, how much more inspiration is there among the two dozen other distinctive planets and moons, not to mention the thousands of smaller moons, or asteroids and comets? And we have spoken only of landscapes, or landscape-inspired abstracts. What of future human history? What of the "urban" scenes among the giant space stations that may orbit Earth, Mars, or other planets in the future? Enterprising artists will always be part of human frontiers.

A literary critic assessing science fiction has asked, In an age of such rapid technical change, how can serious literature *not* be science fiction? That is, how can literature not reflect the amazing world in which we find ourselves? In the same way, if art fails to be at least informed in some way by our cosmic environment, does it not threaten to become provincial and Earth-bound?

We can anticipate a wider interest as space exploration continues. If all goes well, there will be a future when art historians, scientists, and the public look back on the work of the painters who documented our generation's opening of the space age — our first discoveries of new worlds. Would

we not be excited to find treasure troves of paintings by artists on Columbus's voyages, or artists to whom he described what he saw in *his* new world?

Meanwhile, space artists are not unaware of the 1951 short story by Arthur C. Clarke, in which photographers for a twenty-first-century *Life* magazine are assigned to search out and record scenes on the moons of Jupiter or Saturn for the purpose of comparison with the century-old, pre-spaceflight paintings of Chesley Bonestell. Current space artists are anxious to produce paintings that will hold their own in such a situation. ☐

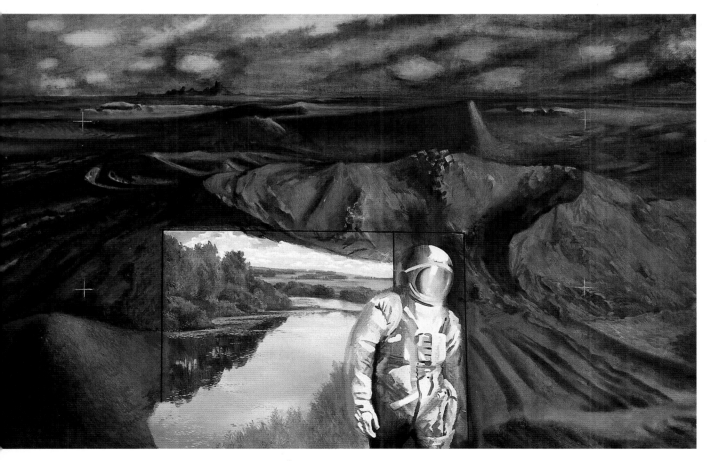

Peter Kovalev and Olga Kovaleva
Warning

Soviet artists, more than Western artists, have linked space exploration and environmental concerns. Here Soviet husband-and-wife team Peter Kovalev and Olga Kovaleva "contrast the lifeless landscape of the planet in the painting with the lively landscape of the Earth." If the painting has a message it is the simple one: Protect the Earth.

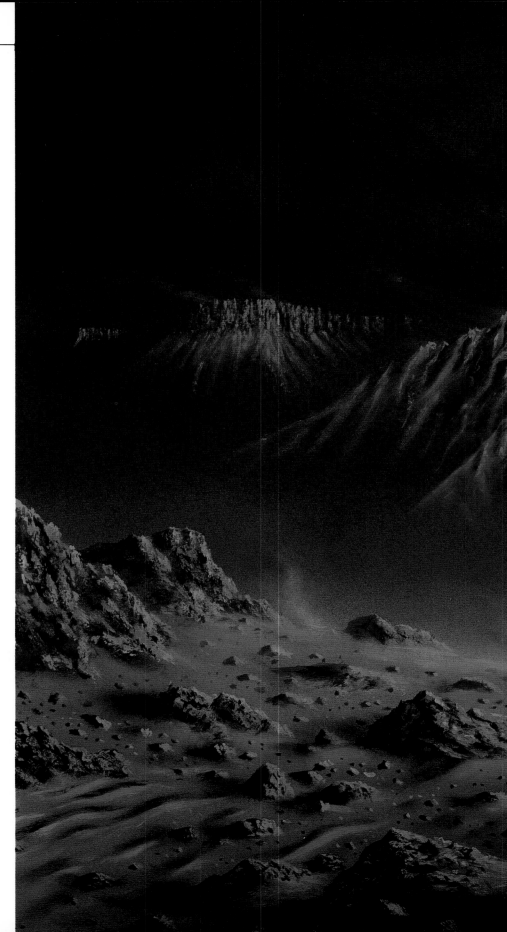

"What is it that draws us to the boundless and the fathomless? . . . Have immensity, space, magnitude a peculiar beauty of their own? . . . And is it not the sublime that we feel in immensity and mystery?

—John C. Van Dyke,
The Desert

John R. Foster
Dust Storm in the Canyons of Mars

The Mariner 9 mission to Mars in 1971 discovered an enormous canyon system big enough to stretch across the U.S. The main canyon and its tributary canyons were filled with dust by the global Martian dust storm of that year, but the dust gradually settled to the canyon floor. This view by John R. Foster shows restless winds stirring the dust on the floor of one of the smaller side canyons as a huge dark dust storm approaches overhead.

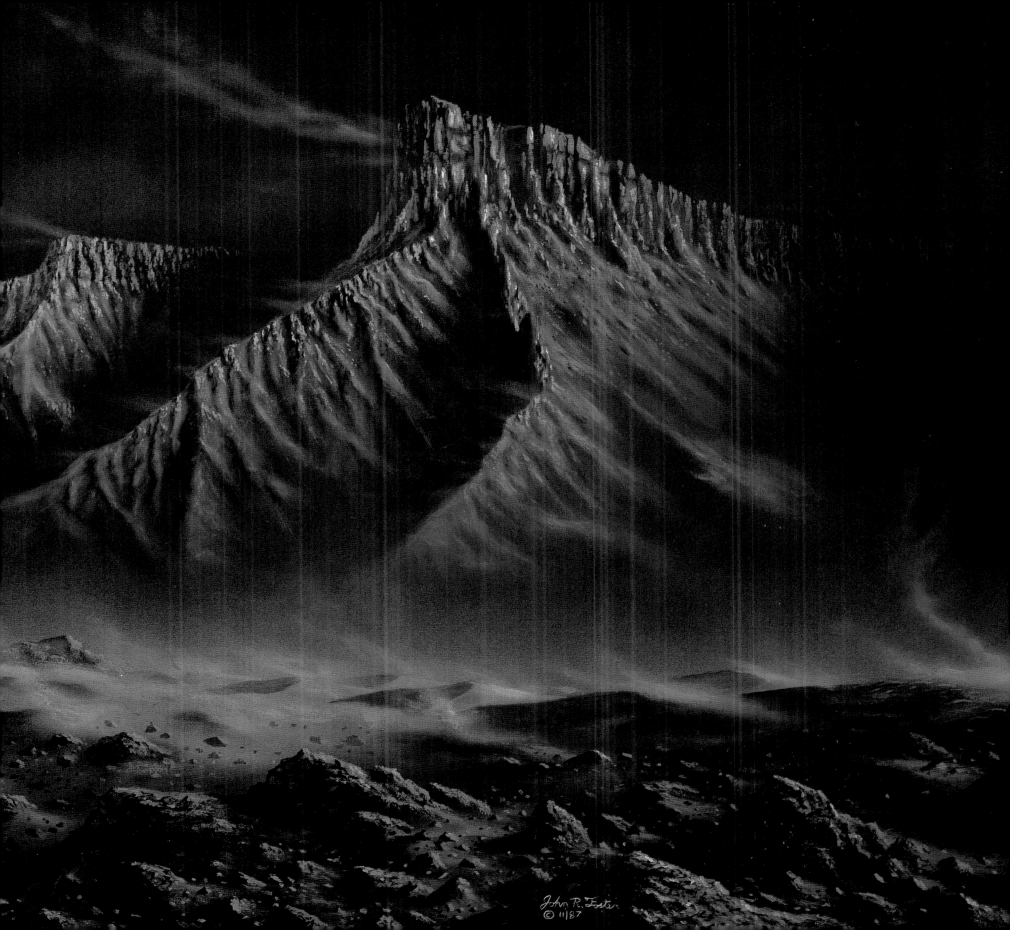

John R. Foster
© 11/87

Mark Paternostro
Black Hole

According to the conception of many astronomers, black holes are super-dense, collapsed stars, often surrounded by very hot, violet-glowing disks of dust and gas, spiraling inward. According to recent observations, many such disks shoot out two jets of very hot material by a process that may involve strong magnetic fields. The system shown here is near the galactic center, a region that abounds in giant stars.

Brian Sullivan
Final Encounter

This mixed-media image depicts the final planetary fly-by of Voyager 2 as it moved out of the solar system past the planet Neptune. The artist created the piece for Armagh Planetarium in Northern Ireland.

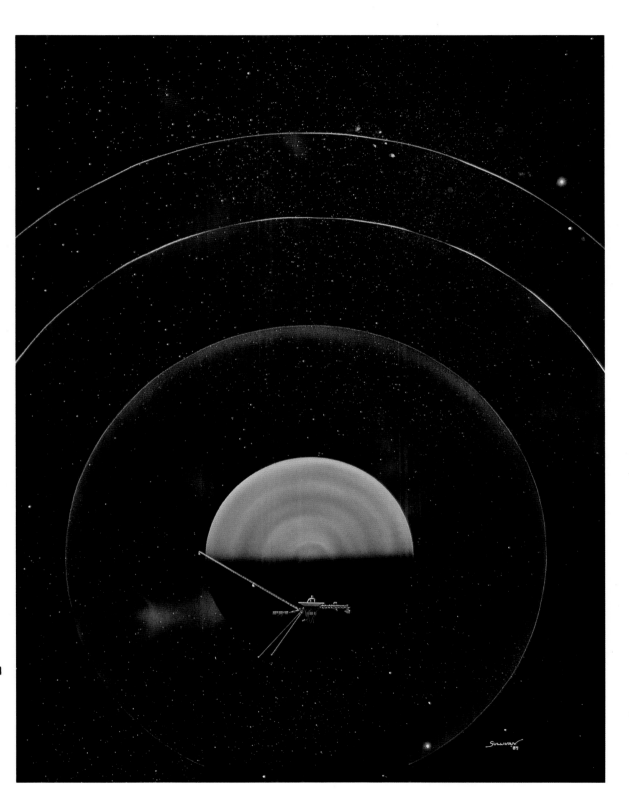

Peter Kovalev and Olga Kovaleva
Unknown Planet

The husband-and-wife painting team of Peter and Olga Kovaleva have created a visual conundrum — they have blurred the distinction (if there is any) between landscape painting and figure painting. Is this icy, barren landscape beneath a cold, indifferent Milky Way an unexplored alien world? Or are the Kovalevs most subtly and slyly suggesting that the most unknown world in the universe is mankind itself?

Geoffrey Chandler
Infinity Series #33

The artist calls this work (left) "a symbolic painting of the entire universe." It echoes modern astronomers' idea of a singular event, the so-called Big Bang that started the universe. Following one stream of galaxies through a point and into another stream, we see a hint that the universe may be cyclic, that the Big Bang was perhaps preceded by a collapsing universe.

Yuri Pochodaev
Mars

In this view from a fantasy Martian moon, the sinister ruddy globe of the red planet peers over the horizon. The cosmonauts seem blissfully unaware that they are being observed by such a sullen and possibly resentful presence.

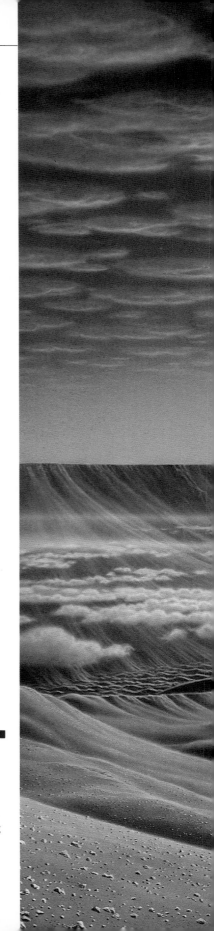

Don Davis
Exploring Noctis Labyrinthus at Dawn

Astronauts are exploring the highly fractured canyon region on the Tharsis volcanic dome of Mars. The artist based the painting on a real Martian location, using Viking orbital photographs to fill in as much detail as possible.

TO INFINITY AND BEYOND

By Andrei Sokolov

Just as the nineteenth century was known as "the steam century," many names have been assigned to our twentieth century. Different names were assigned in different decades: "the electricity century," "the radio century," "the century of the atom," and finally, "the space century."

But perhaps the most important feature of our century is the avalanche-like growth of information continuously accelerating the pace of our life. During the nineteenth century the total sum of human knowledge doubled. Now it doubles in only 10 to 15 years, and the interval seems to be growing even shorter. This process is irreversible and inevitable. In fact, it is a direct consequence of such valuable human qualities as curiosity and creativity. It is these qualities along with scientific and technological innovations which help us, in traveling around the Earth and into space, to know and change the world. We are witnesses to and creators

Translated by Natasha Yampolskaya

of a tremendous breakthrough for humanity. We have earned the right to take pride in it.

However, I would like to touch upon another aspect of this information explosion and to share my ideas on the important role that art plays in it.

All scientific and technological discoveries were born out of the study of nature, or, to be more exact, the study of features of our environment. Similarly, humanity and our natural environment have also been an eternal theme of art. Artists have always turned to the environment, trying to absorb it and show it in their works. The artist has a human response to the environment, in particular to that part of it which we have explored or transformed with our own minds and hands.

This expansion of our environment comes at a price, however. Each new step into the unknown requires even more strength and awareness than our ancestors needed to leave their cozy and secure caves.

In outer space, man must acquire new ways of thinking, new vision, new sensa-

tion, and, in many ways, new psychology. The classic picture of unchanging Homo sapiens is becoming complicated. As we venture beyond the Earth, we are forced to think in a new way. That is why one of the leading branches of space medicine is that of space psychology.

Humankind's ordinary notions have been thrown into disarray by our journeys into space. The Earth is surprisingly small; cosmonauts orbit it in just over an hour and a half. (Compare this with Jules Verne's Phileas Fogg, who struggled to make a world tour in eighty days.) For the first time, the contours of continents have been seen, not on a lifeless map, but in reality. A chain of underwater mountains has been traced in the depths of the sea. Combine these singular sensations with pre-launch worry, the extreme g-force pressure during launch, spine-jarring vibration, and eventually weightlessness. These are just a few of the factors affecting the human psyche in space.

But in spite of all these stresses of space travel, the first thing a person notices in the orbit is the beauty of our home planet. Yuri Gagarin, the first person in space, said on seeing Earth, "How beautiful it is!"

Andrei Sokolov
Work in Space

A pair of cosmonauts are working outside the Mir space station. Their Soyuz spacecraft is docked at the top, and at the far end of the station is an unmanned Progress cargo rocket. Artist Andrei Sokolov is known as the most realistic of Soviet space painters, and he has spent years in close contact with cosmonauts and engineers, familiarizing himself with technical equipment of the Soviet program.

Andrei Sokolov
Correcting a Sketch in Orbit

One of the enviable opportunities artist Sokolov enjoys is that of having his preliminary color studies checked for accuracy by cosmonauts in orbit. In the painting at the left, Sokolov shows a cosmonaut comparing the artist's sketch—prepared on the Earth—with the real scene as it passed beneath him (here, the Aral Sea is below). Sokolov has left space for the cosmonaut to write in his comments on color, form, and lighting. At the right is the sketch that Sokolov prepared for this painting. He determined the angle of view that the cosmonauts would have and made his best guess as to the sea's appearance.

There is little on Earth to match the view of Earth from space. The combination of colors seen from space is much brighter and more vivid, according to our cosmonauts' reports.* Landscapes seen from an airplane are vague and colorless, because we observe them from inside the atmosphere with the light scattered from all around. Cosmonauts are not impeded by the scattered light; they see the Earth in all its magnificence.

*The Soviet space program has conducted a long, fruitful study of the appearance of colors and details of Earth as seen from space by the human eye, while the American program has concentrated more on studying the Earth photographically. Cosmonauts in Soviet space stations have studied Earth with color-sample atlases and color-measuring viewers (designed like camera viewfinders), confirming that the perceived colors are remarkably more vivid than those seen in aircraft.—W.K.H.

have leisure time, they love watching the Earth. In fact, all cosmonauts, particularly those participating in long-term missions, have their own favorite "corners" of the Earth's landscape. (The "corners" are of cosmic size, up to hundreds of kilometers.) It could be the Caribbean Sea, where dark blue patches of deep hollows are seen through light blue shallows. Sometimes it is a group of mountainous heights with glaciers and snow caps. It is especially nice to observe these at the terminator (the boundary of day and night) when the valleys sink into darkness and a chain of snowy mountains is shining in the background. Late in the evening, just beyond the terminator, the very high mountains glow red-orange, like live coals.

Andrei Sokolov
Docking with Salyut 7

Soviet spacecraft Soyuz T-13 maneuvers into position for docking during a critical rescue mission to the early Soviet space station, Salyut 7, in 1985. The space station had become disoriented after the departure of a previous crew. Selected to pilot the Soyuz ("Union") was Vladimir Dzhanibekov, known as the most skilled cosmonaut pilot and also a painter whose work appears in this volume.

Atmospheric phenomena also make a strong impression. From outer space one can watch the birth, life, and death of hazardous hurricanes, or observe mysterious, noctilucent silver clouds, or watch how high mountaintops cleave the clouds, leaving a wake like that of a ship.

Tropical thunderheads, illuminated by lightning flashes at night, recall the blooming buds of white roses. The play of polar auroras is unique, especially "small," distant, phosphorescent ones. But sometimes "huge" red auroras reach beyond the orbital plane so that the station moves through them. The shining constellations of cities at night, enmeshed by a glittering web of highways is also very lovely. One's heart fills with pride at our accomplishments when one recognizes from orbit artificial seas and water basins, and cultivated fields, particularly in virgin lands.*

*An interesting cultural difference between East and West emerges in this statement. Much of Soviet society retains the pride that was common in nineteenth-century America about the domesticating hand of humanity upon the untamed wilderness. With the recognition of environmental problems, this exhilaration has changed to a shudder in much of the U.S. and Europe, as well as in part of Soviet society. —W.K.H.

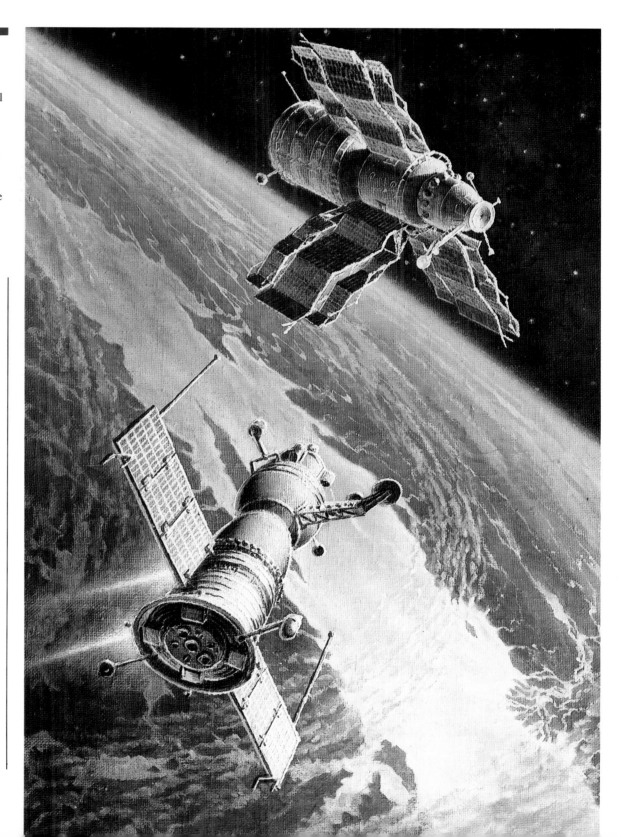

Every human being on Earth should have a chance to see this beautiful planet from orbit. We've all seen photographs and films, but these are just a pale shadow of reality. A human eye can discern details twenty times better than a typical camera and two hundred times better than a typical TV transmission, to say nothing of our human advantage in subtle perception of color. But beyond even that, only a human being is able to comprehend, analyze, and be deeply moved by his or her emotional impressions. That is why I think that the most important landmark of space exploration and space art was the extravehicular activity of Alexei Leonov in outer space. For the first time, the planet Earth was looked at directly, not only by a cosmonaut, but by an artist. For the first time, an artist could compare, for example, nighttime clouds illuminated by city lights with those illuminated by lightning and those illuminated by moonlight.

I believe that cosmic themes will find their way into all genres of art. Two approaches to space art are already well-developed. First the symbolic-fantastic genre, where realism is secondary to symbolism, has already won an honorable place in the history of art. Second, portraits of courageous pioneers of space are also fully represented. But there is a lot more to do in this

Dennis Davidson
Falling Toward the Moon

This is one of a series of paintings examining scale, light, perspective, and design in near-Earth space. "'Toward' is the reality of direction in space, not 'up' or 'down,'" the artist writes.

area because achievements were made in space not only by cosmonauts but by scientists, engineers, testers, workers, and laymen enthusiasts who gave themselves up to the exploration of space.

However, a third genre — the realistic approach to space art — is still evolving. The nature of spaceflight is not always compatible with traditional styles of art. For instance, it is always difficult to paint from life such things as training cosmonauts, testing, and launch facilities. The launch itself is even more difficult because the process is so short that it can be painted only by memory. If one wants to paint the "routine work" of cosmonauts in orbit, the traditional ways of painting are no good at all. Their work must be painted with truth and inspiration. We must reject overly cheerful or romanticized depictions which, unfortunately, have become traditional. We artists must give credit and respect to the heroic, but sometimes difficult, daily and hourly work of cosmonauts in orbit.

Detailed illustrations of equipment, spacesuits, interiors of spaceships, and so on are of minor importance. But major attention must be paid to closer rapport with the space explorers themselves. Artists need spiritual understanding of their impressions, memories, and notes.

The opposite is true, however, when it comes to the painting of space landscapes. A number of specific, cosmic peculiarities of these landscapes must be taken into account — the lack of a conventional "up" and "down," the absence of atmospheric perspective, and so on. Space landscapes must be mastered not only by landscape artists, but also by painters of human activity, because this activity takes place, even today, against a background of space.

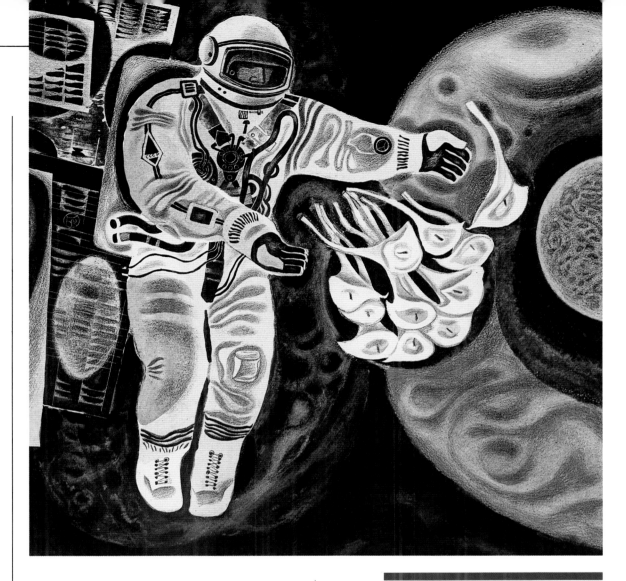

Right now, aerospace engineers around the world are designing space habitats. Some of these habitats are ready now to be launched into near-Earth orbits, where they will be assembled, maintained, and inspected. There will be large modular orbital stations, solar electrical stations generating energy to transmit to Earth, navigation satellites, scientific platforms, communication satellites, space factories where zero gravity and deep vacuum will be used in manufacturing, and later, large, long-term space colonies and shipyards.

In a word, outer space will become a hive of scientific and industrial activity. A painter who wants to depict all this should

Georgii Poplavski
Flowers to the Planet

To the artist, space "means heroism and tragedy. These two emotions are closely connected like everything else in life." In Poplavski's lithograph, this dichotomy is represented by the cosmonaut and the lilies.

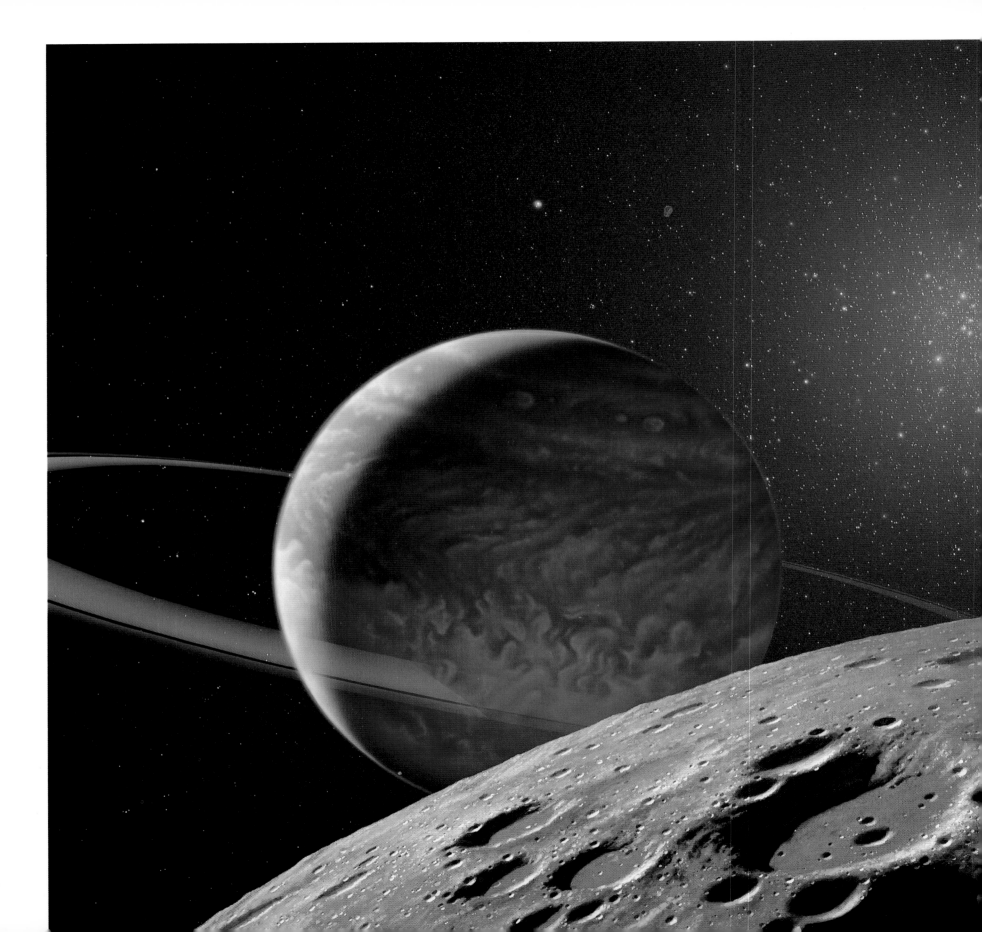

master his painting of space landscapes, get detailed information on existing space facilities, understand conditions of human work in space, and have a basic knowledge of space technology. Painters can get this knowledge partly from popular scientific books, films, and photographs, and partly from consulting with scientists and engineers.

Human scientific and technical activity will take place not only in near-Earth space, however. In the very near future, several planets, asteroids, and comets will be under permanent close-up study. Artists who want to portray dusky orange, super-hot Venus; cold, brick-red Mars with its uncanny daybreaks; jagged-angular asteroids; comet heads emitting gaseous jets; the bottomless stormy gas ocean of Jupiter's atmosphere; or the huge but elegant rings of Saturn, will have to read special books and consult planetologists, engineers, and designers to familiarize himself or herself with details of human exploration of outer space.

I especially insist on a study of landscapes of different corners of our solar system and the technological facilities to be used there: all these will be backgrounds for realistic space paintings of future heroic cosmonauts.

A final word about worlds of other stars, other galaxies. Here there is no need to show the technology of the future. No one can predict future technology. Only a hundred years ago scientists predicted giant steam engines as a means of rocket propulsion.

At present, science has some data on even the most distant galaxies. In this case too, the painter should consult astronomers and astrophysicists. And if the painter was to depict the system of a binary star, for instance, he or she could get information on such pairs. However, there is no information on an extrasolar planet—it is not yet even known whether such planets exist. Here the imagination of the painter, based on real experience, must invent this beautiful world of binary shadows and alien technology.

It is even more difficult to depict other forms of life on other planets. It is hard for anyone to imagine something "extraterrestrial." Most attempts to do so result in a combination of fantastic but earthly objects and images.

As a further example of this genre, I can even envision what, in principle, the human eye cannot see. For example, the theory of relativity might yield images that could be shown only in emotional, artistic form. It could be a symbol, a fantasy, a dream.

But dreams have always advanced reality. I believe that where science and art meet we find a true means for scientific *and* artistic perception of the world. This meeting point will further develop the ability of man to see the invisible, to comprehend the unthinkable, and to dream, thus advancing reality.

The cosmic theme in art is very popular, especially among young people. This is very important, because young people are the creators of and the witnesses to the future. The main task of this genre is to prepare people to accept the incredible, to be prepared to live in the fantastic world of tomorrow. □

Joe Tucciarone
Outerworld

A Jupiter-like giant planet and its moon is seen in some alien star system near a passing globular cluster of stars.

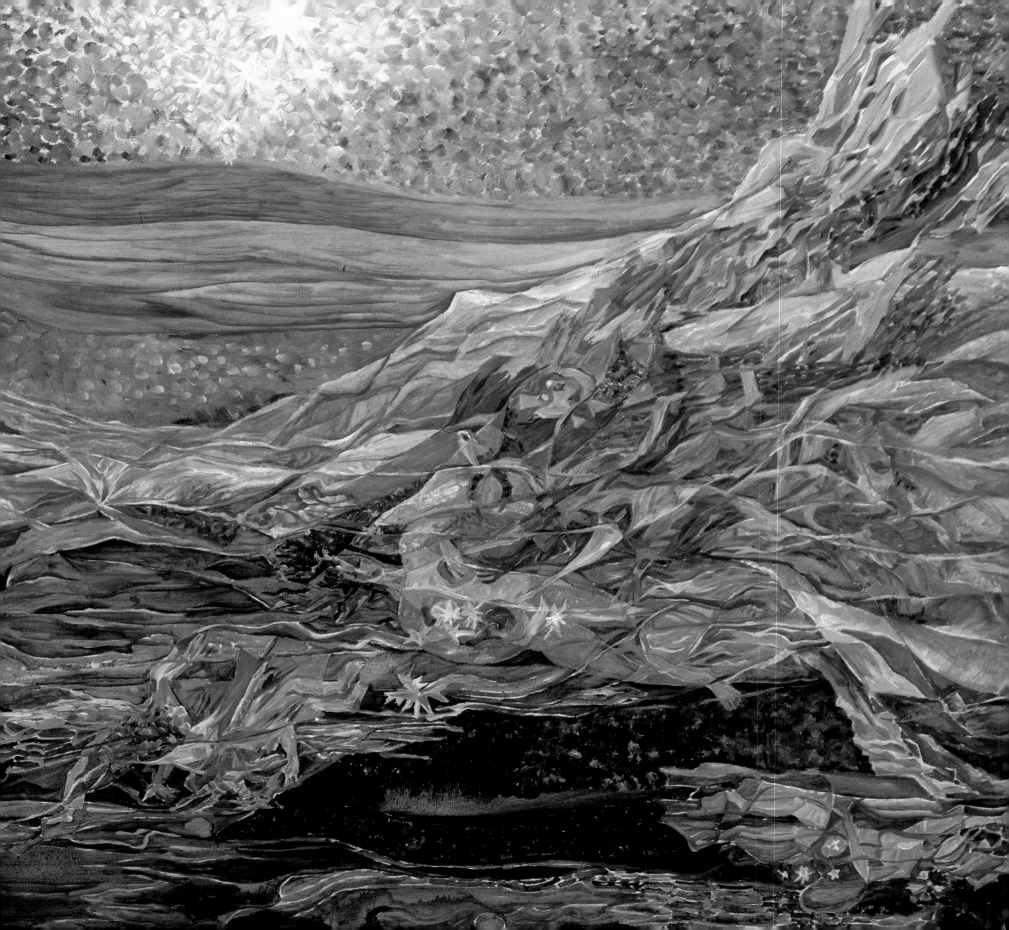

Galina Yakubowskaja
Flight

Yakubowskaja's turbulent, swirling imagery, left, helps to illustrate her belief that "space is a living organism." In the striving, zodiacal figures "the energy of the soul and the energy of space are united." To the artist, space is not only the goal of life on Earth, but it is the source of life as well . . . between life and the universe there is both a continuity and a continuum.

MariLynn Flynn
Lunar Polar Solar Furnace

Here is a long-shot venture in lunar exploration. Some scientists have speculated that if any H_2O were ever released on the moon by impacts of comet ices, it could have condensed and been preserved in frozen form in the cold spots of lunar poles. Because the sun stays near the horizon as seen from the poles, the floors of polar crevasses are perpetually dark and cold. Geologists might find the ice there—a treasure on the bone-dry moon. A solar furnace array on a background hilltop catches the sun's low rays, powering chemical processing of rock samples.

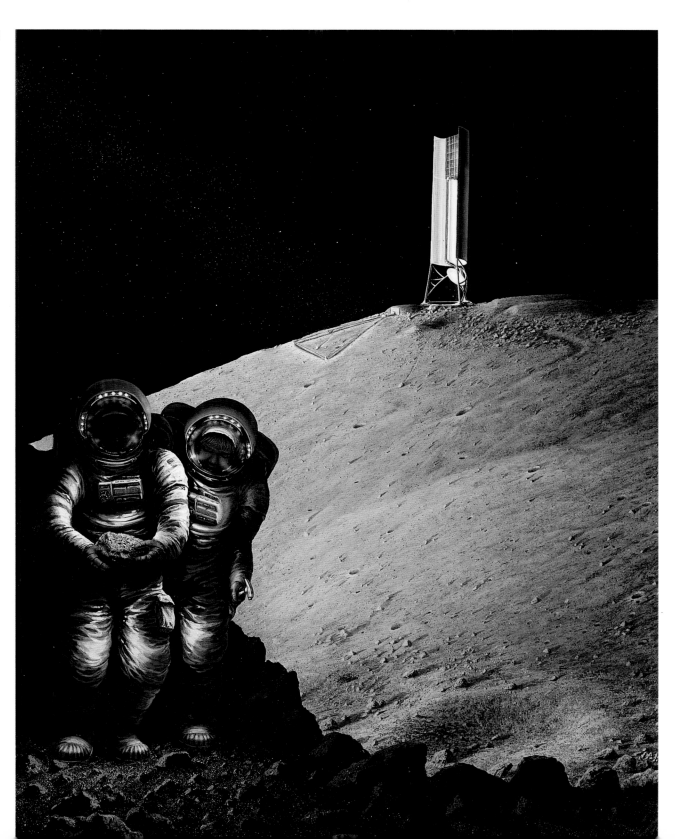

Galina Pisarevskaya
Intercosmos II

The painting is the second part of a diptych that is attempting "to show that space exploration should serve peaceful purposes," and that humankind must "bring together all space exploration programs."

The first half of the diptych, not shown here, depicts a cosmonaut rising genie-like from the smoking furnaces of the Earth—a primal, Vulcan-like Titan as capable of destroying this planet as it is of enhancing it. The painting shown here, the opposing image, shows the cosmonaut as Creator, holding in one hand his carefully drawn plans for our planet and in the other the bounty which space can bring to the Earth.

Mikail Mantulin
Observing from Orbit

Inspired by a reconnaissance satellite image of the Earth, the artist takes the natural semi-abstraction of Earth's fields, rivers, and cities one step further in this mixed-media work.

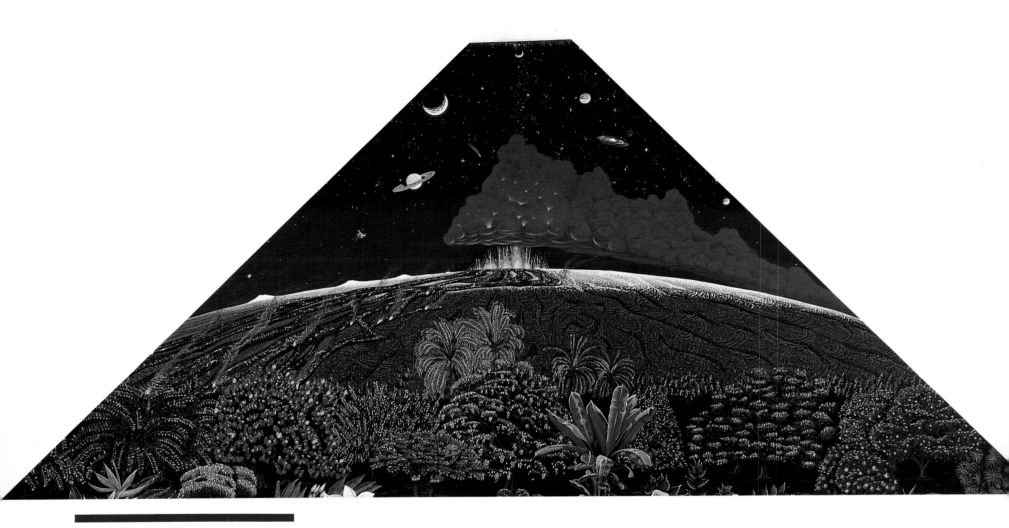

Ken Charon

*Ho Mai Ke Ola Hou; Source of Life
Renew Us*

The unity of creative and destructive
processes is experienced intensely in the
artist's homeland of Hawaii. A volcano
creates new lava flows while tropical
plants colonize earlier flows.

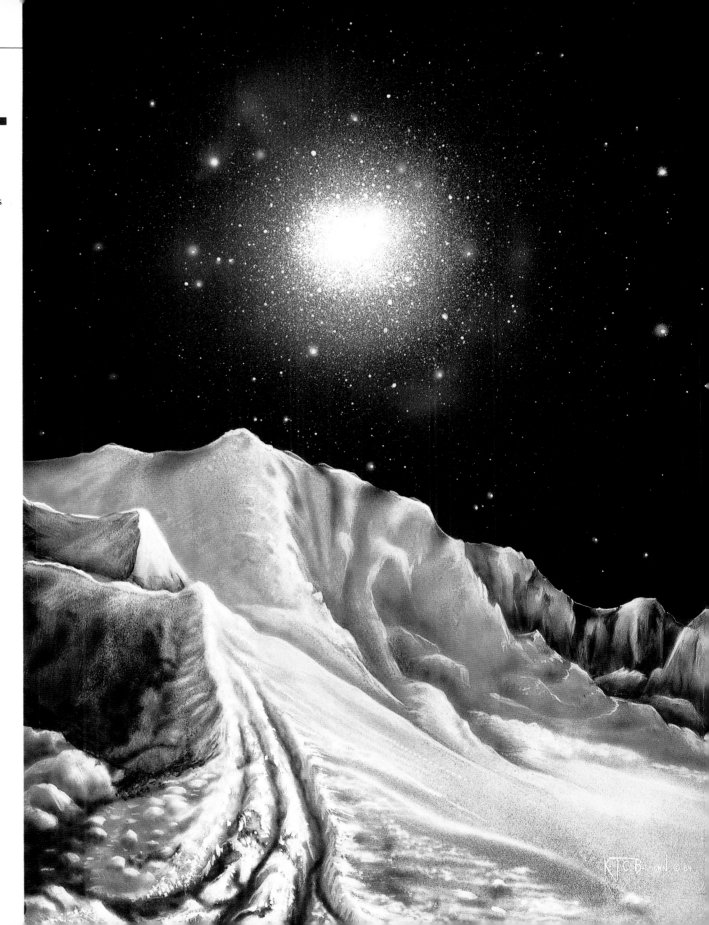

Kurt C. Burmann
Globular Cluster

Many globular star clusters contain fifty thousand or more stars. Orbiting around the galaxy, these huge clusters sometimes pass through the galactic disk near sun-like stars. Here, such a cluster looms above an icy satellite of an alien world near such a star.

Beth Avary
Together

In the canyons of Valles Marineris on Mars, a flag, combining the flags of Earth, points to a time when space exploration will provide a means for people to cooperate. The landscape was derived from sketches and photos made during the 1988 international workshop in Iceland.

Oleg Kokin
Terra Incognita

Moscow artist Oleg Kokin emphasizes the link between Earth and the other planets, at the same time reemphasizing the concern many Soviet artists express about technology. "Space exploration is first and foremost ecology. Space exploration should not destroy the frail life on the planet Earth."

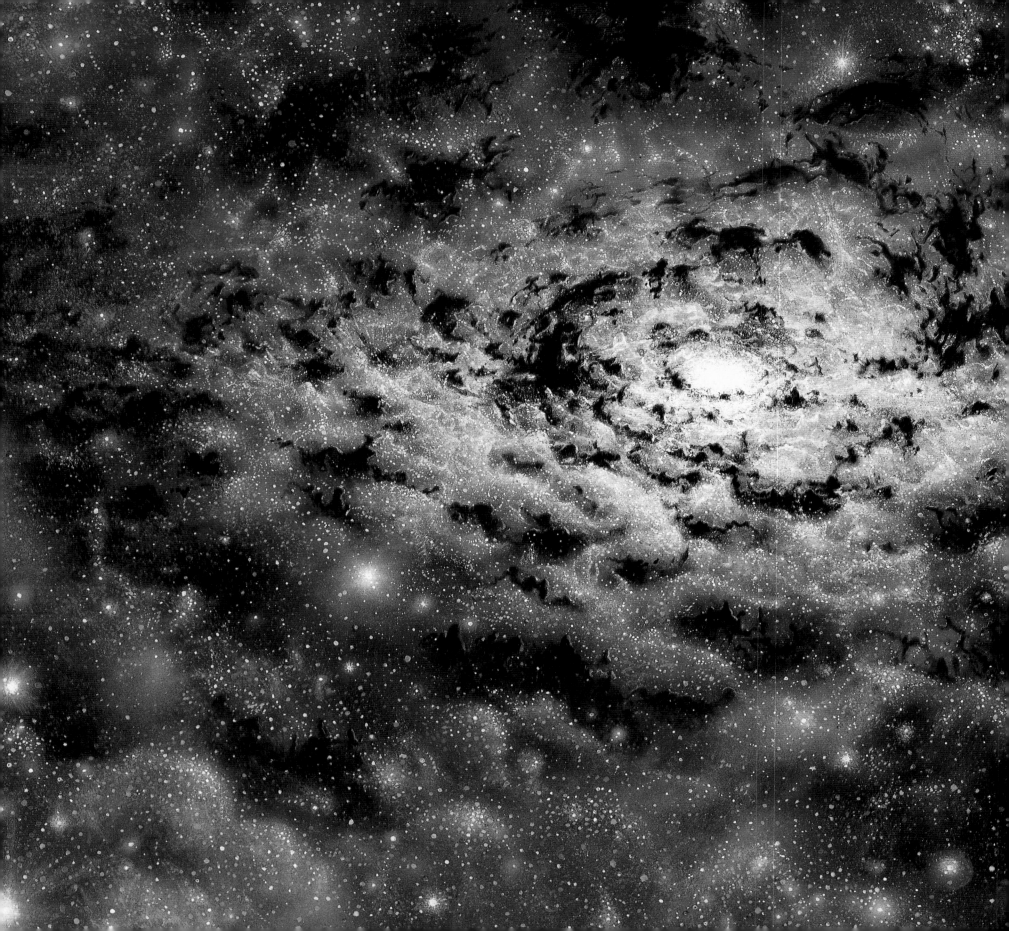

"I have a terrible need of—
dare I say the word?—religion.
Then I go out at night to paint
the stars . . ."

— Vincent Van Gogh
Arles, September 1888

The stars have long been a source of awe and inspiration. Early man watched and pondered the seasonal procession of stars and the rhythmic wandering of planets. He drew pictures and patterns so that the heavens became an integral part of his being. The symbols became friends to greet him, to guide him, and to entertain him. Astronomy grew out of this art.

Now, in the latter part of the twentieth century, there is a group of artists who are dedicated to merging art and astronomy once again. This group is the International Association for the Astronomical Arts. Its membership has grown quickly since its formation in 1983. By 1987 the IAAA had become a player in historic projects involving international collaborations such as those mentioned in this book; by 1988, it had become a non-profit corporation whose aim was to create an international school of art to celebrate this "new" genre. It is a school with a broad menu of styles and one single focus . . . the cosmos around us.

This book, this wonderful collaboration, is merely the beginning of a human adventure, a stepping stone to a global initiative involving all humanity, as we step together from ancestral Earth . . . into the stream of stars.

—Kara Szathmáry
President, IAAA

Geoffrey Chandler
Stellar Oculus

The artist remarks that a galaxy is "the grandest of subject matters," and that this image was "a personal, fun, and imaginary interpretation of a galaxy." For him, the painting became a form of "galactic mind-travel." Many spiral galaxies have extremely brilliant objects at their cores, and many astronomers believe these may be hot disks of dust and gas surrounding giant black holes—an interpretation hinted at by the glowing core of the image.

ARTISTS' BIOGRAPHIES

Andrei Akhaltsev

"Space exploration is ruinous for my country," states Akhaltsev with more than a little bitterness. "It can only be supported by those whose ambitions are of greater importance than the interest of the Motherland." It is true that the Russian space program has been a terribly expensive proposition for a country still recovering from the devastation of World War II and trying to deal with a faltering socialist economy. In spite of this, the artist still finds that the "romanticism of space exploration attracts me. I admire the courage of space pioneers."

Akhaltsev was born in 1945 and studied at the Moscow Art Institute. He is a member of the Moscow Organization of the Russian Artists Union and has exhibited in all-Union, Russian, and international shows. His work was included in the book *Painters of the 70s*, as well as in numerous art journals, magazines, and other publications. (*Page 94*)

Vladimir Arepiev

Born in 1949, Arepiev studied at the Art College in Kazan. He now lives in Kaluga, the home town of space pioneer Konstantin Tsiolkovski, where he belongs to the Kaluga Organization of the Russian Artists Union. He has shown his work in several exhibitions, including all-Union and Russian, as well as in Germany and Poland.

"Space exploration," says Arepiev, "has made me operate within these ideas: the sphericity of the earth; the momentary motion in time; the microcosm and the macrocosm; etc. That made me work out a new way of depicting my feelings on canvas. I understand that scientific research is neverending, that sometimes new discoveries contradict earlier ones—that's why I am not intending to be the only one who knows the truth." (*Page 127*)

Vladimir Artikov

Vladimir Artikov was born in 1934 and educated at the Turkmen Art School in Turkmenistan, where he now lives in the city of Ashkhabad. He is a member of the Turkmen Artists Union and has been exhibiting in all-Union, republic-wide, and international exhibitions since 1956. (*Page 72*)

Beth Avary

Beth Avary was born in Indiana in 1941, and obtained a B.F.A. degree (cum laude) from the California College of Arts and Crafts in 1965. Her work has evolved from abstract and naturalistic landscapes toward a style of astronomical art she calls "astrosurrealism." Her evolution was influenced by the works of William Holman Hunt and Maxfield Parrish. She has participated in shows in California, Japan, Mexico, and the Dialogs/Starway of Humanity international exhibition in 1989. In 1987 she was curator of the show Art of the Cosmos at the Lawrence Hall of Science, Berkeley, California, and she is currently the IAAA's director of exhibitions. She works mainly in acrylics with selective use of airbrush. Avary writes, "Art is a way of sorting out reality so that it makes sense . . . For me, discovering how the universe works is an important part of discovering what I am. Words can't express this for me the way painting can. That's why I paint." (*Page 14, Page 171*)

Valery Balabanov

Valery Balabanov was born in the Russian Federation in 1939. He now lives in Moscow and is a member of the Moscow Artists Organization. Since 1960 he has participated in all-Union, Russian, and international exhibitions. (*Page 67*)

Wayne D. Barlowe

Wayne Barlowe was born in 1958 in New York, and attended the Art Students League and The Cooper Union for the Advancement of Science and Art in New York City. He apprenticed at the American Museum of Natural History. He is known for anatomically and biologically realistic, but imaginative, renderings of imaginary alien species and their relations to their environments. His 1979 book, *Barlowe's Guide to Extraterrestrials*, received several awards. His paintings have appeared on over 100 book and magazine covers, and have been exhibited at the Society of Illustrators and the Hansen Gallery in New York. His new book, *Expedi-tion*, depicts the evolution of life forms on an imaginary, fertile, heavily populated world of another sun. He lives in New York City. (*Page 144*)

Julian Baum

Julian Baum was born in 1960 and grew up in England "with a diet of astronomy, space travel, and science fiction . . . Seeing the moon through my father's four-and-a-quarter-inch refractor on cold winter nights gave me a taste of all the things that might be, the worlds which one day will be visited and perhaps settled by humankind." Baum developed an interest in special photographic effects and worked in this field for Liverpool Planetarium. He became a free-lance artist in 1983, having developed a technique that mixes miniatures, color montage, optical photographic effects, and airbrushed illustration. He plans a series of works on alternate possible futures of Earth and its civilization. Baum resides in Chester, England. (*Page 93, Page 120*)

Alan Bean

Alan Bean's varied career has involved both space exploration and space painting. As a U.S. Navy test pilot in 1962, he took art classes at night. He was selected as an astronaut in 1963, and flew to the moon on the second manned lunar expedition, the flight of Apollo 12 in 1969. He went into space again in 1973 for the fifty-nine-day Skylab 2

mission in the first American space station. Training for these missions had left him too busy to pursue his art, but he resumed studies of painting in the 1970s, and when he resigned from NASA in 1981, he took up painting as a profession, specializing in views of lunar exploration based on his own observations and the experiences of other Apollo astronauts. (*Page 111, Page 112, Page 113*)

Wayne Begnaud

Wayne Begnaud was born in 1955 and graduated with a B.F.A. in illustration from the Art Center College of Design in Pasadena. His fascination with spaceflight was sparked as he watched the Apollo 8 mission in 1968. He became inspired by the art of Robert McCall and began his own space art in 1969. In 1975 Begnaud helped design the Apollo-Soyuz flight patch worn by American astronauts and Soviet cosmonauts during that mission. He participated in the 1989 Dialogs/Starway of Humanity space art show in Moscow and Pasadena, California, and thinks of himself as fifty percent illustrator and fifty percent fine artist—with a desire to be 100 percent fine artist. He works in gouache or acrylics, and sometimes in oils, and uses an airbrush. He currently works with Lockheed Corporation, and lives in Rialto, California. (*Page 95*)

Ludmila Bulatnikova

This young artist was born in 1952 in the republic of Latvia, where she studied at the Latvian Academy of Arts. She is presently living in Riga, and is a member of the Artists Union of Latvia.

She has exhibited widely in Latvian Young Artists shows, Watch Over Socialist Achievements, and Dialog/Starway of Humanity. "I support space exploration," she writes, "and find it necessary to expand it." She has visited Zvezdny Gorodnok, "Star City," and is inspired by Soviet and Western science fiction. (*Page 141*)

Kurt C. Burmann

Kurt C. Burmann was born in 1956 and grew up in rural Michigan as a self-taught artist. In 1987 he was a member of the first graduating class of the MIT International Space University. His paintings have been reproduced in numerous magazines and in the Isaac Asimov *Library of the Universe* series. He participated in the 1984 IAAA Other Worlds show, and in numerous other solo and joint exhibitions. He distributes his work through Burmann Art Productions in Armada, Michigan. (*Page 169*)

Michael Carroll

Michael Carroll was born in 1955 in San Diego. He has a B.F.A. in graphic design from Colorado State University, and works as lecturer and astronomical artist at the Reuben H. Fleet Space Theater and Science Center in San Diego. He is also known for his astronomical writing, and has published numerous popular articles. He was a founding member of the IAAA and a participant in Soviet-American space art exchanges beginning with the thirtieth anniversary celebrations of Sputnik 1 in Moscow in 1987. His paintings have been published in magazines in fifteen countries. (*Page 135*)

Geoffrey Chandler

Geoffrey Chandler attended Osaka University of Arts on a scholarship in 1972 and obtained a B.F.A. from the California College of Arts and Crafts in 1973. His paintings of star fields, nebulae, and galaxies are well known and widely collected, especially in California. Chandler has had one-man shows at Stanford University, the California Academy of Science, Oakland Museum, and numerous other galleries. He participated in the Planetfest 1981 exhibition in Pasadena which launched many of the IAAA joint activities, the 1987 Art of the Cosmos show in Berkeley, California, and many other joint shows. Chandler lives in San Francisco. (*Page 153, Page 172*)

Ken Charon

Ken Charon was born in New York in 1954 and grew up in Paris. He studied art at the American Center for Students and Artists in Paris, at the American College of Switzerland, and at the California College of Arts and Crafts in the 1970s. In 1978 he spent seven months living with a family in the Seychelles and this began his love affair with the tropics, which led him ultimately to his present residence in Hawaii. He lives near Hawaii Volcanoes National Park, and this proximity to volcanic activity, tropical landscapes, and one of the world's great astronomical observatories is reflected in his art. His pictures offer a strong sense of ongoing creation, captured in scenes which synthesize human, biological, and geological processes of renewal, rendered realistically, yet projecting a surreal quality. He participated in the 1986 International Space Art Workshop in Hawaii and has had one-man shows in Europe and the U.S. (*Page 168*)

Dennis Davidson

Dennis Davidson describes himself as "an artist who works in the idiom of space, painting in the style and context of interpretive realism." Davidson comes to his art through a background in science, having studied biology and chemistry at the University of California at San Diego. He states, "My focus on space exploration reflects my interest in the interaction of science, technology, and the arts. Since the beginnings of the industrial revolution, science and technology have been divorced from the world of art, to the detriment of both disciplines. I find myself at the edges of both worlds . . . seeing new metaphors emerging which incorporate the creative energies of the sciences and the arts. Today space represents what is new, unknown, and unexplored as the oceans were to our ancestors many generations ago. My goal is to communicate the wonder and excitement of humankind's transformation from an Earth-based culture to a space-faring civilization." Davidson participated in the 1989 Dialogs/Starway of Humanity international exhibition of space art in Moscow and Pasadena, California. He presently lives in New York City. (*Page 160*)

Don Davis

Don Davis was born in the San Francisco Bay area in 1952. Aside from art classes in high school and pointers from fellow space painters, he is a self-taught artist. In 1968 he began work as an illustrator at the astrogeology branch of the United States Geological Survey. He has also worked for the Hansen Planetarium in Utah. His work has appeared in numerous books, magazines, and TV programs, including

Carl Sagan's *Cosmos* series, for which he won an Emmy award. He has worked in special effects and made animated spacecraft short features for NASA. His paintings are widely known for his devotion to realistic detail based on data from space missions. (*Page 122, Page 155*)

Nadezhda Devisheva

Devisheva was born in 1947 and studied at the Moscow Textile Institute. She is a member of the Moscow Organization of the Russian Artists Union and has had her work shown in all-Union, Russian, and international exhibitions since 1976.

"My interest in space," she recalls, "began after I met Konstantin Kedrov, a poet and a philologist, and learned about his table of cosmic reorientations. Later I made a series of lithographs devoted to the theory of 'metacode' elaborated by the poet." (*Page 106*)

Vincent Di Fate

The artist attended the Phoenix (now the Pratt-Manhattan Center) for his formal art training, worked as a photoengraver, taught elementary school art and worked in animated films before turning to free-lance art in 1969. He has since received many awards for his work including the Frank R. Paul Award for Outstanding Achievement in Science Fiction Illustration, the 1979 Hugo Award for Best Professional Artist, and the Skylark Award for Imaginative Fiction in 1987. He has had a number of one-man shows at museums and galleries in North America, Europe, and Japan. His work is included in the collection of the National Air and Space Museum (Smithsonian Institution).

In addition to his art activities, Di

Fate has lectured extensively about the methods and history of his craft and has been a consultant for MCA, 20th Century Fox, and MGM/United Artists. He is the current chairman of the Permanent Collection for the Museum of American Illustration (Society of Illustrators) and is a past president of the Association of Science Fiction/Fantasy Artists. (*Page 45, Page 90*)

Paul DiMare

Paul DiMare was born in 1959 and studied art at the Cooper School of Art and apprenticed in a commercial art studio in Cleveland. He became interested in astronomy and space exploration during the Gemini mission of the mid-1960s, and concentrates on commercial art, developing the ideas of engineers and scientists in space exploration. His work has been widely published internationally in books and magazines including *Air and Space* and *Smithsonian*. (*Page 118*)

Don Dixon

Don Dixon was born in 1951 and majored in mathematics, astronomy, and physics at Victor Valley College and the University of California at Berkeley. He became a free-lance illustrator in 1972, and became well known through his trademarked "Spacescapes," marketed as slides. His work has appeared in many exhibitions, magazines, and books. A spectacular collection of his art appeared with his own text in the 1981 book *Universe*. He has also worked on various films and TV productions, including the well-known *Cosmos* series. He attended the founding workshop of the IAAA in Death Valley, California, in 1983, and now resides in California. (*Page 71*)

Victor Dubrovin

Born in 1948, Dubrovin studied art at the Moscow Pedagogical Institute, Faculty of Painting and Graphic Art. He is a member of the Moscow Organization of the Russian Artists Union and has participated in all-Union, Russian, and international exhibitions.

"Space exploration," Dubrovin explains, "is the exploration of the present and the past, and the prediction of the future of mankind. It is further development of science and engineering and human personality. Thanks to it, mankind will fill its place in the cosmic process." (*Page 64, Page 145*)

Vladimir Dzhanibekov

Dzhanibekov is one of the Soviet Union's most experienced cosmonauts, and one of three space explorer/artists represented in this book. Born in 1942, he now lives in the city most space artists can only hope to visit: Zvezdny Gorodok, "Star City." This is an entire town created around the center for cosmonaut training, where the cosmonauts and their families can live together. Star City is in a rural, wooded setting not far from Moscow and resembles a comfortable and attractive retirement village more than it does a military base.

Dzhanibekov is a cosmonaut and a major-general in the Soviet Air Force, twice Hero of the Soviet Union. He became a cosmonaut in 1970 and made five flights as spacecraft commander, spending an aggregate of 146 days in space between 1978 and 1985. He commanded the heroic effort that saved the Salyut 7 space station in 1985.

He studied art at the V. Komarov Higher Air Force School at Eisk. He is a member of the USSR Artists

Union and its Cosmic Group. He's held numerous exhibitions in the Soviet Union, the United States, Saudi Arabia, and other countries.

"Space exploration," he states, "is my main job and my favorite profession. In my artwork I try to show the philosophical side of this not-always-easy work." (*Page 1, Page 49*)

Bob Eggleton

Bob Eggleton was born in 1960 in Massachusetts. He recalls developing his lifelong interest in space exploration in his youth during the Gemini explorations and while watching the film *2001: A Space Odyssey*. He considers himself mostly self-taught in art, though he did study both art and astronomy at Rhode Island College. He recently illustrated an edition of *The First Men in the Moon*, and his work has been published in magazines in the U.S. as well as in Germany, Sweden, and Poland and on paperback-book covers. He participated in the 1989 Dialogs/Starway of Humanity space art show in Moscow and Pasadena, California. (*Page 16*)

Carter Emmart

Carter Emmart was born in 1961 in New York City. His family has a long history in painting and architecture, and he received training from his father, but did not pursue formal art-school training. He developed a boyhood interest in space exploration and astronomy during the Gemini and Apollo programs. His college training at the University of Colorado was in physics and geophysics, and he was heavily involved in planning the Case for Mars conferences in Boulder, Colorado, in the mid-1980s. At that time he worked with Michael Carroll and Paul Hudson, and reoriented his

career toward depicting the flight hardware proposed for Martian and other space expeditions. He is known for technical accuracy in his renderings of spacecraft and regards this as an integral part of the process of communicating ideas during space mission engineering design. His art has been published in international books and magazines, including *Aviation Week*, *U.S. News and World Report*, as well as NASA and Public Broadcasting Service films and planetarium exhibitions in New York and Salt Lake City, Utah. He participated in the 1989 Dialogs/Starway of Humanity exhibition in Moscow and Pasadena, California. (*Page 130, Page 131*)

MariLynn Flynn

MariLynn Flynn was born in 1954 in Ontario, Canada, and studied art at the Banff School of Fine Arts in Alberta, and in Toronto and San Francisco. She currently works in Flagstaff, Arizona, as a free-lance illustrator. She writes: "My interest in astronomy was sparked by my father giving me a telescope for Christmas, and taking me out to see an aurora and a meteor shower." This interest blossomed into a desire to become an astronaut. Flynn has scuba-diving experience and a private pilot's license, which she pursued in order to "move in all dimensions, and [to] free me from being a 'gravity slave.'" She has participated in the NASA Arts Program and was an eyewitness to the Challenger disaster. She also has been an active participant in IAAA workshops. Her works have appeared in numerous publications and shows, and can be seen in a mural in the Space Hall of Fame Museum in Alamagordo, New Mexico. Flynn notes current goals of seeing an erupting volcano, experiencing weightlessness in NASA's KC135

aircraft, and painting on location from Earth's orbit or the surface of another planet. (*Page 138, Page 165*)

John R. Foster

John R. Foster was born and raised in Portland, Oregon. Since 1983 he has been acting astronomical artist for the Kendall Planetarium in Portland. He is known for a highly realistic style, and his paintings have been in numerous shows including the 1987 Art of the Cosmos show in Berkeley, California, and the 1989 Dialogs/Starway of Humanity show in Moscow and Pasadena. Foster paints a variety of subjects, including science-fiction art, figure studies, and wilderness landscapes, and remarks that a terrestrial landscape is space art in the sense of being "a closeup of a tiny planet at the frontiers of the Milky Way galaxy." Foster notes that "all things are inseparably bound to the rest of the universe, regardless of time, space, size, distance, or any other factor. Anyone who wants to explore and understand nature must reject [such] factors [as limitations]. Art is the only vehicle capable of this kind of exploration. Art is the by-product of my adventures, which I share with anyone who wants to travel with me." (*Page 10, Page 148*)

Kelly Freas

Kelly Freas has been called the dean of science fiction illustrators, and his work ranges from scientifically informed art of space exploration through whimsy to fantasy illustrations. His science-fiction magazine and book covers have stirred imaginations since 1950. He has designed the insignia for the Skylab 1 mission and various posters for NASA. Freas resides in Los Angeles with

his wife, Laura Brodian, who is his manager and artistic assistant. (*Page 126*)

Joel Hagen

Joel Hagen was born in Los Angeles in 1948. His academic background was in anthropology, but he began to work as a free-lance artist and writer in 1978. Combining his interests in paleontology, astronomy, art, and planetary exploration, he became known for realistic sculptures of hypothetical alien life forms and fossils. He is a co-host of *Contact*, an annual interdisciplinary symposium on the search for extraterrestrial life and the impact of its discovery on human cultures. Hagen presented a paper, "Design Considerations for Orbital Space Habitats," at the NASA–co-sponsored Case for Mars III Conference in 1987. He was a founding member of the IAAA and has participated in the Dialogs project and exhibitions. His work was also featured in three public television documentaries in 1984, 1987, and 1988. (*Page 146*)

David A. Hardy

David Hardy was born in 1939 in Birmingham, England. He studied chemistry, physics, and art before serving in the Royal Air Force for two years. After a stint in a design office, he became a free-lance artist in 1965. He has illustrated dozens of books, including six of his own since 1974. He has held several one-man exhibitions and participated in the 1989 Dialogs/Starway of Humanity international exhibition in Moscow and Pasadena, California. In 1989 he published *Visions of Space*, a major book on the general field of space art, emphasizing the development of the genre through

realistic fine art, science-fiction illustration, and fantasy paintings by European, American, and Japanese artists. (*Page 42*)

William K. Hartmann

William K. Hartmann is internationally known as a planetary scientist and also as an astronomical painter and writer. He authored two successful college textbooks and a highly praised chronicle of the southwest, *Desert Heart*. He also co-authored the astronomy books *The Grand Tour*, *Out of the Cradle*, and *Cycles of Fire*, published by Workman Publishing Company. (*Page 13, Page 23, Page 140*)

Paul Hudson

Paul Hudson was born in 1960 in Anchorage, Alaska. "The first recollection I have of being interested in space was in third grade when a classmate got a birthday present of a picture of an Apollo lunar ascent module lifting off the moon. That was before the first landing. I was nine during the first landing and I felt I had already been there from seeing the picture. That's when the art-science connection clicked for me." In high school, Hudson began majoring in science and minoring in art, but eventually reversed the two. He attended Pasadena Art Center College of Design, and subsequently worked on the Disney Corporation's Epcot Center. He has also worked on space projects at Boeing and Orbital Sciences Corporation. He is currently a free-lance artist living in Washington. His work has been published in *National Geographic*, Time-Life Books, and numerous periodicals. (*Page 60, Page 116*)

Tom Hunt

Tom Hunt was born in 1951 in Wisconsin. He began his university training in oceanography and switched to a B.A. degree in art at the University of Wisconsin/Milwaukee. He is currently art director for *Astronomy Magazine* and participated in IAAA/USSR workshops as both an artist and as a journalist. His work has been published internationally in various magazines, and he participated in the 1989 Dialogs/ Starway of Humanity international exhibition of space art in Moscow and Pasadena, California. (*Page 74, Page 115*)

Jean-Michel Joly

Jean-Michel Joly is one of the best-known space artists in France, and has a background in illustration and science popularization. He has published numerous magazine illustrations on the subject of astronomy, and has created public park sculptures and installations on this subject. He participated in the 1989 Dialogs/Starway of Humanity exhibit in Moscow and Pasadena, California, and now resides in Saint-Étienne in southern France. (*Page 109*)

Rafik Karaev

Karaev (b. 1950) is a native of Uzbekistan, where he studied at the Tashkent Institute of Theatre and Art. He is a member of the Uzbekistan Artists Union and he has taken part in all-Union exhibitions since 1987. He has visited Zvezdny Gorodnok, the center for cosmonaut training, and believes that a prime concern of the space exploration program should be ecological issues. (*Page 63*)

Robert Kline

Robert Kline was born in Niagara Falls, New York, in 1954. He is primarily self-taught as an artist, specializing in planetarium show artwork, exhibits, and production, and in original paintings for collectors. He attended the IAAA Death Valley workshop and made the original design for the IAAA logo. His work has been published in magazines, such as *Astronomy*, and used in the *Nova* series on public television. Kline lives in California. (*Frontispiece, Page 133*)

Peter Kovalev and Olga Kovaleva

Peter and Olga (b. 1945 and 1948, respectively) are a husband and wife team of painters who often collaborate on individual works. They were educated at the Art College in Ryazan, a city southeast of Moscow. They are members of the USSR Artists Union and have had paintings exhibited in all-Union shows as well as in Poland, Norway, France, West Germany, Japan, Finland, and the United States. While they have not been fortunate enough to visit Baikonur, they have been to Zvezdny Gorodok, "Star City," the cosmonaut training center.

"We are trying," they say, "to make use of the scientific information that mankind has gotten by means of space exploration. Although space exploration offers infinite possibilities, we see space through human eyes." (*Page 104, Page 105, Page 147, Page 152*)

Oleg Kokin

Kokin (b. 1947) lives and works in Moscow, where he attended the Moscow Polygraphic Institute. He is a member of the Moscow Organization of the USSR Artists Union and has had work included in both national and international exhibitions.

"Space for me," he says, "is everything that there is under my feet when I walk on the earth . . . an anthill included. But mostly it is *terra incognita*," the mysteries of which inspired the example of his work included here. (*Page 170*)

Pamela Lee

Pamela Lee graduated with honors from the University of Arizona and did graduate work at the Pasadena Art Center School of Design and the San Francisco Academy of Art. She became interested in space exploration during the Apollo missions, but began her work in space art a decade later, after work as a corporate art director and advertising illustrator. Her astronomical work is widely known through popular magazines, science-fiction book covers, television productions, and the Workman Publishing Company books *Out of the Cradle* and *Cycles of Fire*. Her cooperation with Soviet artists began with the Young Astronaut Council/Young Cosmonaut exchange program in the Soviet Union in 1986. She has participated in the NASA Art Program, IAAA workshops, and various international exhibitions including the 1989 Dialogs/Starway of Humanity space art show. She currently lives in California. (*Page 51*)

Alexei Leonov

One of three space explorer/artists represented in this book, Leonov is a true pioneer. In 1965 he was the first man to walk in space and in 1975 was co-commander of the Apollo-Soyuz Test Flight.

Born in 1934, he is a graduate of a military flying school and the Zhukovsky Air Force Engineering Academy. After serving in the Air Force, he joined the cosmonauts' group in 1960. In three missions he has accumulated a total of seven days in space. He is twice Hero of the Soviet Union, a major-general in the Soviet Air Force, and head of cosmonaut training at Star City, where he currently resides.

Leonov studied art at the Kharkov Higher School of Pilots and is a member of the USSR Artists Union and its Cosmic Group. He has taken part in numerous exhibitions both in the Soviet Union and abroad, including the U.S., West Germany, and France. He has been published in seven books, often in collaboration with his friend Andrei Sokolov, the first, *Wait for Us, Stars*, and the most recent, *Man and the Universe*.

He took part in the IAAA Icelandic Space Art workshop in 1987 and in the Senezh workshop in 1988.

Leonov is unique among the cosmonaut/artists in that he took a few colored pencils and paper into space with him in order to create the first eyewitness sketches of the Earth from space.

"Space exploration," Leonov states, "and work in space must serve the people of the whole world. I've been in space, I've seen it and feel obligated to share my vision of space with people by means of the art I have at my disposal." (*Page 96, Page 97, Page 98*)

Jon Lomberg

Jon Lomberg developed his artistic career in Canada and became widely known as the illustrator of several of Carl Sagan's books. His art stresses themes of the interconnectedness of life and the physical universe. He is active not only as a painter but also in the field of video journalism. He

has participated in various efforts of the IAAA and the Planetary Society. He has recently taken up residence in Hawaii and is actively interested in sea life and diving. (*Page 6, Page 20*)

Angela Manno

Angela Manno was born in 1953 in Queens, New York. She studied art in the 1970s, including work in the Sarah Lawrence Art Program in Lacoste, France, batik painting with Jyotirindra Roy, and photography and printmaking at the San Francisco Art Institute. She specializes mainly in artwork for commercial galleries, non-profit exhibition spaces, commissioned projects, and distribution in audio-visual and video formats. She writes that her blending of ancient batik practice with modern photo heat transfer techniques "represents . . . the integration of opposites and the need for interplay between ancient wisdom and modern technology, male and female, intellect and emotion, East and West. Thus the medium in which I work is also my message: unity in diversity, the condition of all healthy living systems." Manno has had numerous one-person exhibitions and participated in the NASA Art Program and the 1989 Dialogs/ Starway of Humanity international exhibition in Moscow and Pasadena. (*Page 18*)

Mikhail Mantulin

Born in 1950, Mantulin studied art at the Tashkent Polytechnical Institute, Faculty of Architecture. He now lives and works in the city of Kashira in Tashkent, where he is a member of the Kashira Organization of the Russian Artists Union. His work has been exhibited in the

all-Union Youth of the Country shows in 1976 and 1982, and in the International Plein-Air exhibition in Poland in 1989.

"Space exploration," explains the artist, "enlarges human knowledge about the universe, and it may contribute to forming a new art idiom." (*Page 167*)

Mark Maxwell

Mark Maxwell was born in 1960 in Alabama. He studied radio broadcasting at the University of Tennessee and is self-taught in art. He states that he "always had an interest in space exploration and science fiction, a result of growing up in the 1960s as the U.S. space program came to fruition." He began a serious art career as a result of seeing space art at a science-fiction convention and in the book *Grand Tour*. His art has appeared in a number of magazines including *Omni*, *Final Frontier*, and *Ad Astra*. He participated in the 1989 Dialogs/Starway of Humanity space art show in Moscow and Pasadena. (*Page 44, Page 69*)

Robert McCall

Robert McCall was born in Ohio in 1919. He studied at the Columbus Fine Arts School and has made his living as an artist since age seventeen. He became interested in science, especially astronomy, as a teenager. Isaac Asimov once referred to McCall as "the nearest thing to an artist in residence from outer space." A resident of Arizona, McCall is internationally known for an unusual range of artistic work, which has included conceptual paintings for the films *2001: A Space Odyssey* and *Star Trek*; designs for postage stamps and NASA mission

patches; and well-known murals at the National Air and Space Museum in Washington, D.C., and at NASA's Johnson Space Flight Center. Known for both aviation and space art, McCall was one of the earliest artists in the NASA Art Program, and the only artist who has chronicled the program from the Mercury flights of the early 1960s to current missions. (*Page 50, Page 83*)

Ron Miller

Ron Miller was born in 1947. He holds a B.F.A. in illustration and is widely known for his astronomical and science-fiction paintings. He was co-illustrator of three Workman Publishing Company illustrated books on astronomy and space exploration, *Grand Tour*, *Out of the Cradle*, and *Cycles of Fire*. He also published *Space Art*, a review of historical and contemporary space art, in 1978, and with Frederick Durant, co-authored *Worlds Beyond: The Art of Chesley Bonestell*, a 1983 biography of the father of space art. He recently published an illustrated version of Jules Verne's *20,000 Leagues Under the Sea*, and is currently working on his first novel, a fantasy adventure. He is a charter IAAA member and participated in the Death Valley and Iceland workshops as well as in other Soviet-American space art exchanges. (*Page 21, Page 68, Page 70*)

Josef Minsky

Born in Minsk in 1947, the artist now lives and works in Moscow. He inherited his talent from both of his parents. His father was a noted muralist and his mother is a well-

known landscape painter. Minsky studied at the Moscow Pedagogical Institute, Faculty of Painting and Graphic Art. He is a member of the USSR Artists Union and its Cosmic Group. He has exhibited widely in all-Union, republic-wide, and international shows. Among other projects, he is working on several collaborative pieces with American artist Ron Miller.

Long interested in space exploration, Minsky has visited the cosmonaut training village Zvezdny Gorodok, or "Star City," and the Space Exploration Institute. "For me," writes the artist, "space exploration is both a realization of a child's dreams and a possibility to look into the future, to feel time as something material. The main thing for me is that space exploration has two aspects: technical and human." (*Page 58, Page 101*)

Pierre Mion

Pierre Mion was born in 1931 in Pennsylvania. He began watercolors at age nine and, at sixteen, was helping his father, an Italian fine artist and architect. His unusual career included being a national champion race-car driver and serving in the U.S. Marines. He studied art in the Washington, D.C., area and began his career as an illustrator in 1955. He has worked with Norman Rockwell, the NASA Art Program, and many scientists and writers, including Wernher von Braun, Jacques Cousteau, and Arthur C. Clarke. He has exhibited in many galleries and museums, including the National Air and Space Museum, is published in many magazines, and has designed U.S. Postal Service cards. He lives in a restored 1860s farmhouse in Virginia. (*Page 124*)

Vitaly Myagkov

Vitaly Myagkov is the secretary of the board of the Union of Artists, an organization boasting more than twenty thousand members in every republic of the Soviet Union. Born in the Ukraine in 1936, he studied at the Kiev Art Institute and now lives and works in Moscow. His work has not only appeared in all-Union and republic-wide exhibitions, but in twelve shows held outside the Soviet Union.

He has been instrumental in arranging and managing the space art workshops held in Russia that have enabled many Western artists to work with their Soviet counterparts. In turn, Myagkov has taken part in two workshops outside the Soviet Union. One was the first Soviet/ Western space art workshop, held in Iceland in 1987. That was followed by a workshop held in the American southwest in 1989.

Myagkov's work was featured in two books on the history of Ukrainian art, both authored by Yuri Belichko: *Art Born of October, 1917– 1987* and *Through the Centuries*.

Myagkov believes that "space exploration is an act of gaining knowledge; knowledge is part and parcel of human activity. Knowledge leads to discoveries." (*Page 55, Page 57, Page 59*)

Togrul Narimanbekov

Narimanbekov leads a double life: one as a renowned and respected artist, and one as an opera singer. His magnificent voice has melted hearts at several international space art workshops. An Azerbaijani native, born in 1930, who studied at the State Art Institute in Vilnius, Narimanbekov has exhibited widely. His work has been shown both in all-Union exhibitions and in one-man shows in Italy, West Germany, Poland, and Yugoslavia. Two books of his work have been published, both titled *Togrul Narimanbekov.*

Narimanbekov has had an abiding interest in space flight, believing that "space is the future of mankind, and its continuing discoveries and progress of life." He has been privileged to visit the Baikonur Cosmodrome and counts many well-known cosmonauts among his friends. (*Page 107*)

Georgii Orlov

Georgii Orlov is a native of Leningrad, where he was born in 1946. He studied at the Repin Art Institute and is now a member of the Leningrad Artists Union. His work has been published and exhibited widely, including all-Union, Russian, and international shows. He has worked in the genre of space art since 1980. (*Page 75*)

Larry Ortiz

Larry Ortiz was born in 1948 and was trained in commercial art at San Diego City College. He has long been interested in space and has published both science-fiction illustrations and realistic space art. He is currently a free-lance artist in San Diego, California. He participated in the 1983 IAAA space art workshop in Death Valley, and in the 1989 Dialogs/Starway of Humanity international exhibition in Moscow and Pasadena. (*Page 76*)

Anatoly Paseka

Paseka is a young illustrator living in the western Siberian industrial city of Sverdlovsk. He is one of the few Soviet artists represented in this book who has made a specialty of illustrating science fiction and fantasy. His work has appeared in print in publications in numerous countries, including the United States, and his original art has been exhibited at science fiction conventions internationally. His favorite and preferred medium is pen and ink — the work in this book is one of his rare forays into painting. He is a member of the USSR Artists Union and the Association of Science Fiction and Fantasy Artists. (*Page 62*)

Mark Paternostro

Mark Paternostro was born in Wisconsin. He was educated at the University of Wisconsin in the early and mid 1970s, where he studied airbrushing technique, among other things. He served as staff artist at *Astronomy* magazine from 1976 to 1978, and became a free-lance artist in 1978. He is especially known for his airbrushed astronomical art. His work has been shown in many planetarium and audio-visual shows and in exhibitions, and has appeared in magazines, the *Nova* TV series on PBS, and on music album covers. He is currently the artist and visual designer at Adler Planetarium in Chicago. (*Page 150*)

Ludek Pesek

Ludek Pesek was born in 1919 in Kladno, Czechoslovakia, where he studied at the Academy of Arts. He has been active as both a painter and writer since 1945. When the Soviet Union took control of Czechoslovakia, he moved to Switzerland, where he has lived since 1968. He has written several novels, including *Earth Ahead*, a science fiction novel about the first expedition to Mars. His first big picture book of space art, *The Moon and the Planets*, was published in 1963 and was almost immediately translated and reprinted in Great Britain, the Netherlands, France, Germany, Italy, Japan, Mexico, Denmark, and the Soviet Union. It was awarded a prize at the International Biennale of Illustration in Bratislava in 1966. It is now a highly-sought-after classic. A companion volume, *Our Planet Earth*, appeared in 1967. His work first became well-known in the United States when his art accompanied the article, "Voyage to the Planets," published in *National Geographic* in 1970. He has had exhibitions of his work internationally, including at the Smithsonian Institution, where many of his paintings are in the permanent collection. (*Page 47*)

Alexander Petrov and Elena Korennova

Alexander "Sasha" Petrov was born in the town of Kuybishev, on the Volga River, in 1947. He graduated from the equivalent of high school in 1966 as a painter and went on to study at the Moscow Institute of Fine and Industrial Arts, where he graduated in 1971. He has been exhibiting his work since 1972 both within the Soviet Union and internationally (Holland, Switzerland, India, France, the United States, England, for example). His work can be found in the permanent collections of numerous museums, such as the Tretyakov Gallery in Moscow, the Tambrov in Sverdlovsk, Kaliningrad, and Ulyanovsk in Kazan, as well as in many private collections all over the world.

Elena Korennova has been collaborating with Sasha Petrov since 1986. She was born in 1960 and graduated from the Moscow Institute of Fine and Industrial Arts in 1984.

She has been exhibiting her work since 1981, and already has had numerous Soviet and international exhibitions. Her paintings have been shown in Finland, Indonesia, the United Kingdom, the United States, Italy, and other countries, and are represented in museums in Brjansk, Sverdlovsk, and Kaliningrad and in many private collections worldwide. (*Page 13, Page 73*)

Galina Pisarevkaja

Pisarevskaja was born in 1940 and now lives in the city of Kemerovo, in central Russia. She attended the Art College in Irkutsk and has since been widely exhibited in all-Union and Russian shows since 1969, as well as shows internationally. Like many other artists interested in space, she has visited Zvezdny Gorodok, or "Star City," the cosmonaut training center not far from Moscow. (*Page 166*)

Yuri Pochodaev

Pochodaev (b. 1927) studied art at the Surikov Institute of Art in Moscow, where he presently lives. He is a member of the USSR Artists Union and has taken part in many exhibitions both in the Soviet Union and internationally. His work has been reproduced in numerous periodicals as well as in the book, *Pochodaev Yuri*. He counts many cosmonauts among his personal friends and has visited Baikonur, the main launch site for manned missions; the Center for Flight Coordination; "Star City"; and Kapustin Yar, a launch site near Arkhangelsk.

"Space exploration," he believes, "has given mankind a chance to realize its own nature and get a new idea of the reality of our planet. The artist is a prophet and a barometer, in a way, of the ongoing changes in life. Like the philosopher and the poet, he reflects changes occurring in his time."

"Space art," he continues, "is deeply rooted in history and has occupied its own place in world culture. In our time borderlines between science fiction, science, and real life are blurred. Space art gives the artist a chance to expand the limits of his work. Only artistic imagination is capable of showing a thoroughly new world, never seen before by anyone, with its beautiful colors, and the potential of looking into the impossible." (*Page 121, Page 154*)

Kim Poor

Kim Poor was born in 1952. He studied physics before taking up art, and is known for his colorful landscapes and use of unusual perspective. As first president of IAAA, he headed an American delegation of artists to Moscow and Iceland at the beginning of *glasnost* and oversaw early IAAA-USSR interactions. His work has been published in nearly every major science magazine, from *Omni* in the U.S. to Germany's *Kosmos* and the popular Soviet monthly, *Ogonjok*. He is founder and president of Novagraphics, the world's largest distributor of space art prints and posters. (*Page 46*)

Georgii Poplavski

Poplavski is a native of Byelorussia, where he was born in 1931. He studied art at the Byelorussia Art Institute and is a member of the Byelorussia Artists Union. Poplavski lives and works in Minsk, the republic's capital. His work has been featured in numerous exhibitions, both domestic and foreign, including Soyuz-Apollo (1980), Madras (1980), Damask (1978), Paris (1989), and many others. His art is the subject of the book *G. Poplavski*.

He has been among the fortunate few to have visited Baikonur, as well as Star City and the Museum of Cosmonautics.

He admires the "courageous, clever, emotional people [who] take part in space exploration. All the discoveries that are being made belong to all people and should be of much use to mankind. For me, space means heroism and tragedy. These two notions are closely connected, like everything else in human life." (*Page 125*)

Ron Russell

Born in 1938 of a pioneer California family of artists, Ron Russell studied philosophy and medicine in college. He became a theater designer and builder for the San Francisco Actor's Workshop, and began cosmic paintings in 1973. He has developed a unique technique for his paintings, working on the back of glass. The paint is baked under infrared lighting to fuse it to the tempered glass surface. Russell writes, "I consider my content to be 'romantic/symbolic' like some of the Soviet painters, as I eschew literal illustrative techniques and try to talk about the bigger picture, the place of the 'spirit.'" He has created cover paintings for magazines such as *Omni*, and his paintings are in numerous collections, including those of the National Air and Space Museum, the DeYoung Museum, and the Guggenheim Collection. He recently moved his studio from Sonoma, California, to Denver, Colorado. (*Page 129*)

Robert Schulman

Robert Schulman was born in Massachusetts in 1924. He is director of the NASA Art Program and curator of art for its space art collection. He studied design, drawing, and painting at the Whitney School of Art in Connecticut and at the Corcoran School of Art in Washington, D.C. He received a gold medal for art direction from the New York Society of Illustrators, and awards from the Art Directors' Club of New York and the Art Directors' Club of Washington, D.C. His works have been exhibited at the Society of Illustrators, the National Air and Space Museum, and other institutions. He is director of NASA Graphics Design, for which he received the First Presidential Award for Design Excellence. Schulman is a member of the Graphics Evaluation Panel for the National Endowment for the Arts. (*Page 84*)

Joe Shabram

Joe Shabram was born in 1950 in Washington state. He began oil painting at age ten, and completed his first space painting, a Martian landscape for a high-school art project, in 1966. After art studies at Monterey Peninsula College, he began serious astronomical art in 1976, inspired by the successful Viking landing on Mars. He generally works in acrylic on ragboard, currently using glazes, stippling, and washes instead of airbrush. He finds his work divided between smaller works for publications (usually 16 × 20 inches), and larger works for gallery sales and exhibits. He participated in the 1989 Dialogs/Starway of Humanity international exhibition and his work has been widely published in books and magazines. (*Page 137*)

Zacqueline Souras

Zacqueline Souras was born and raised in Athens, Greece. She was inspired in 1985 when she joined the Infrared Processing and Analysis Center of the Jet Propulsion Laboratory in Pasadena, California, and saw Infrared Astronomical Satellite (IRAS) computer-processed images of planets and stars taken from space. She writes: "the evening sky acquired a new dimension. I could never have imagined images of the heavens with such vital, sharply-contrasted colors . . . always set against a dramatic background of black sky." This sparked a new astronomical theme in her paintings. Her paintings have been published in England and the U.S., and exhibited in the U.S., Britain, and Switzerland, as well as in the 1989 Dialogs/Starway of Humanity international exhibition in Moscow. (*Page 134*)

Alexei Stepanov

Stepanov, born in 1923, lives and works in the city of Alma-Ata, the capital of Kazakhstan. He studied art at the Repin Art Institute in Leningrad, and belongs to the Artists Union of Kazakhstan. He has taken part in annual exhibitions held in his republic since 1950. (*Page 19*)

Brian Sullivan

Brian Sullivan was born in Rochester, New York in 1953. In 1968 his father took him to see *2001: A Space Odyssey* and ever since then his self-taught, space art talent has been dedicated to showing people the world of space exploration. A graduate of the Rochester Institute of Technology with a B. S. degree in Audio-Visual Communication,

Brian also studied at the Strasenburgh Planetarium in Rochester, New York. His works have appeared in *Omni*, *Smithsonian*, *Aviation Week*, *Reader's Digest*, *Time* and numerous book publications. Currently he is a producer at the Hayden Planetarium in New York City. (*Page 92, Page 151*)

Igor Shelest

To this young (b. 1961) lithographer, space "is an enigma, a mysterious phenomenon." Shelest lives and works in Kiev, the capital of the Ukraine, where he attended the State Art Institute of Kiev. He is a member of the Association of Young Artists of the Ukraine Artists Union, and has exhibited his work at the all-Union exhibition On One's Guard and at numerous Ukrainian exhibitions.

Like many of today's young people, Shelest shares a concern about the welfare of the planet he lives on. "In my work," he states, "I am trying to tell about the peaceful initiatives of people. (*Page 66*)

Mikail Skvorzhov

Skvorzhov is a native of Krasnodar, a city about fifty miles from the Black Sea, where he was born in 1950. He received his training at the Art College of Krasnodar. He is a member of the Krasnodar Organization of the Russian Artists Union and has taken part in many all-Union, Russian, and international exhibitions since 1975.

His enthusiasm for cosmonautics has led him on visits to Zvezdny Gorodok, or "Star City," the cosmonaut training center, and to many of the cosmonauts museums. Space travel, he believes, is "very interesting and an important scientific venture. Being an artist, I feel affected by scientific progress." (*Page 108*)

Andrei Sokolov

Andrei Sokolov can be rightly called the dean of Soviet space art. This enormously prolific and influential artist has been active for decades in promoting the recognition of space art both in his own country and abroad. He works closely with the cosmonauts, particularly with his friend and collaborator Alexei Leonov, and has visited the Baikonur launch facility many times.

Sokolov was born in 1931 and studied art at the Moscow Architectural Institute. He is a member of the USSR Artists Union where he is chairman of the Cosmic Group. He has held numerous exhibitions both in the Soviet Union and abroad, including in the U.S., West Germany, Holland, and Japan. He is active internationally in the promotion of both space art and interest in space exploration. His art work has been published in many American books and magazines, including *Air & Space*, and in seven books of his own (some done in collaboration with Alexei Leonov).

He is the envy of most other space artists in having the active cooperation of cosmonauts in the creation of his art work. Sokolov will prepare a sketch of some region on Earth that he knows a cosmonaut crew will be passing over while in orbit. Using his vast and expert knowledge of light, color, perspective, and geography, he tries to depict what the cosmonauts will see as accurately as he can. These sketches are done on a light, flexible cloth that can be rolled or folded. On space left for the purpose, the cosmonauts are able to make notes, comparing Sokolov's view with reality. Using these critiques, Sokolov is able to render his final painting with great accuracy.

"Space exploration," says

Sokolov, "is the most impressive achievement of mankind; it's the forefront of human knowledge. The chief and only theme of my artistic activity is space, the universe, and cosmonautics." (*Page 103, Page 157, Page 158, Page 159*)

Kara Szathmáry

Kara Szathmáry was born in 1947 in West Germany, of Hungarian parents, and immigrated to Canada in 1951. He holds a B.S. in Physics and Mathematics with honors from McMaster University, and an M.S. in astrophysics from the University of Western Ontario. He is the current president of the IAAA, and lives in Quebec, where he teaches mathematics at Champlain College. He developed the board game Quantum Baseball, and his paintings have been exhibited in the 1989 Dialogs/ Starway of Humanity International show in Moscow, as well as in other exhibitions. He writes that in his paintings, "many of my themes are metaphors for the interaction of scientific knowledge, philosophic intuition, and emotional reflection . . . The inspirations often spill over into spiritual and religious impacts on our human condition at the threshold of space travel." (*Page 22*)

Joe Tucciarone

Joe Tucciarone was born in 1953 in Ohio. He holds B.S. and M.S. degrees in physics with an astrophysics minor from Youngstown State University and the University of Toledo, respectively. His "formal" art training took place only from the age of eight to the age of thirteen in

weekly art classes at the Butler Institute of American Art in Youngstown, Ohio. He writes, "I prefer the Ansel Adams approach to fine art. We know that Mr. Adams must have used a pile of photographic gear for his work, and a car to get him to his mountains. But he left both car and tripod out of his pictures, and instead showed us the mountains." His paintings have been shown in the 1987 Art of the Cosmos show in Berkeley, California, and the 1989 Dialogs/Starway of Humanity International show in Moscow and Pasadena, as well as in other exhibitions and publications. He lives in Cocoa, Florida, within sight of launches from the Kennedy Space Center. (*Page 142, Page 162*)

Anatoly Veselov

This Soviet artist is known for his work in large lithographs and mosaic arrays of lithographs, featuring a lyric interpretation of humanity's place in the universe. He participated in the 1988 joint workshop in Iceland. He lives and has a studio in Moscow, has traveled and shown his work, and is forming a cooperative to promote wider distribution of his own art and that of other Soviet artists. (*Page 65*)

Oleg Vukolov

Born in 1933, Vukolov lives and works in Moscow, where he is a member of the USSR Artists Union. He has exhibited widely, including all-Union, Russian, and international exhibitions. His work is the subject of a book, *Oleg Vukolov,* published in 1988.

Vukolov believes that the exploration of space is of much use, but fears that at the same time it may be damaging the environment of the home planet. (*Page 52*)

Galina Yakubowskaja

Born in 1941, a student of the Moscow Polygraphic Institute, Yakubowskaja now lives and works in that city, where she is a member of the artists union and the Moscow Organization of Russia. Her works have been exhibited in all-Union and republic-wide shows, as well as in international shows, since 1968. A book on her life and work was published by P. Muratov.

Yakubowskaja has been interested in space and space exploration for many years. Like many similarly minded artists she has visited Zvezdny Gorodok, or "Star City," the center for cosmonaut training. Her interest has expressed itself in an unusual way: she has been the set designer for numerous stage productions with themes relating to space, science fiction, or creation mythology, such as "Solaris," "Creation of the World," "Adam and Eve," and "Orpheus." (*Page 164*)